ART AND HISTORY OF CRETE

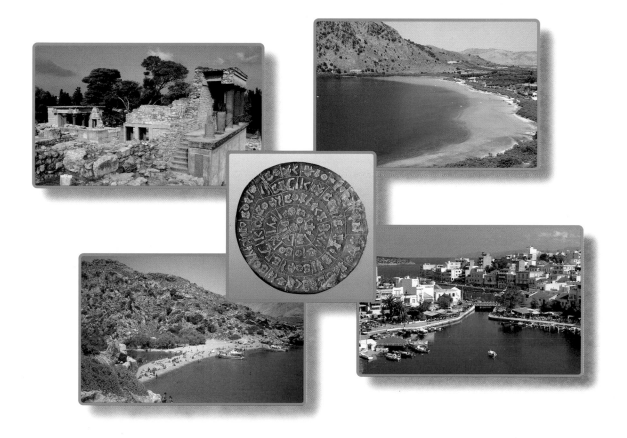

Text by
Mario Iozzo

BONECHI

ART AND HISTORY OF CRETE

Publication created and designed by Casa Editrice Bonechi
Picture research: Giovanna Magi
Layout and videographics: Manuela Ranfagni
Text: Mario Iozzo
Translation: Mark Roberts
Editor: Simonetta Giorgi
Drawings:Stefano Benini
Map: Bernardo Mannucci

ISBN 88-8029-424-5

* * *

*T*he ancient and splendid island of Crete, steeped in mystery and with so many of its treasures still to be explored, offers a link between the classical civilisation of the Mediterranean and the more ancient ones of Egypt and Asia Minor.
The rugged island of Minos serves therefore as a bridge (artistic, religious and linguistic) between three continents: Asia, Africa and Europe.
The elongated island is characterised by mountain ranges; by the White Mountains, by Mt Ida and Mt Diktys, the unusual Lasithi mountain plateau. Unlike other Mediterranean islands of this size there are few fertile stretches which makes the lush plain of Mésara, in the centre of the southern coast, all the more remarkable.

The troubled history of the island, a long series of invasions and more or less short-term occupations, reflects the continuous fascination and attraction of Crete.
There were groups of hunters settled on Crete as early as the Palaeolithic and Mesolithic period. Between the seventh and fourth millennium B.C. the island was further populated with Neolithic groups from Anatolia (modern Turkey) who probably reached the island in crude sea-craft. These people from Asia Minor brought seeds and domestic animals with them and settled either in caves or simple rectangular constructions and soon started to produce terracotta pots modelled by hand. The abundance of female idols of the kind known as steatopìgi (" of

Occasionally the barren and battered landscape is broken by magnificent ravines fed by the rush of the winter torrents forcefully moulding the Cretan landscape. The scorching heat of summer reduces these torrents to pitiful trickles.
This continuous succession of rocky bays and steep valleys, of tiny plains and small plateaux, is dominated by the massive form of Mt Ida, visible from almost every part of the island. Mt Ida is the birthplace of the father of all the Olympian gods, Zeus, whose symbol of power, a bull with impressive horns, is reflected in the mountain's two sharp peaks between which lies the Dictaen cave, the cradle of the god. These peaks undoubtedly gave rise to the symbolic image of the double horns, linked to the cult of the father of the gods, apparent in all the Minoan palaces and sanctuaries to acknowledge the divine presence and in recognition of the royal household's debt to his power.
The beauty of Crete is most potent around the coast: a heavily indented series of bays, ports, beaches and coves which are easily accessible and often backed by steep and forbidding cliffs, reflected in the azure sea. For thousands of years these bays offered safe access to Mediterranean vessels in search of new lands to discover and conquer and to those in search of new commercial, political and cultural alliances: the Egyptians, Cypriots, Rhodians, Phoenicians, Minoans, Mycenæans, G r e e k s, Romans, B y z a n t i n e s, A r a b s, Crusaders, the Maritime Republics of Medieval Italy, Turks, right up to the fleets of modern naval vessels and tourist cruises.

the large muscles") of the same period discovered throughout the Mediterranean region documents the existence of a persistent and deep-rooted cult of the Mother goddess, the symbol of fertility and plenty, which endured in successive periods and was the principle object of devotion of the Aegean world.
During the third millennium B.C. other settlers from Anatolia arrived. These people were probably of the same origins as the powerful Hittites who later lived on the inland mountain plateaux of modern Turkey. The arrival of the settlers led to that blend of local cultural traditions with external influences from which the Bronze age civilisation developed, the most important episode in Cretan history, taking its name, the Minoan period, from the mythical king of the island, Minos. The power enjoyed by the cities of Crete between 2700 and 1100 B.C. (with the height of greatness between about 2000 and 1450 B.C.) is reflected in the fantastic enterprises of the gods, many of them set in Crete, and in the myths which became known throughout the classical world and have survived in modern western culture. The tribute demanded by Minos annually from Athens of twelve youths and twelve maidens from the city's aristocratic families as food for his monstrous son, half man and half bull, the Minotaur, is an obvious allusion to historical events. The story reflects in particular on the period when Minoan domination of the sea reached as far as Athens which was compelled to send occasional tributes to Crete, including slaves, until halted by a revolt of the Athenians (in the myth represented by the liberator, Theseus, son of Egeus, king of Athens). There are also politi-

3

cal and diplomatic parallels in the love story involving the young Athenian hero's involvement with the daughter of Minos, Ariadne.

The Minoan period was certainly one of great splendour for the island, with the construction of sumptuous palaces by royal families who had complete control of every aspect of production in their territories. After collecting the fruits of this activity the families then supervised their just redistribution among the population. The success of this system is evident in the almost identical reconstruction which followed the destruction of the first palaces in about 1700 B.C. Their collapse was caused by a catastrophic earthquake, accompanied by tidal waves and fires, and was immediately followed by invasions from the Greek mainland. This social organisation continued for several more centuries until about 1450 B.C., when the second stage of Minoan culture was destroyed in the aftermath of the tremendous eruption of the volcano on the island of Santorini (Thera). This great event is referred to in the Bible. It probably gave rise to the mythical account of an entire civilisation with its cities of gold, Atlantis, which sank beneath the waves. Archaeological traces of the eruption of Santorini includes several metres of ashes and lapilli erupted from Thera discovered in the Gulf of Taranto, thousands of kilometres away.

The size and splendour of the palaces reflects the success and power of the Minoan monarchies which had much in common with the kingdoms in the Near East. They possessed, in addition to their luxurious palaces, villas and private houses from which they exercised a real thalassocracy ("dominion of the seas") over the Aegean. Their representatives recorded their customs, their accounts and their contracts writing on clay tablets in a language akin to future classical Greek and with a script derived from hieroglyphs but which has not yet been deciphered. They established close contact, not only with the surrounding islands, but with Phoenician Syria, with Asia Minor, and with Egypt where documents make mention of the Keftìou, allies generally identified with Minoan Cretans.

Palace of Knossos: north entrance.

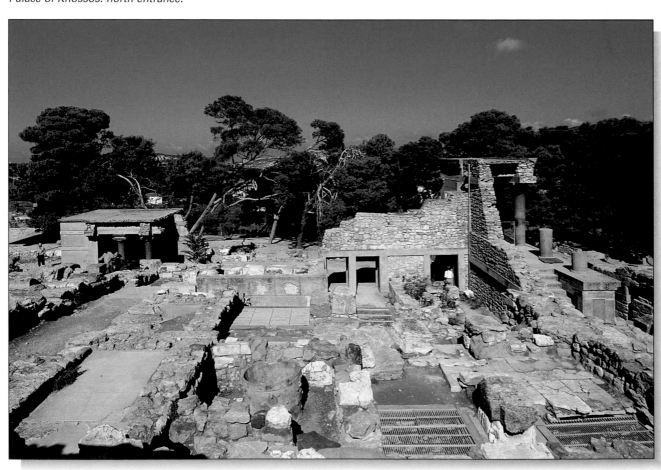

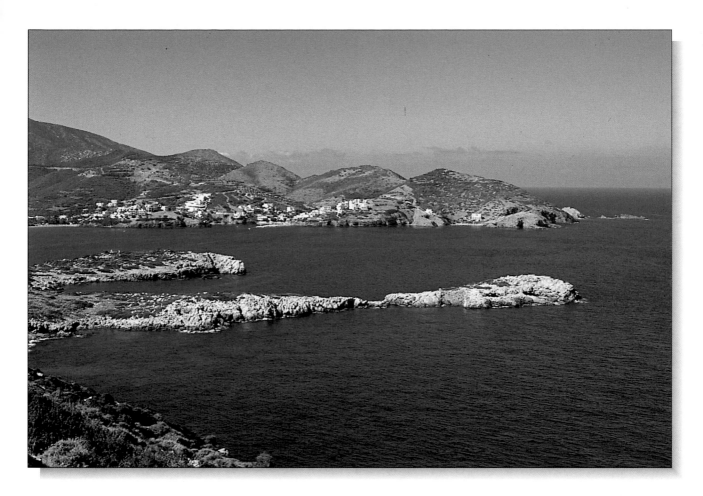

The beautiful bay of Balion.

A complex and varied spiritual life is reflected in Minoan burial rites, attesting to the belief in an after-life, and also in the religious symbols, the most important being the Double Horns and the Double Axe, with which the priest-king exercised his dual political and religious role: his power over life and death, with one blade for the citizens and the other for the sacrificial victims.

Minoan culture spread to and was diffused throughout the Peloponnese, where the flourishing cities of Argos, Pylus, Nauplia, Mycenae and Tiryns reflected the achievements of the island civilisation.

With the destruction of the Minoan world, after the eruption of Santorini, the people of the Peloponnese, of Achaean origin, turned to the coastal areas of Crete where they easily conquered the weakened cities. This gave rise to one of the most extraordinary reversals in history: Mycenæan civilisation, in many ways an offshoot of the Minoan one, in which it was deeply rooted, now supplanted it in Crete itself.

The Mycenæan period was one of great power and

artistic splendour for Crete; it is to this period that we date the events recorded in myths and legends such as the involvement of brave heroes from Crete in the Trojan wars, as recounted by Homer. The Achaean kings settled on the sites previously occupied by the Minoans, rebuilding and adapting them. Their documents are written in a language which gave rise to classical Greek, and in script in some ways linked to their predecessor, Linear B.

About 1050 B.C. the invasion of people of Doric origin signalled the end of Mycenæan civilization (in Greece as well as in Crete) and the beginnings of Classical Greek civilization. Crete became a great power, with numerous city-states spreading the enormous economic and cultural wealth of the Mycenæan kingdoms throughout the island and beyond. Linguistically and culturally the population remained tied to its Doric origin. Rich, powerful and strategically placed, Crete had close contacts with the East and it contributed, through the exchange of goods and craftsmen, to the creation of a classical Greek style, which drew lively inspira-

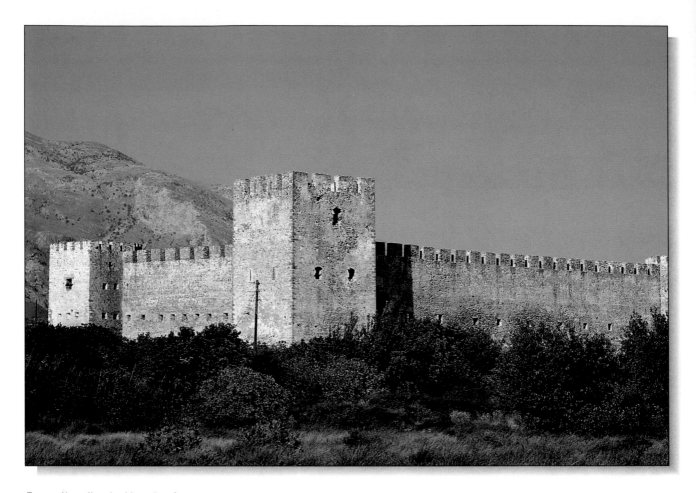

Frangokastello: the Venetian fortress.

tion from that of the Greek colonies of coastal Anatolia. These historical traditions disappeared when Crete fell to the Romans, the new lords of the Mediterranean, in the first century B.C when the consul Metellus, surnamed Cretanus, brutally conquered the island for the Roman Empire. Crete was unified with Cyrenaica (now Libya) to form a new province with its capital and the residence of the governor in Gortyn on the plain of Mésara; it was one of the richest provinces in the Empire.

From the late Roman era the history of the island became increasingly dramatic and turbulent as it was the object of conquest by the surrounding Mediterranean people, with periods of bloody oppression and revolt. From 324 it formed part of the Byzantine Empire, as did the rest of Greece and then for over 100 years, 823-961 the Saracen Arabs held the island. Reconquered by the Byzantine Emperor Nicephorus II Phocas, it was contested after the fourth crusade by the powerful maritime republics of Genoa and Venice, with the final victory to the Venetians. Venetian rule brought prosperi-

ty and lasted from 1204 to 1669; during this period many attempts at revolt, still commemorated throughout the island, were crushed. Attacked and invaded by the Turks in 1645, it was completely conquered when the capital Candia fell in 1669 after a strenuous siege of some 24 years, causing the Venetians finally to withdraw.

The period of Turkish domination from 1669 to 1898 is the lowest point in the island's history, with constant resistance from the Cretans and open revolts mercilessly repressed with the loss of thousands of lives. With the support of the British the island led a successful revolt in 1898 and declared its independence, which it retained until its annexation to Greece in 1913. In 1923 the Muslims left the island in exchange for Greeks fleeing from Turkey.

During the Second World War Crete was occupied by the Germans who faced the fierce hostility of a proud people whose troubled history had taught them the value of freedom.

Today Crete is the most splendid of the islands belonging to Greece.

Early Minoan: circa 2800-2200 B.C.

Subdivided into at least three principle phases, during the first Bronze age Cretan society was organized into tribes, with roughly five villages per 1000 sq. km. Crafts flourished, both pottery and the engraving of gems and precious stones; there was a distinct style of architecture, but no palaces were yet built and there does not appear to have been any organized central government.

Middle Minoan: circa 2200-1550 B.C.

Also subdivided into shorter periods, the Middle Minoan period saw the first palaces built, and a stable economy controlled by the reigning dynasties was established. Communities were large and not always directly connected with the palaces: the rich, at the apex of a flourishing and renowned civilization, increased to some 200/220.000 units, distributed on average in twenty-six settlements per sq. km., and they had overseas commercial and trade relations. The most characteristic places of worship were the peak sanctuaries. Crafts, especially pottery, thrived, with the development of the Kamares Ware and the appearance of the quick wheel. Hieroglyphics were used. After the destruction of the first palaces (circa 1700 B.C.) the second palaces were built, decorated with new fresco techniques; naturalistic art predominates and, on vases, the floral style.

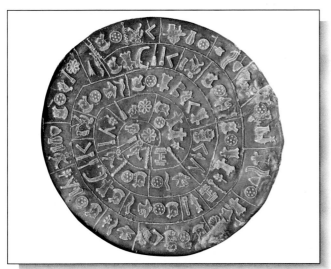

Late Minoan:circa 1550-1100 B.C.

This corresponds to the last of the Bronze Age periods and is subdivided into phases, encompassing the Golden Age of Crete and the end of Minoan civilization. This followed the destruction of the palaces circa 1450 B.C. when the population numbered some 250,000 distributed in a large number of settlements. Luxurious houses were decorated with figurative and naturalistic frescoes, and pottery was painted with floral and marine motifs. With the arrival of the Acheaens from mainland Greece (Peloponnese) and the beginnings of Mycenæan civilization, a language akin to Greek was introduced and Linear B script appeared.

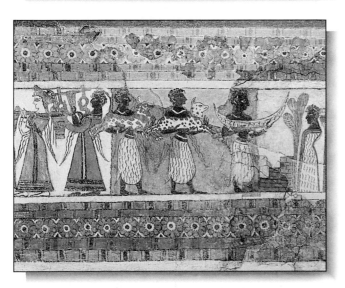

KHANIA

ARCHAEOLOGICAL MUSEUM - AKROTIRI MONASTERIES - TOMB OF VENIZELOS
GORGE OF SAMARIA - KHORA SFAKION - FRANGOKASTELLO

The capital and second largest of the island's cities with some 50,000 inhabitants, Khaniá rises above and is protected by the *Akrotiri* peninsula. It is built on the site of the ancient Greek city of *Kydonia*, the most powerful city in western Crete, from which the remains of a Minoan palace (destroyed in Minoan III but rebuilt) have been excavated on the *Kastelli* hill. Khaniá was frequently in conflict with the cities of central and eastern Crete, above all with *Knossos* and *Gortyn*, with a particularly fierce encounter taking place in the Hellenistic era (171 B.C.). The city enjoyed a period of prosperity under Byzantine rule, when private residences, churches and chapels were erected together with a wall which surrounds the old city, called *Kastelli* after the place-name *Castello Vecchio* given it by the Venetians. The Venetians established a flourishing port here in 1252 called *La Canea* after the Byzantine *Chania*. The Byzantines rejected the earlier appellation of *Kydonia*, and took the new one from a nearby town *Alchania* (an ancient inscription records its existence), and applied it to the enlarged urban area. After a fierce naval battle the Venetians were defeated by the Genoese who ruled the city from 1266 to 1290. The city, enclosed within walls, partly rebuilt by the Venetians, included the Governor's palace, the Cathedral, merchants' houses and those previously belonging to the ruling Venetians as well as a popular quarter, also enclosed by a protective wall in 1336 and again in 1536. Following the second disastrous attack by the Turkish sea rover known as Barbarossa, Venice sent the most celebrated architect and engineer of the day, Michele Sanmicheli to *Iráklion* and to Khaniá to strengthen the city against further attacks. Unfortunately the fortifications did not prevent the city's destruction by the Turkish fleet in 1645, after a siege of 55 days. Under

Khaniá: views of the port.

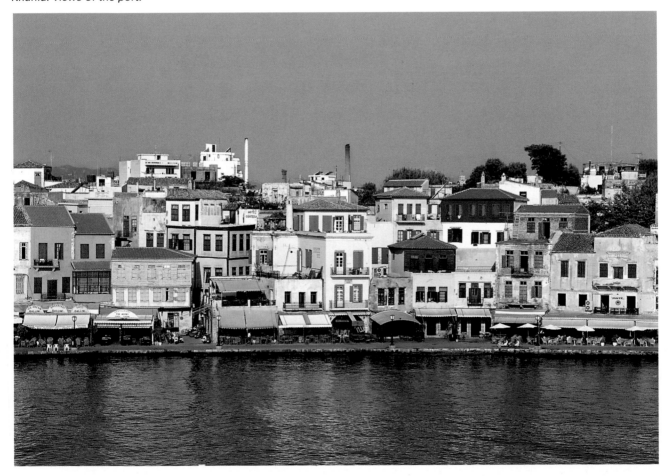

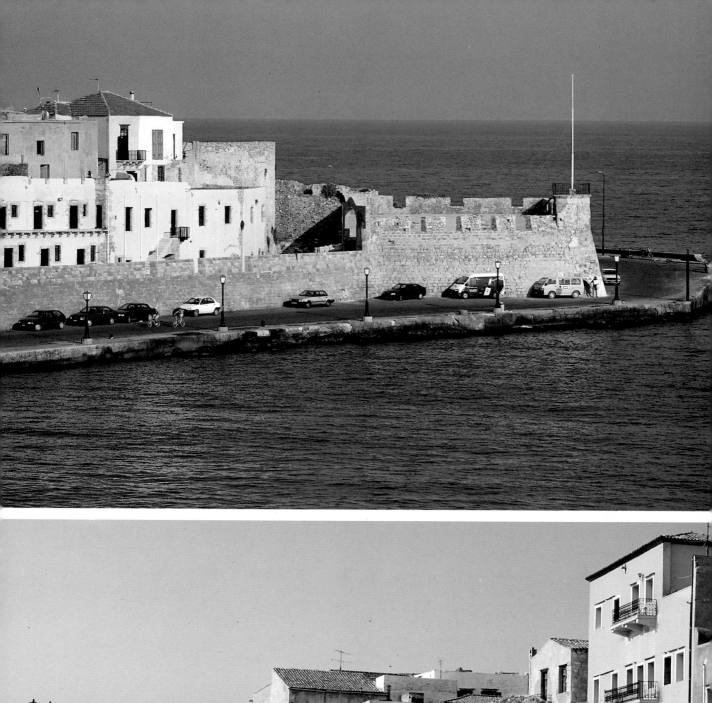
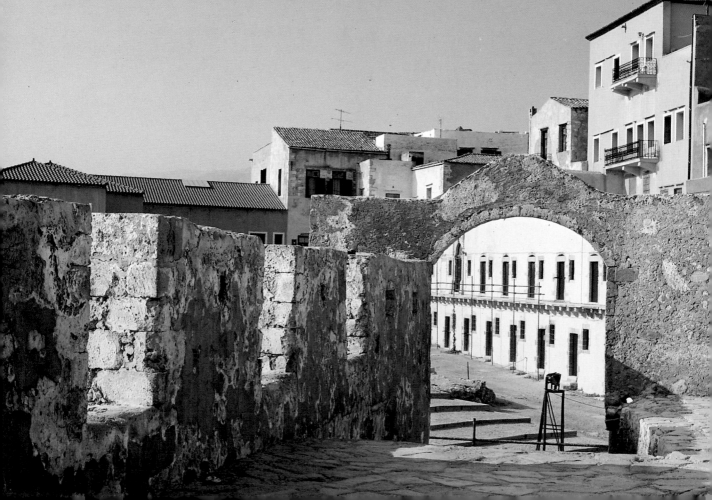

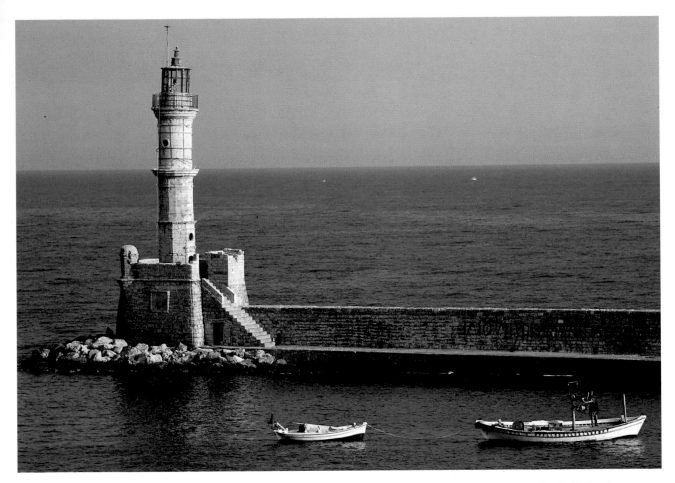

The harbour lighthouse with minaret.

Venetian fortress bastion.

Old city wall.

On the following pages:
view of the port with the mosque of Hassan Pasha
in the centre foreground.

Mosque of Hassan Pasha or of the Janissaries.

Lively night-life in the port.

Turkish dominion the city went into decline and the population suffered harsh reprisals after a series of revolts against their oppressors. Liberated at the end of the nineteenth century and reannexed to Greece in 1913, Khaniá was the administrative capital of the island until 1971.

Under Venetian rule the city enjoyed cultural and economic prosperity, evident in the houses built around the port, occupied by Venetians from the thirteenth century onwards, which face later buildings from the Turkish period (the present city is served by the adjacent port of Souda). Several of the pleasant cafés with terraces overlooking the sea, which always provide visitors with a warm welcome, were built during the years of Venetian rule. The **Phirkas Fortress** on the port has been turned into a small **Maritime Museum** while the **Hassan Pasha** or **Janissaries' Mosque**, the present Tourist Office, with its small domes, is a potent reminder of the long years of Turkish occupation. The minareted

lighthouse at the end of the mole bears witness to the short years of rule by the Egyptians (1830-1840). This harmonious co-existence of so many different architectural and decorative elements, having been considerably battered in the last war, is now in further danger with unchecked modern development schemes which threaten the city's historic heritage. Near the Mosque, below the *Kastelli*, stands the sixteenth-century Venetian **Arsenal**, with seven enormous vaulted rooms in which goods brought by sea were stored. This stands not far from the remains of the **city wall** built by Sanmicheli between 1540 and 1543, the southernmost point of which reaches the well-preserved **Bastion of Ayios Dimitri** (1546-49) and the partly preserved **Gritti** or **San Salvatore Bastion**, also constructed on the design of Sanmicheli between 1538 and 1540.

Not far from *Odhos Khalkidhon*, which leads to the centre of the city, stands a beautiful **Venetian loggia** bearing coats of arms and inscriptions in Latin.

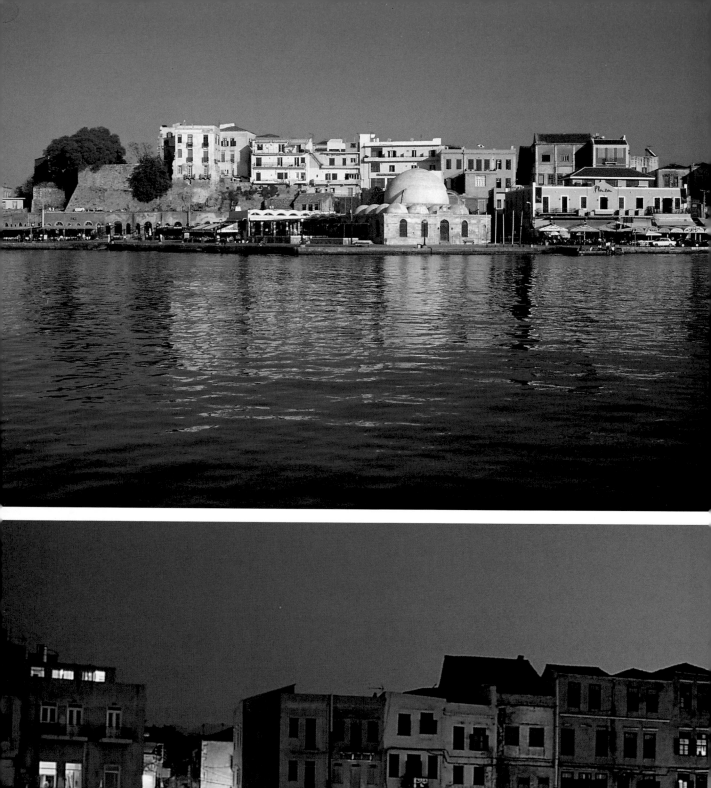
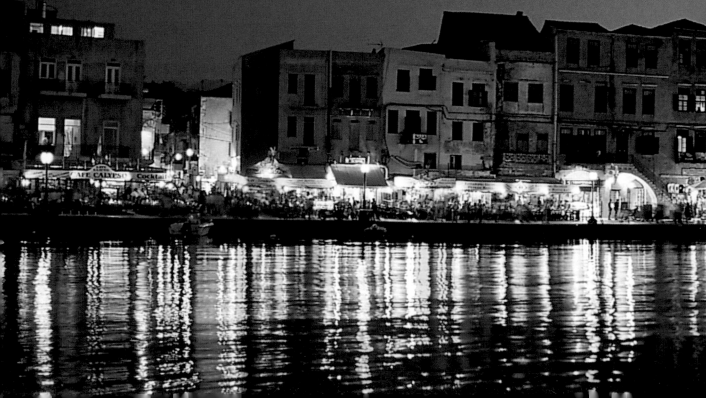

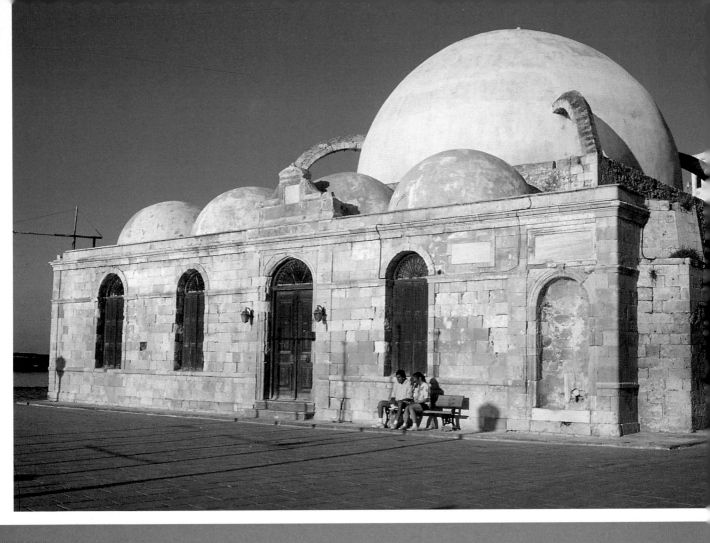

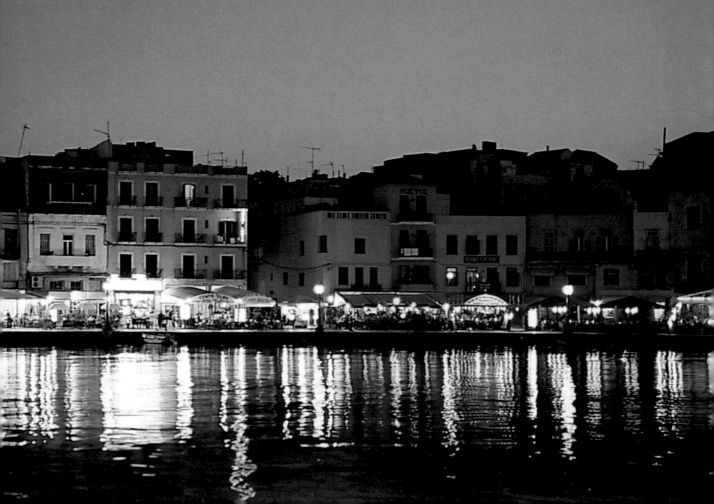

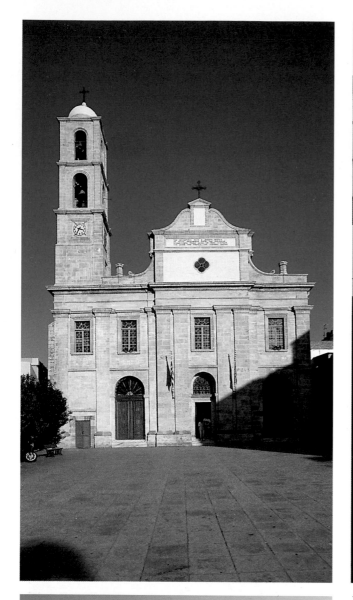

The Orthodox Cathedral.

Typical town houses with circular openings below the roof.

Venetian house (16th-17th century).

In the centre is the **Sandrivani** fountain, the small but elegant **church of San Rocco,** recently restored by the Archaeological Society of Western Crete, and the **Cathedral** dedicated to St Francis, built by the Venetians in the fifteenth century and the best preserved Latin church in Khaniá, with a square bell-tower with triforium openings. The cathedral later became a mosque before being converted into the **Archaeological Museum;** in the adjoining gardens, among archaeological finds, is a hexagonal Turkish fountain and a fine Venetian marble doorway.

ARCHAEOLOGICAL MUSEUM

The impressive **Archaeological Museum of Western Crete** in the nave and aisles of the Basilica of St Francis houses a fine selection of polychrome Minoan pottery. Important among these is the rich collection from the *tholos* tomb (a circular plan with a false dome lid) discovered in ancient *Kydonia*. The *lanarkes* are outstanding examples of small terracotta tombs painted with naturalistic motifs dating from the late Minoan period (circa 1500-1100 B.C.). Archaic and classical art is best represented by the terracottas, some of which are "Daedalic" (the primitive style associated with the mythical sculptor and inventor Daedalus). The marble sculptures include a piece from the Asclepian sanctuary (Asclepius was the god of medicine) at Lissos on the south coast of the island, and a small statue of Aphrodite, fragments of a relief and the statue of a Roman from the ancient site of Kydonia.

Noteworthy also is the lively Roman mosaic depicting Poseidon carrying off Amymone.

Khaniá, Archaeological Museum: balsam jars in glass paste, probably of Phoenician manufacture.

Minoan terracotta seal depicting a god standing on a palace.

Minoan terracotta jar decorated with birds and a kithàra player.

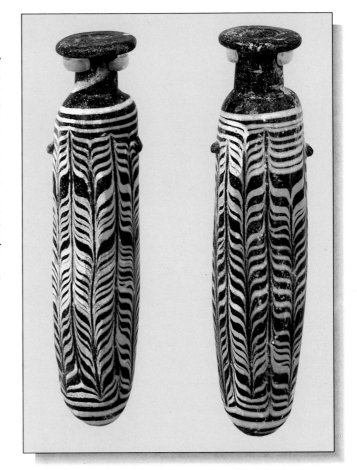

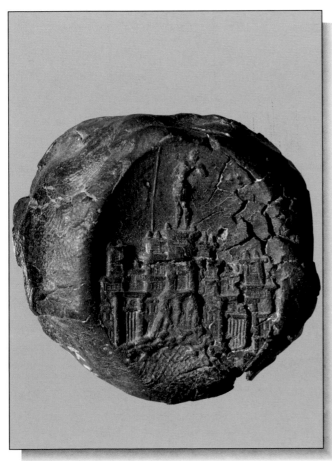

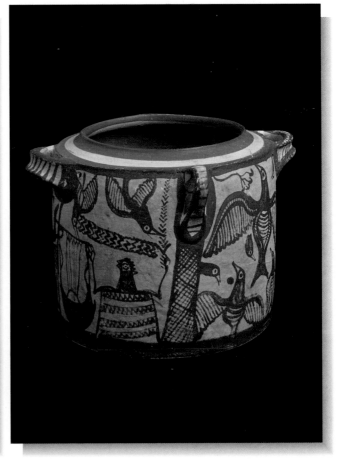

THE AKROTIRI MONASTERIES
OF AYIA TRIADHA AND ST JOHN OF GOUVERNETO

The *Akrotiri* peninsula, which protects Khaniá from the north-east and terminates in the port of *Soudia*, important in ancient times and now a busy modern port, is the site of two monasteries which have practically remained unaltered since their foundation. The **monastery of Ayía Triádha** (Holy Trinity), known also as *Moni Tzangalioù*, founded in 1608-1620 by the Tzangaroli brothers, Orthodox Venetians, is built around an interesting church strongly influenced by the Venetian Renaissance with a high bell-tower and splendid carved portal which lends movement to the façade. An inscription records the consecration of the church in 1632. The monastic buildings surrounding the church dedicated to the Trinity give the appearance of a fortress with neat rows of windows, an impression reinforced by the even smaller windows on the ground floor. The monastery today houses one of the most celebrated theological colleges in Greece, founded in the last century. It was rebuilt after being partially destroyed during the rebellion against the Turks in 1821. About an hour's walk to the north lies the isolated and well-fortified **Monastery of St John of Gouverneto**, founded in the sixteenth century, under Venetian rule in honour of the Virgin "Mother of the Angels". The church is of especial interest, built in 1548 in the Venetian style with an unusual façade (the portal is surmounted by a bell-tower with two storeys) at the centre of the monastic buildings. This building was also partly damaged in revolts against the Turk. Nearby is the impressive *Cave of Arkoudia,* an important natural cave consecrated in antiquity to Artemis worshipped here in the form of a bear (*arkouda* in modern greek). The cult probably drew inspiration from the strange shapes of the stalagmites in the cave; the profile of one is distinctly reminiscent of a bear. During the Byzantine period a chapel in honour of the Virgin Mary *Arkoudiòtissa* was built, evidence of religious continuity and the survival of an ancient cult.

Monastery of Gouverneto: general view.

Church façade.

Monastery of Ayía Triádha: entrance and bell-tower.

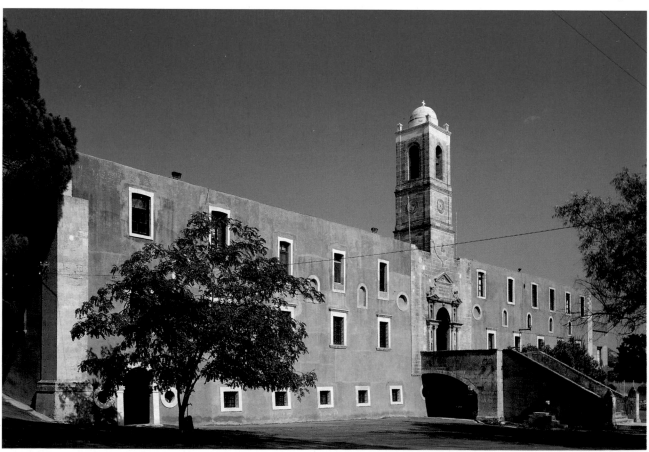

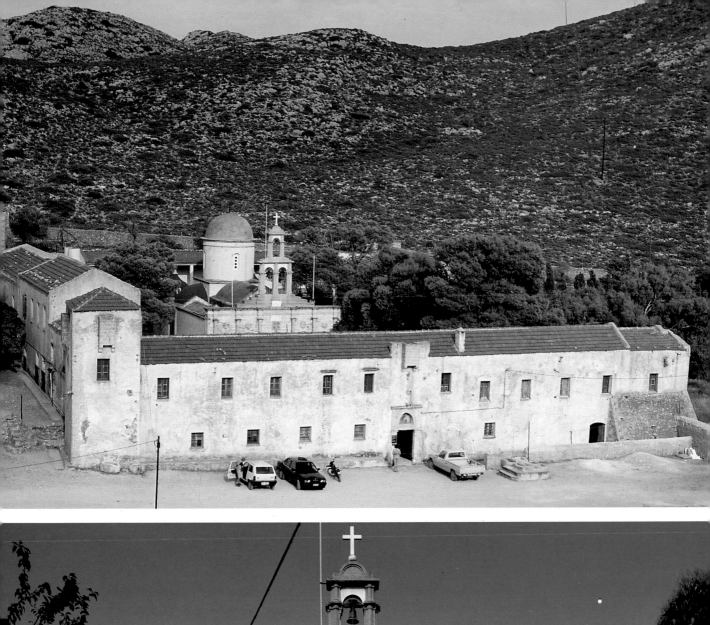

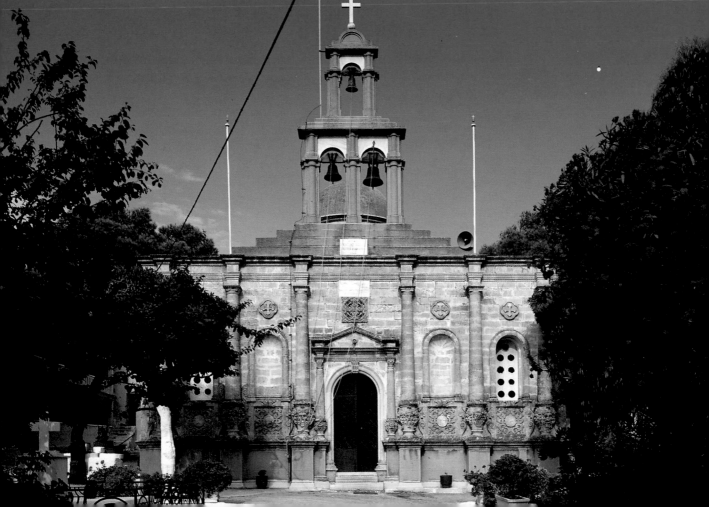

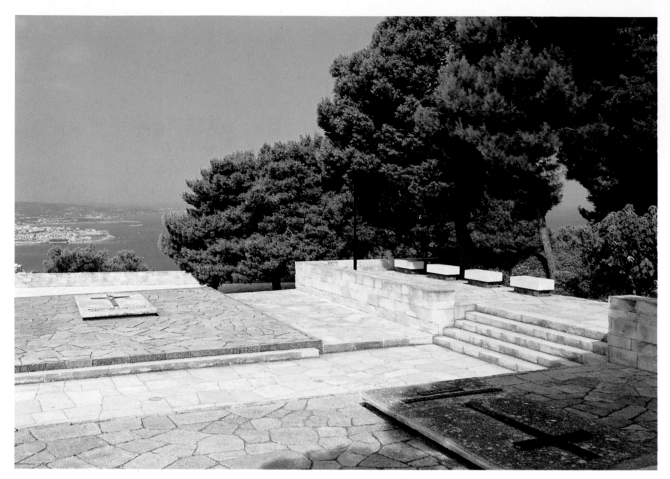

Venizelos's tomb with an exceptional view over the city and the White Mountains (Lefkà Ori) to the south.

Gorge of Samaria: general view.

The abandoned village of Samaria.

A natural swimming-pool.

The exit into the sea at Ayía Roumèli (site of the ancient Tarrha).

TOMB OF VENIZELOS

On the hill of *Prophitis Ilias*, on the south side, stands the tomb of **Eleutherios Venizelos**, the statesman, born in Mounies (Khaniá) in 1864. The statesman's name (*Eleuthería*,i.e. Liberty) was emblematic of his life's struggle for the freedom of his island and its people. Implicated on several occasions for his role in the uprisings against the Turk, in which he was the guiding spirit, he was forced into exile in Greece after the 1888 revolt only to return for the victorious 1897 rebellion, after which he became a member of the provisional government. He worked for Cretan independence, supported by Prince George of Greece, but following disagreements with the prince he established an insurrectionary independent council and proclaimed Crete's union with Greece in 1905, a move which led to the defeat of Prince George. Venizelos was then responsible for prudent reforms and the strengthening of the Cretan army and navy. He was still in power during the First World War and his efforts to protect the island from enemy attack led him into conflict with Greece and he was condemned to death in his absence. He died in exile in Paris in 1936.

GORGE OF SAMARIA

The longest and most beautiful gorge, not only in Crete but in Europe, runs from the village of *Xyloskalo* for 18 km through the *Lefkà Ori*, the White Mountains. This marvellous canyon was created by the erosion of the waters from the main summit of the White Mountains (2452 mts) to the east and the torrents from Mt Volaki (2116 mts) to the west, and its cleft extends from the *Omalòs* plateau in the north to the southern coast village of *Ayía Roumèli*. The walk along the bottom of the gorge takes about 8 hours but cool refreshment is provided by the reduced water flow occasionally forming natural swimming pools. The sides of the gorge reach towering heights of over 600 metres and are often as narrow as a metre apart.

About half-way along is the **abandoned village of Samaria**. If lucky you may spot a rare example of the exotic *Ibis Cretese* which survives in limited numbers in the gorge.

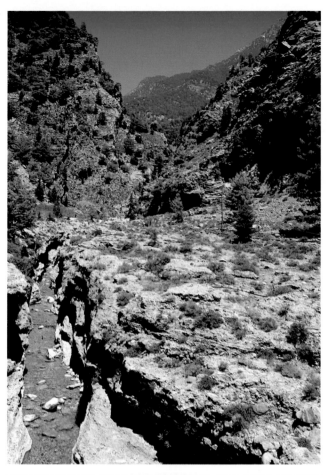

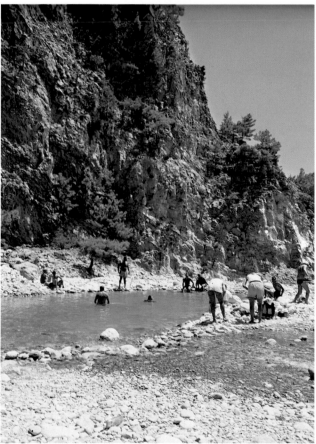

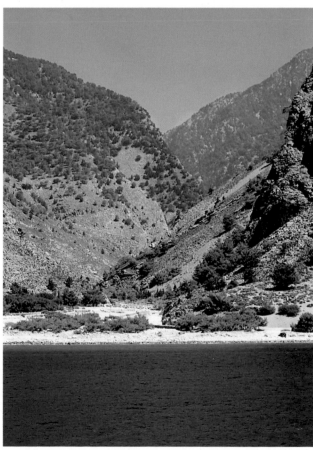

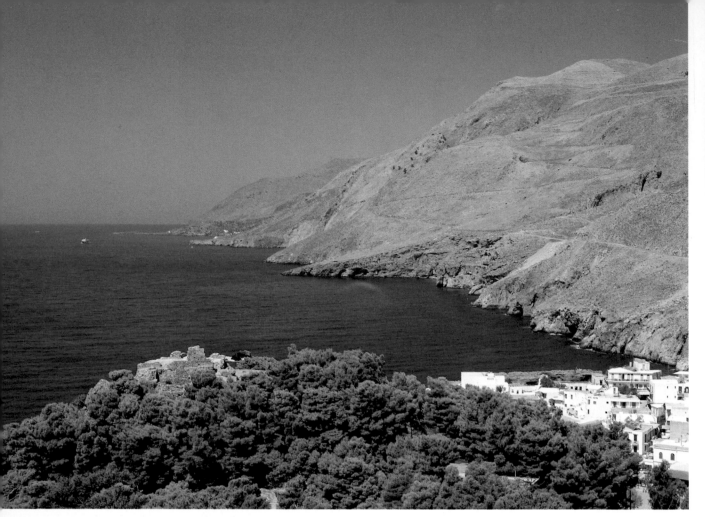

Khora Sfakion: view of the coast with the Venetian fortress and the harbour.

KHORA SFAKION

Protected from behind by the massive White Mountains the small seaside town of *Khora Sfakion* (the capital of the *Sfakiots*),on the south coast of the island, is famous as one of the centres of resistance against the occupying forces of both the Venetians and the Turks. It is also the birth-place of one of the most celebrated Cretan revolutionaries, Daskaloyannis. Apart from the outstanding natural beauty of the indented rocky shoreline Khora Sfakion is also worth visiting for the small Venetian **fortress** built here in 1526 as part of a defensive system of towers and fortresses later taken over by the Turks. It is well worth taking a boat from the harbour to Ayía Roumèli or Frangokastello.

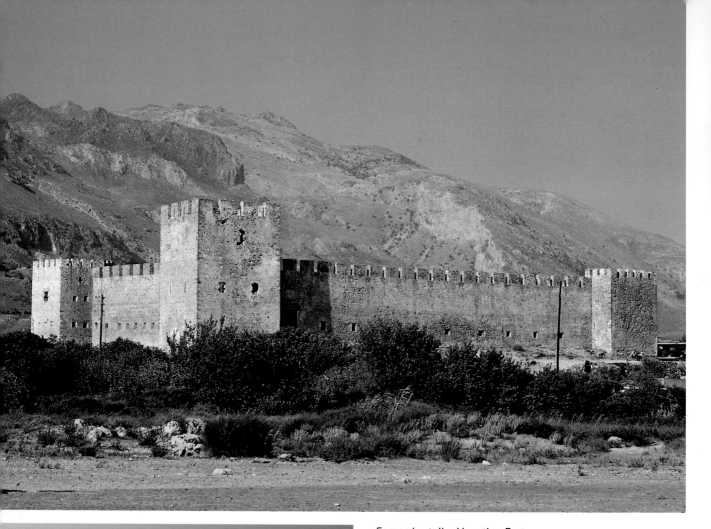

Frangokastello: Venetian Fortress.

Main entrance and flanking tower.

View of the inside.

Panorama of the beach.

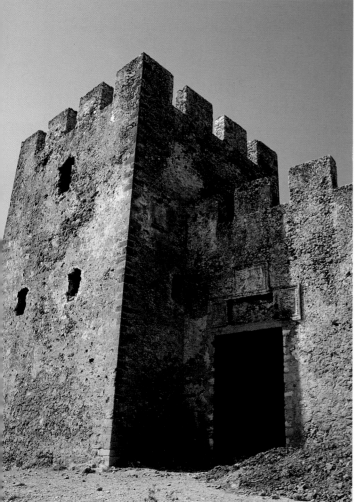

FRANGOKASTELLO

On the south coast of the island, on a magnificent white sandy beach, stands one of the most beautiful Venetian fortresses, Frangokastello, built in 1371 on the coast of Sfakia. This **fortress** is very well preserved and has a splendid view; it consists of a massive rectangular keep reinforced at the corners with square towers, battlemented all round. The Venetians called it *Castel Franco*, and as its function was military it never developed a surrounding village. In the 1828 uprising it was seized by the Cretans from the Turks, who however recaptured it after a bloody battle. According to a local legend, at certain times of the year in early morning there appears a ghostly procession, the so-called *Drosoulites* ("the shadows of the morning dew"), dancing around the fort. This phenomenon has been well attested over a period of time; at one time explained as a mirage from the coast of north Africa, it is now thought to be caused by mass suggestion.

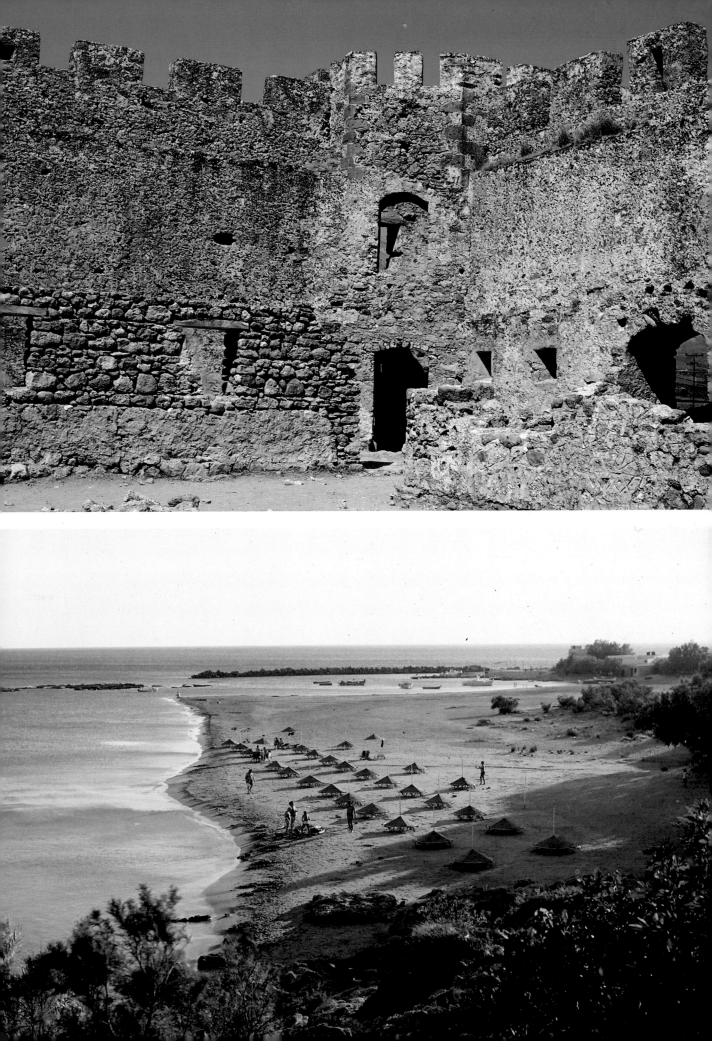

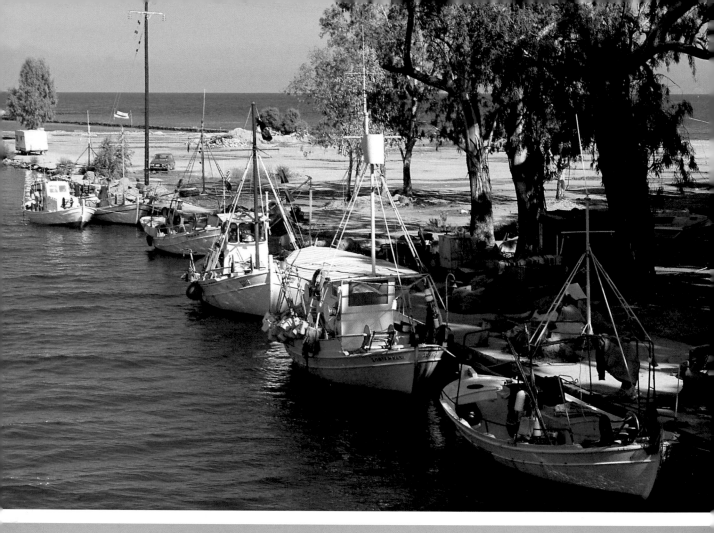

RETHYMNON

PORT - FORTRESS- CHURCH-MOSQUE - AYIA AIKATERINI AND AYIOS THEODOROS
ARCHAEOLOGICAL MUSEUM - MONASTERY OF PREVELI - MONASTERY OF
ARKADHI - GROTTOES IN THE ZONIANA AREA - ANOYIA - FODHELE

The third largest city in Greece, with about 20,000 inhabitants, Réthymnon is the capital of the district of the same name and is built on the *Hormos Armirou* or the bay of Armiro. (It is also worth visiting another pleasant locality on the bay, on the road to Khaniá, *Ghergioupoli*). Réthymnon is built on the site of a Late Minoan (1500-1100 B.C.) settlement, it developed into the ancient Greek city of Rithymna (a name of earlier origin), of some historical significance, maintaining its independence with its own mint which produced coins with a pair of stylish dolphins, a clear reference to the city's commercial dependence on the sea and trade with Greece and the Mediterranean world. The **acropolis** of the ancient city rose to the south of the modern city centre.

The city is protected from the south by *Mt Vrysinas*

(852 mts) where one of the most beautiful Minoan religious sites has been discovered, the *peak sanctuaries*, dating from the middle Minaon period (2200/2000-1580/1550 B.C.). Réthymnon was the provincial capital during the years of Venetian rule, when it was called Rettimo, and the trading potential of the port was fully exploited, with exports of Malvasia, the celebrated sweet wine, grown in the nearby valley of *Malevisiou* extended throughout Europe and as far as the Portuguese colonies in India. It was also during the years of Venetian domination that the city became the cultural centre of the whole island. It was sacked in 1538 by the pirate Barbarossa and again in 1567 by Oulouch Ali, a desperate renegade of Italian descent who later took part in the battle of Lepanto (the famous naval battle on 7 October 1571 which resulted in the defeat of

Bathing resort of Gheorgioùpoli, on the Hormos Armirou.

The lake of Kournás, between Khaniá and Réthymnon.

Réthymnon: panorama.

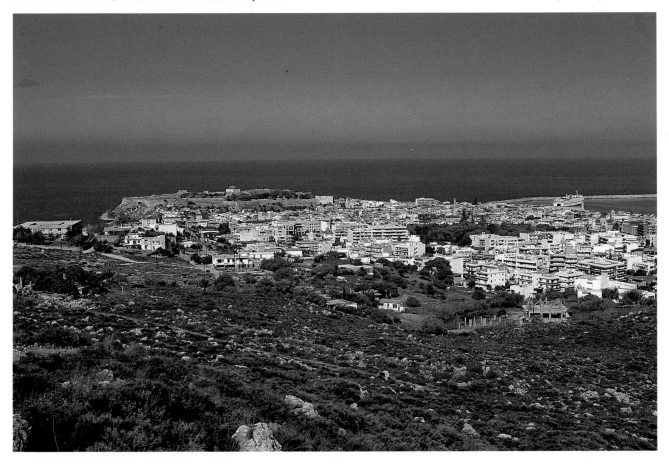

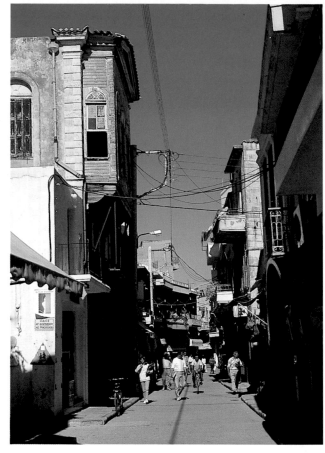

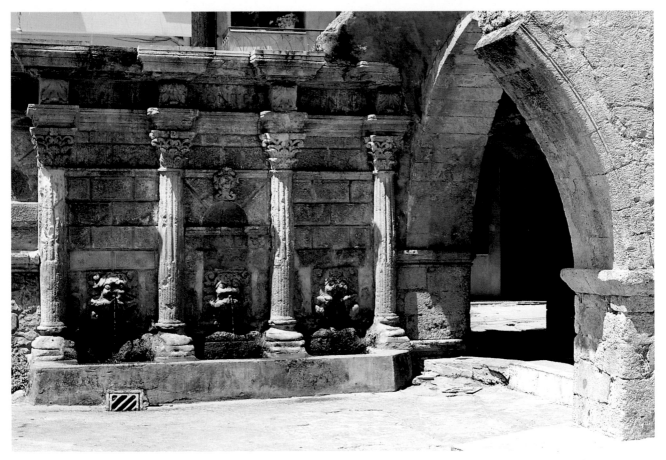

Views of the old city.

The Rimondi Fountain.

the Turks by the fleets of the Holy League under the command of Don John of Austria). Réthymnon was unfortunately besieged by the Turks in 1571 while they were on route to the Lepanto encounter, prompting the Venetians to fortify the city. Despite the construction of a **city wall** and an impressive **fortress** on a small peninsula to the west of the port the city was further besieged and captured by the Turk in 1646.

Several fountains and houses in the Venetian style today survive among the less pleasing modern constructions together with a number of churches converted into **mosques** under the Turk. The sight of these **minarets** gives the city an oriental fascination enhanced by the winding streets lined with small white houses.

The area with streets sloping down to the port preserves the some fine examples of carved **Venetian doorways**, of the sixteenth and seventeenth cen-

turies, standing alongside **Turkish houses** with wooden balconies leaning over the streets. Here too is the fine Venetian loggia, a rectangular arcaded building of measured elegance built at the end of the sixteenth or early in the seventeenth century probably as a mercantile exchange: it now houses the **Archaeological Museum**.

To the same period dates the partially destroyed but enchanting **Rimondi fountain**, built in 1629 and adorned with four Corinthian columns and three carved frieze panels.

After the siege of 1646, Réthymnon was predominantly populated by Turks who built several mosques but more frequently converted the existing churches. None of these mosques is of great interest but at the city gate where the road leads to Khaniá a fine minaret stands (*Tzami Neratses*) with a double balcony from which the *Muezzin* would call the faithful to prayer.

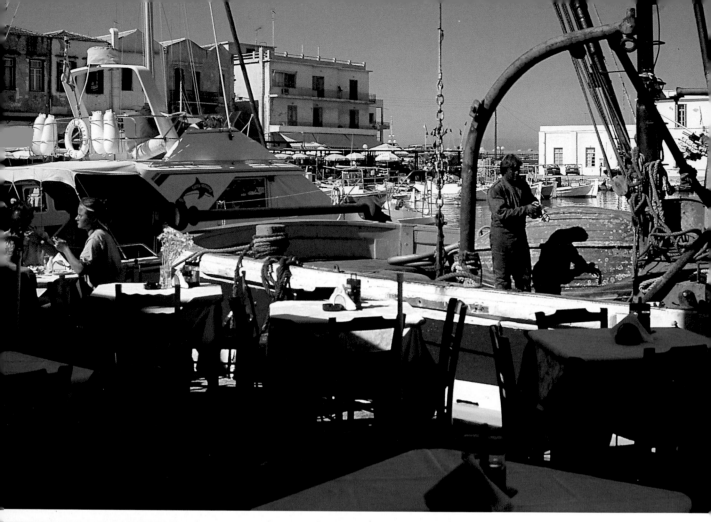

Réthymnon: the Venetian port, with the light-house and café terraces.

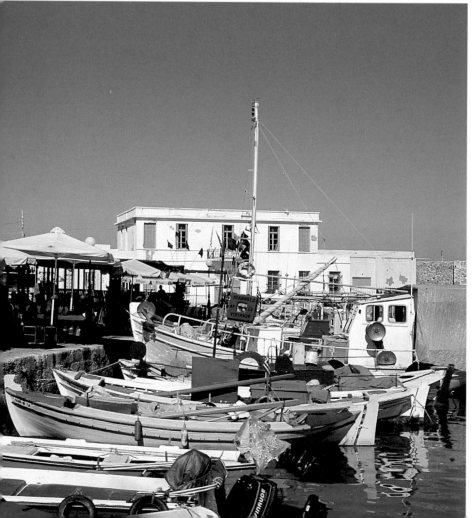

THE PORT

The lively and picturesque port of Réthymnon, always crowded with fishing and pleasure boats, was built by the Venetians as is evident in the structure of the port and in the fortifications, called the **Mikrò Kastro** above which stands the **light-house**. Typically Venetian is the simplicity of design and the arrangement of the buildings with the terraces of the many coffee houses built on the port, giving it added colour and life.

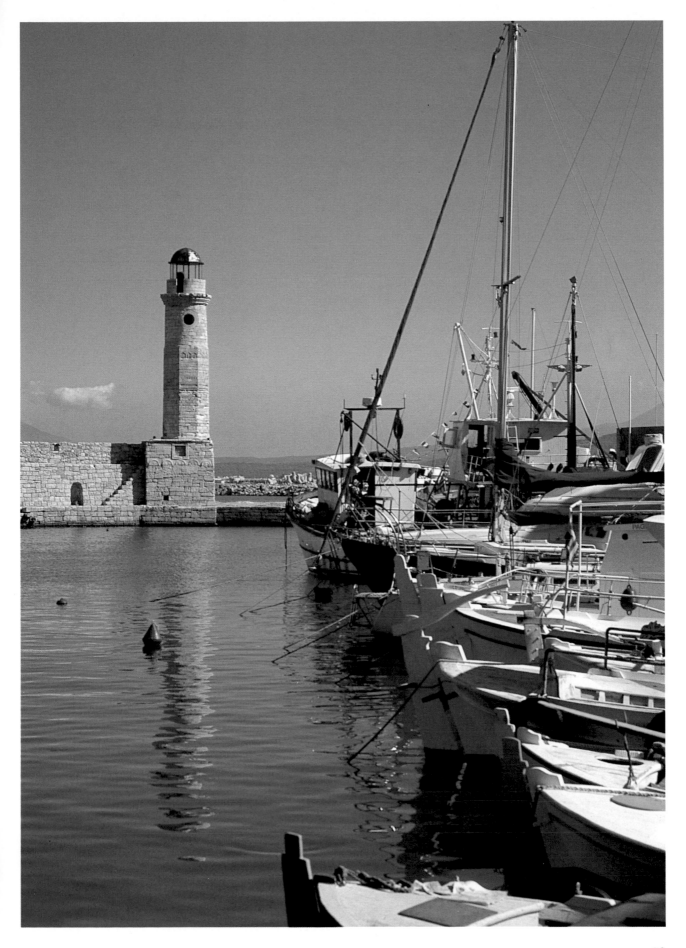

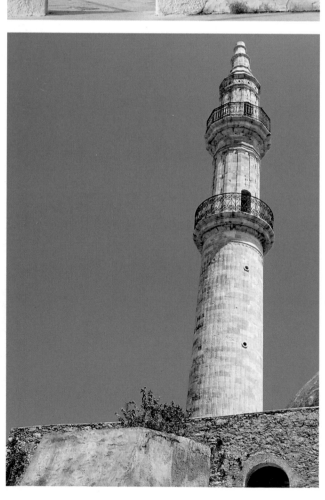

Réthymnon: the port area: a church, a street with Venetian and Turkish-style houses, the Tzami Neranes minaret.

Réthymnon: the port by night and the bastion lighthouse called Mikrò Kastro.

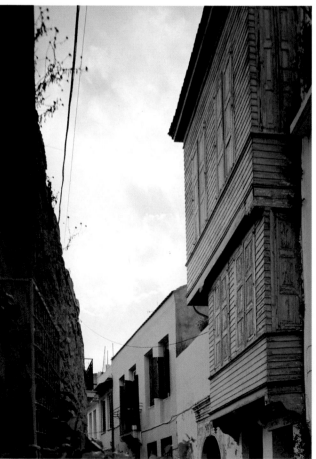

30

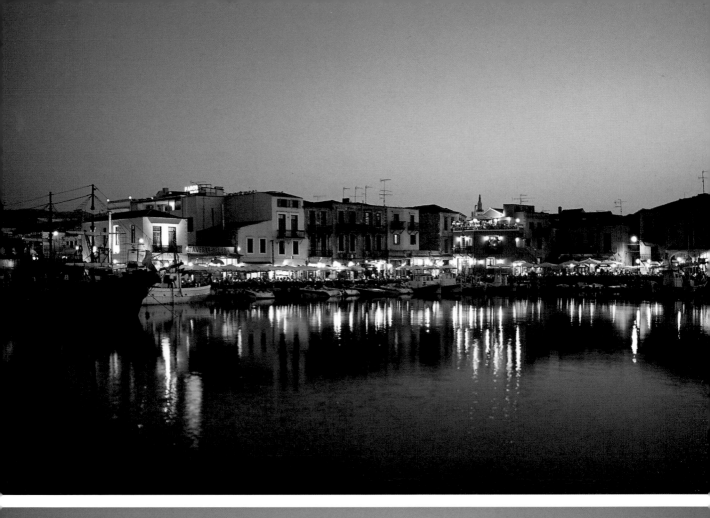
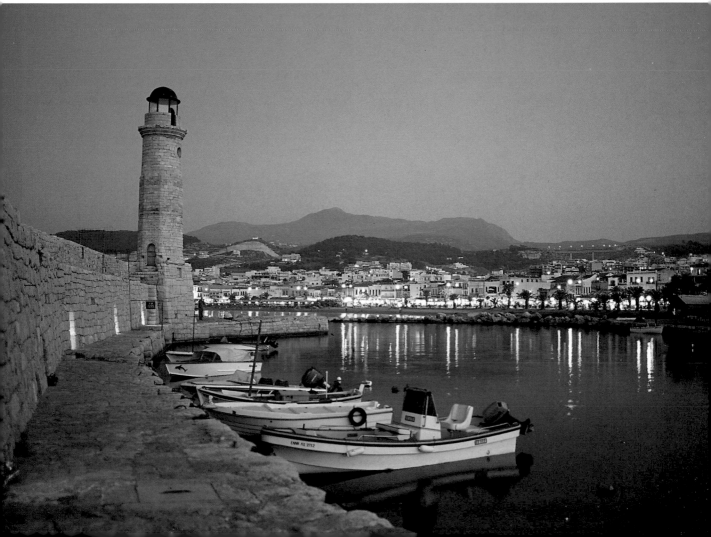

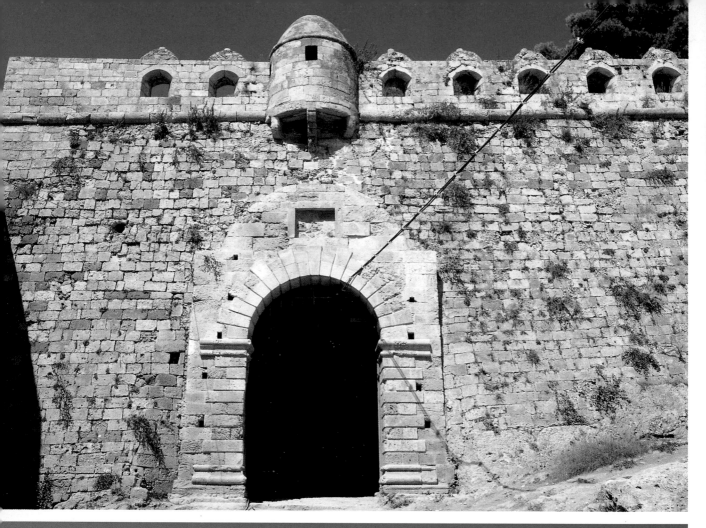

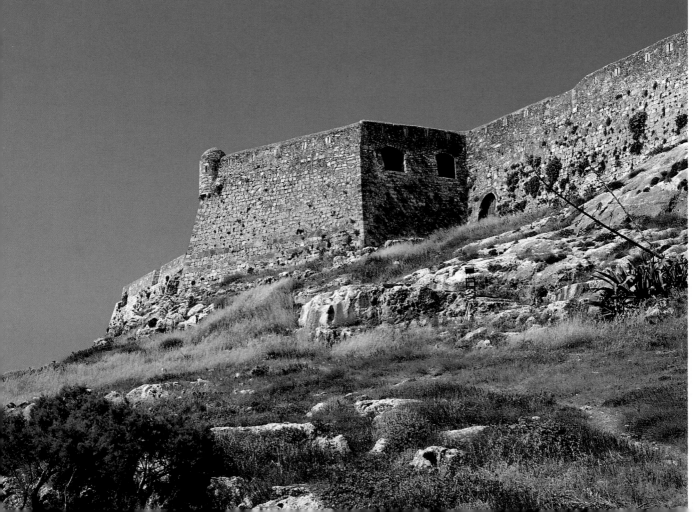

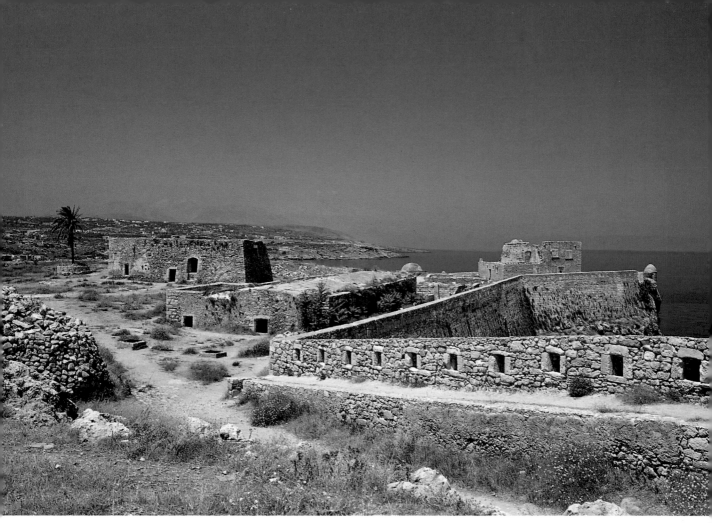

Réthymnon Fortress: main entrance.

View of the walls with loop-holes and walkways.

View of a corner bastion.

THE FORTRESS

The enormous fortified bastion, which still bears its Italian name of *Fortetza,* was built by the Venetian Republic after the battle of Lepanto in 1571 on the extreme end of the small peninsula which juts into the sea west of the port. Together with the city walls it was intended to withstand the attacks repeatedly suffered at the hand of the Turk and of pirate marauders, such as Barbarrossa and Oulouch Ali. It failed to withstand the attack by Turkish forces in 1646 after which the city and surrounding area came under Turkish occupation.

The fortress is extraordinarily well-preserved and unspoilt by later alterations with a massive surrounding **wall** masking a plateau, in part natural and in part created to fit military requirements. A series of **loop-holed ramparts** still survive and surround an internal courtyard, doubtless intended for military exercises. A series of **chapels** and religious buildings were built at the base of the corner bastions which then assumed the names of the churches dedicatory saints (St Nicholas, St Theodore, St Luke, etc.).

The main **gateway** offered an effective and original defence, built into the keep, protected by loop-holes and surmounted by a **watch-tower** which projecting over the entrance, not only served to sight the enemy from afar but offered the chance of attacks at close range.

Similar projecting watch-towers are placed at strategic points on the corner bastions.

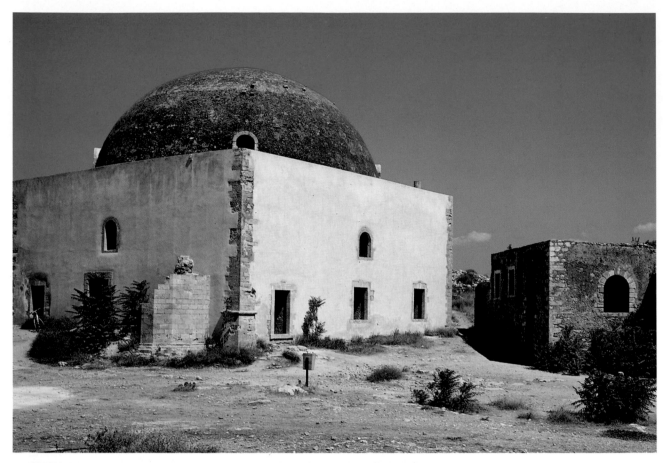

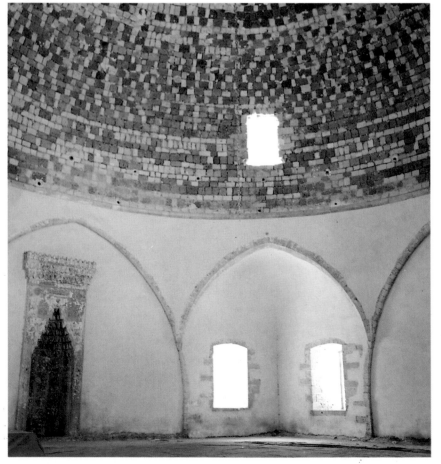

Réthymnon Fortress, Church-Mosque: view of the outside and detail of the inside showing the Mihrab.

CHURCH-MOSQUE

The church-mosque stands in the middle of the Réthymnon Fortress. It was built by the Venetians in the sixteenth century as the cathedral, dedicated to St Nicholas, but under the Turks it was radically altered to become the **mosque** of Ibrahim Han: the interior was redesigned with pointed arches, windows were opened in the walls and the typical oval chapel, the *Mihrab*, directed towards Mecca, was added together with the large semi-circular **dome**.

Réthymnon Fortress, the church of
Ayía Aikaterini and the interior of
the church of Ayios Theodoros.

AYIA AIKATERINI AND AYIOS THEODOROS

The small church dedicated to **St Catherine** stands beside the church-mosque. It was built around a well and is surmounted by a simple bell tower. The interior has inlaid furniture and an *iconostatis*.

The other small church with bell-tower, built on east side of the fortress, is dedicated to **St Theodore**. The interior has pointed arches and is of especial interest for the wooden choir stalls and the *iconostastis* depicting saints.

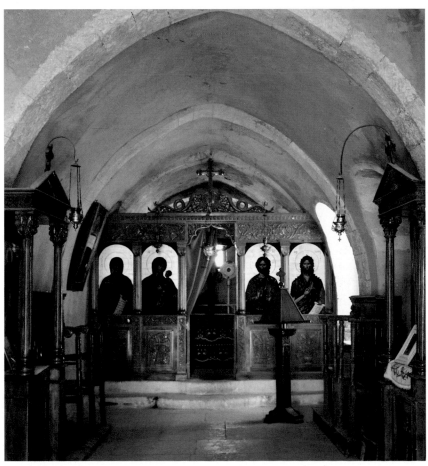

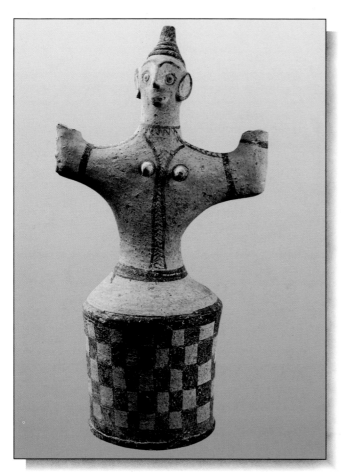

ARCHAEOLOGICAL MUSEUM

The small Archaeological Museum includes a rich selection of exhibits from the period of Réthymnon's greatest prosperity and from sites in the surrounding area as well as from further afield. The collection of painted terracotta *statuettes* (from the Late Minoan to Hellenistic periods) representing divinities or devotees in the act of worship is of particular interest. There is also an admirable *ceramics* section, a remarkable collection of *inscriptions* and *coins*, including examples of the gold coined at *Knossos*. The statuary includes a fine Roman copy of the "Grande Ercolanese" (named after the discovery of the best known copy in Herculaneum); the original by Praxiteles was lost after being discovered on the site of ancient *Eleutherna*, between Réthymnon and Iráklion. The museum also houses a collection of marble sarcophagi from the first to the third century A.D. decorated with mythical scenes.

Réthymnon, Archaeological Museum: late-Minoan clay idol of a goddess with raised arms (1400-1300 B.C.).

Clay vase with cover from a chamber tomb at Stavroménou, late-Minoan (1550-1400 B.C.).

Gold coin from the mint at Knossos showing the labyrinth (5th century B.C.).

Marble statue of the "Grande Ercolanese" from Eleutherna, Roman copy of the 2nd century A.D. of a Greek original of the 4th century B.C.

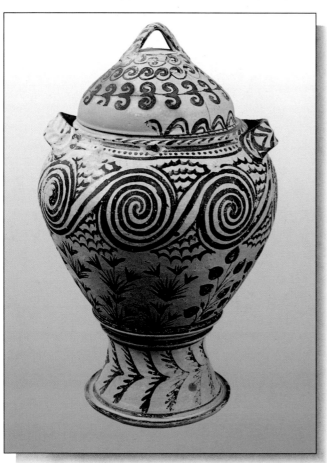

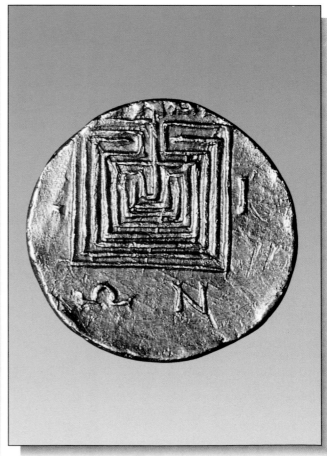

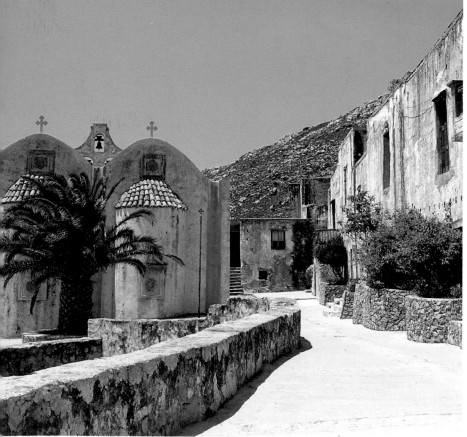

The Preveli Monastery: the church and surrounding monastic buildings.

THE PREVELI MONASTERY

Some forty kilometres to the south of Réthymnon, on the coast between Frangokastello and the Gulf of *Mésara*, in the middle of a magnificent valley by the *Megapótamus* gorge stands the Preveli monastery, built between the end of the 16th and the beginning of the 17th century, which because of its isolated position played an important role in Cretan revolts against the occupying powers.

Sir John Spratt an admiral of the Royal Navy mentions it in his mid-19th century diary as "one of the happiest places to withdraw

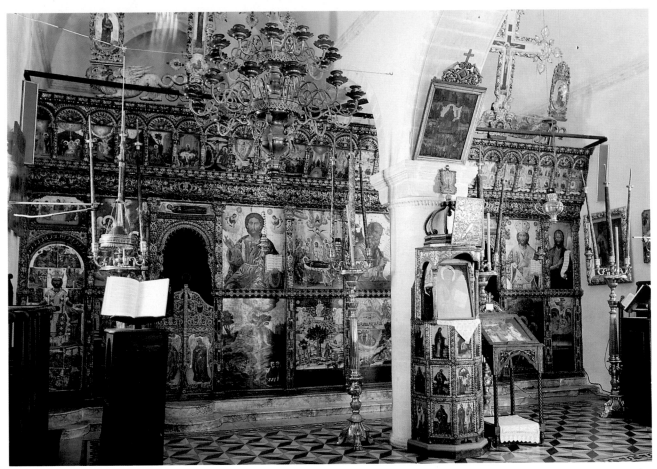

Interior with the splendid iconostasis and lectern.

The miraculous Crucifix.

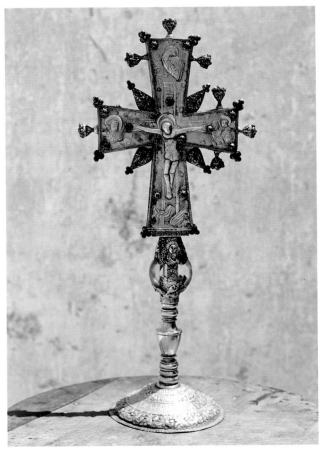

from the trials and responsibilities of life". The monastery is composed of a series of buildings to house not only the monks but pilgrims from land and sea come to venerated the miraculous reliquaries kept in the small church.

The **church** is at the centre of the monastic buildings with a double apse, two naves and barrel-vaulted ceilings.

The external simplicity of the building, painted white with a modest bell stands in contrast to the imposing mountains behind. The interior has richly carved and inlaid **choir-stalls** and some traditional late-Byzantine icons but most remarkable is the splendid **iconostasis** of Christ and the saints; the pulpit is decorated in the same style, covered with small painted icons.

In the church and especially on the iconostasis itself numerous ex-votos (mostly smaller icons or figures made of thin strips of embossed silver) hang, placed there by the faithful who have visited the monastery over the centuries to petition the miraculous eighteenth-century **Crucifix** kept there.

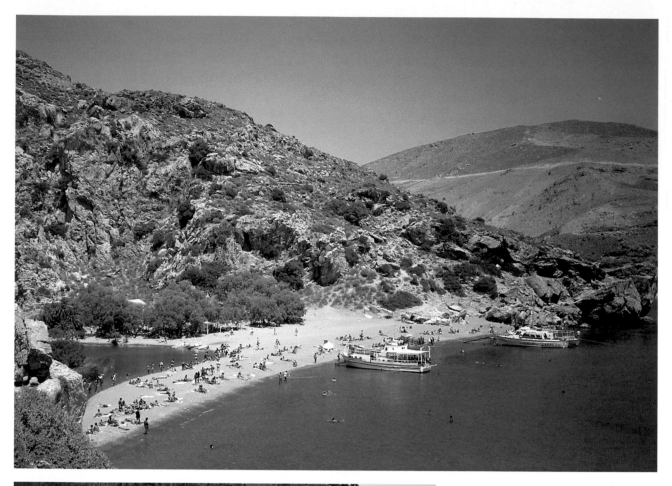

Preveli: the beach at the mouth
of the Kourtaliòtiko.

The Megapótamus.

The resort and a view of the sea.

Almost everywhere in Crete, but
especially on the south coast the
sea is clean, fresh and of dazzling
range of greens and blues.
This is especially true of the Preveli
area where the *Megapótamus* flows
into the sea from the *Kourtaliótiko
gorge*. The relatively unfrequent-
ed **beaches** have soft white sand
backed by Mediterranean shrub-
bery and there are a few facilities
for the visitor.

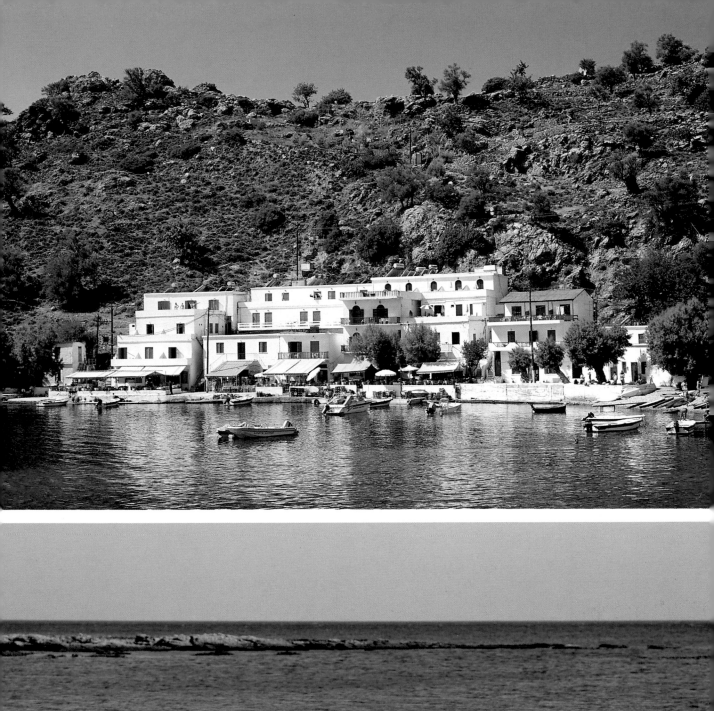

Arches in the nearness of the Arkádhi Monastery.

The façade of the church (1587).

THE ARKADHI MONASTERY

Between Réthymnon and Iráklion, some 7 kilometres from the coast, on the slopes of celebrated Mt Ida one may visit the Byzantine monastery of Arkádhi.

Founded before the 14th century by the monk Arkadhios in this beautiful and remote spot the monastery became one of the largest and richest monasteries on the island. Like so many religious buildings in isolated and strategic positions it became a centre of organized resistance to Turkish oppression. Although by 1866 it no longer housed the 300 brothers and 200 demijohns of wine recorded in the 1700 documents there were still enough inmates to offer brave resistance to the Turkish attack of that year. A fierce conflict took place between 15000 Turkish soldiers and some 1000 peasants, including women and children, who joined forces with the monks. After two days siege the abbot Gabriel blew up the gunpowder barrels stored in part of the monastery so sacrificing the lives of many of the besieged in order to keep prisoners and munitions from the enemy. The monastery then became a symbol of independence and resistance and the monk Gabriel a patriotic hero.

The **monastic buildings,** simple and solid in structure, are the oldest part of the complex although they have undergone successive alterations, mainly in the eighteenth century: these include the monks' cells, oratories and a large barrel-vaulted refectory, intended to house numbers of pilgrims. At the centre of these buildings stands the **church**, built in 1587, uniting renaissance and baroque elements in pleasing harmony. It has survived without damage or alterations with a fine façade, with slender compos-

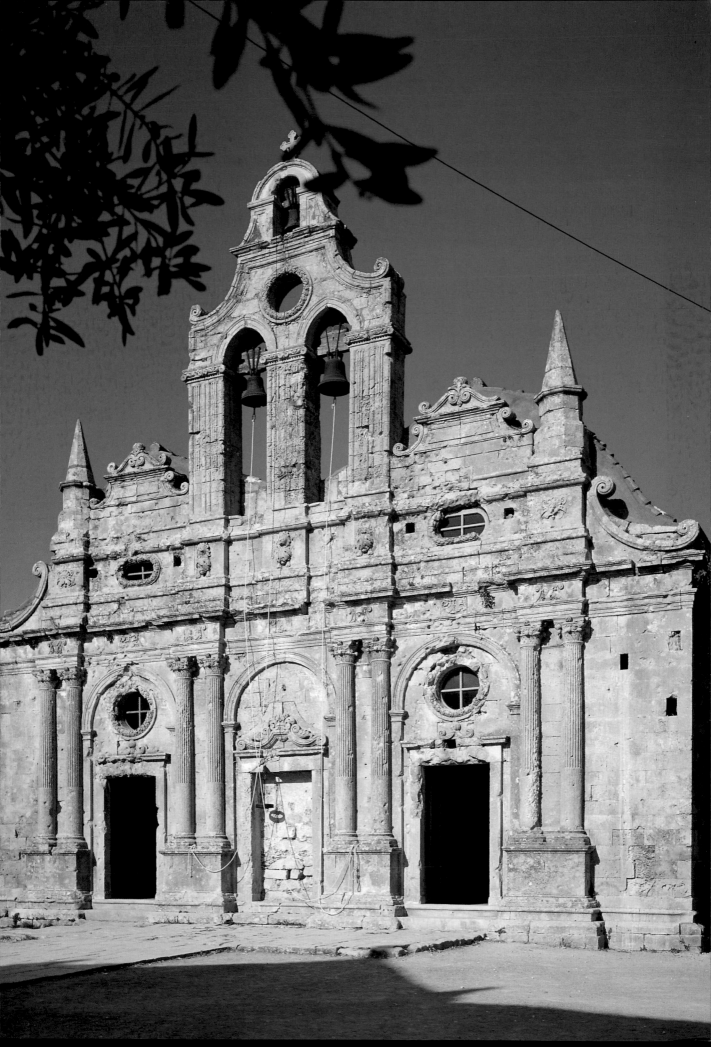

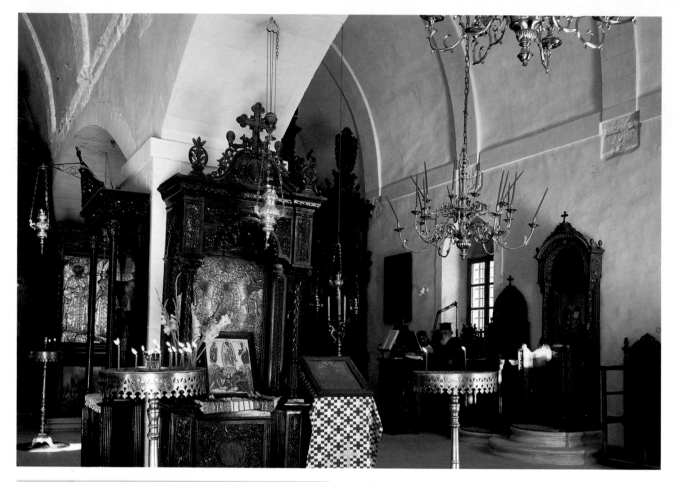

Inside the church.

Icon of the Resurrected Christ.

The refectory with barrel-vaulted ceiling.

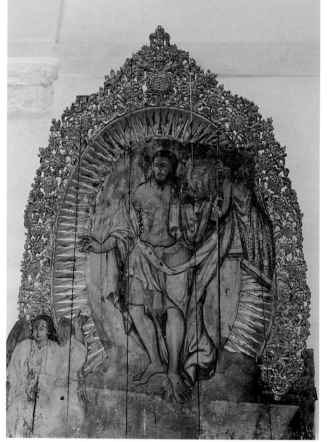

ite columns and pilasters, classical arches and side volutes combined with richly carved foliage decoration. The two-tiered double **bell-tower** gives a triangular thrust to the entire structure. The interior is richly decorated with precious *iconostasis* and carved inlaid furniture also decorated with an enormous variety of icons, including some masterpieces of the celebrated Cretan school.

The monastery also housed a magnificent library, in which ancient Greek manuscripts were copied but all was destroyed in a Turkish attack in 1645.

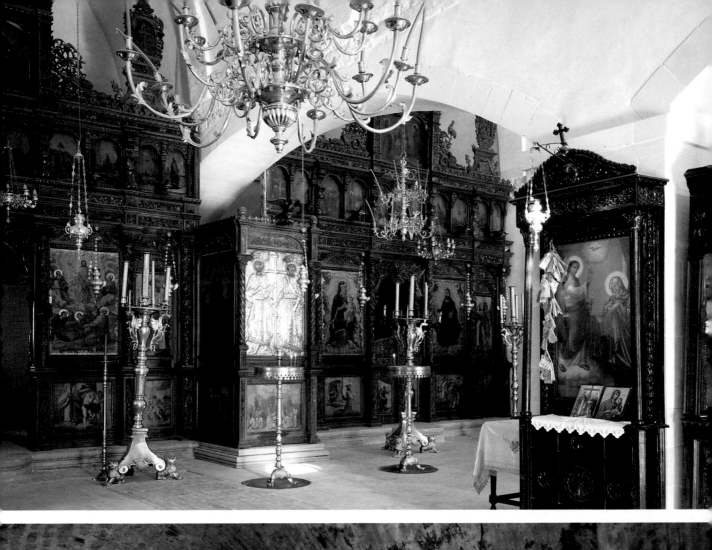

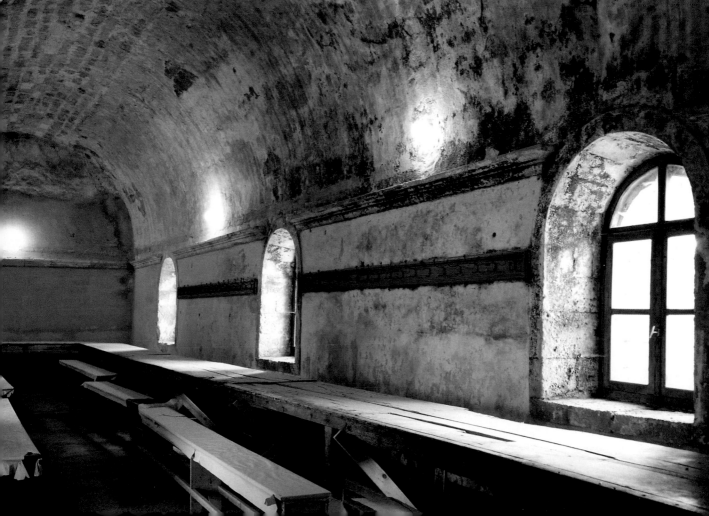

GROTTOES IN THE ZONIANA AREA

Caves and grottoes are a notable characteristic of the Cretan landscape (there are supposedly some 2000 of them) and those carved into the white chalk of Mt Ida are among the most impressive, visually and historically. They were religious sites in pre-historic times and during the Minoan period and served as places of refuge for rebels fighting the Turks. Near Pérama, between Réthymnon and Iráklion, in the Zoniana area the **Spilià Sphendòni** grottoes are well worth a visit, with their magnificent stalactites and stalagmites. The **Melidoni** cave is also famous for its stalactites and for the wretched massacre there of 370 Christians, women and children, who had taken refuge from the Turk.

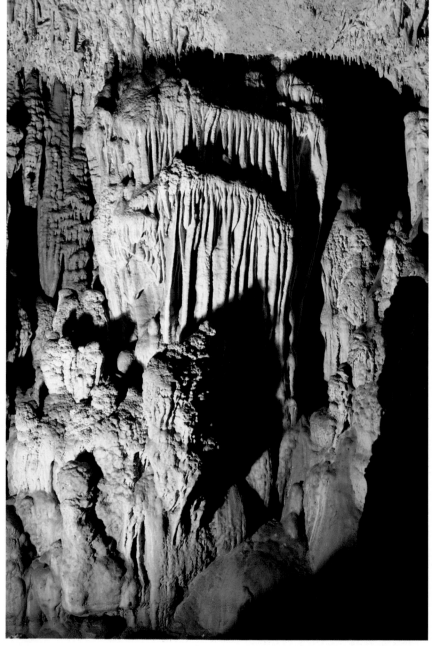

Zoniana, Sphendòni grottoes: outside.

Detail of the spectacular interior.

Anóyia: views with Mt Ida in the background.

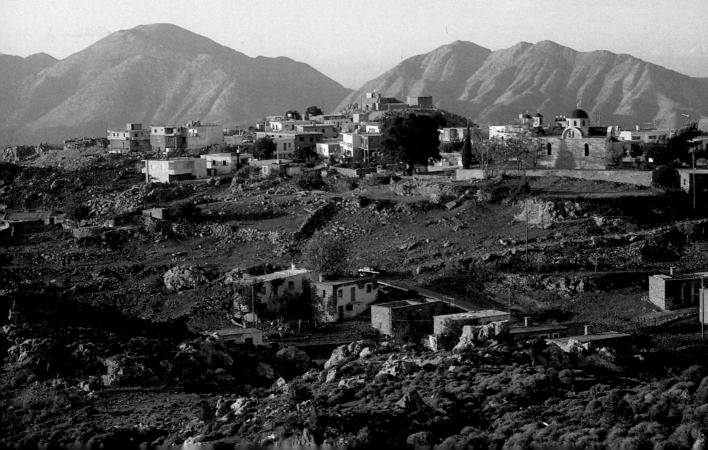

The house of D. Kallerghis (1865-1926) and the monument dedicated to him stand near Pérama, not for from the village of Houdetsi. Kallerghis instituted the celebration of the first of May in Greece.

A shop selling brightly coloured carpets and materials.

The house of Nikos Ksilouris who was born in Anóyia but had an early death in 1985. He was one of the most famous popular singers of the 70s and 80s, and sang works by celebrated Greek composers including Theodorakis.

ANOYIA

The picturesque mountain village of Anóyia rises some 20 miles outside Iráklion. It was entirely rebuilt after the last war having been burnt by the Germans in 1944 in reprisal for the part played by the villagers in sheltering the English captors of General Kreipe.

Anóyia is famous for its weaving of carpets, rugs and bags and is a point of departure for excursions onto Mt Ida and to the **Idaian Cave**. The sacred cave was excavated by the Italian Mission with rich finds from the Iron age (11th-9th centuries B.C.) and an altar with small idols.

According to legend it was here that Zeus was brought up on the milk of the goat Amalthea and protected by the Corybantes who rattled their lances against their shields and drums to drown the cries of the tiny baby, the son of Gaia (Earth), to keep him from his father Cronus (Saturn, Time).

Cronus had already devoured other children by Gaia; Poseidon, Hades, Demeter and Hestia, and would do the same to Zeus to prevent him disinheriting his father. Eventually it was Zeus who killed Cronus after making him regurgitate the swallowed siblings, therefore establishing Order out of Chaos to become the father of all the Olympian gods.

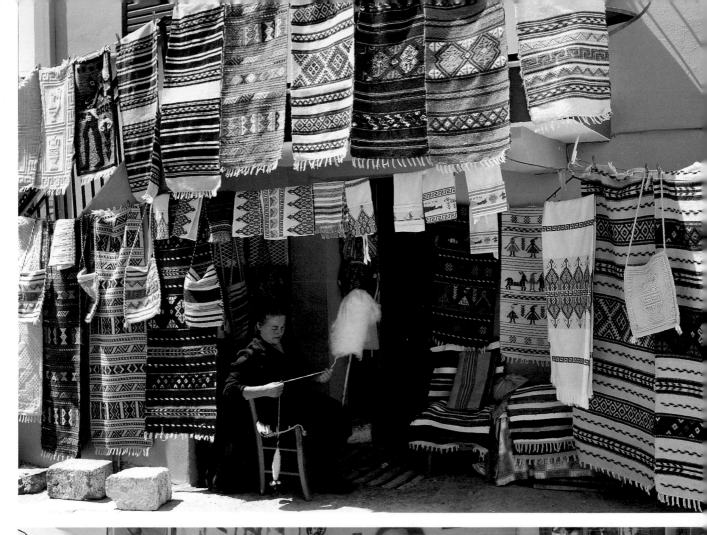

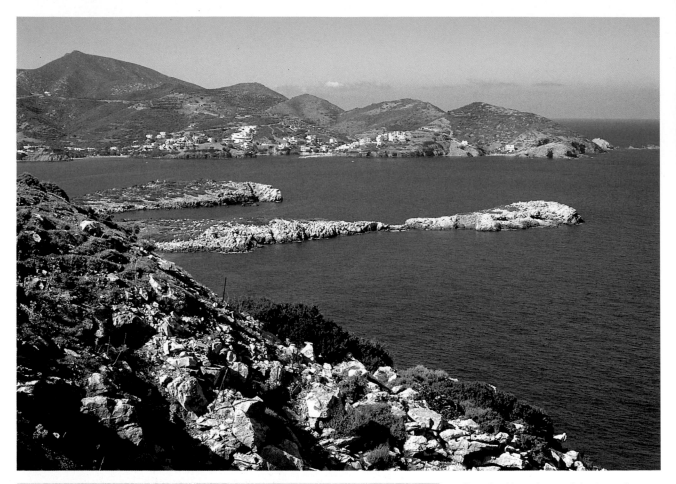

Breathtaking views of the bay of Balion and neighbouring coastline.

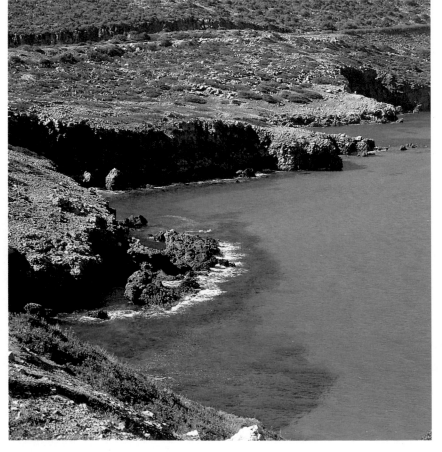

THE COAST BETWEEN RETHYMNON AND IRAKLION

The indented coastline between Réthymnon and Iráklion deserves close attention, not least for the wonderful panoramic views it offers. Of particular interest is the village and bay of **Panormos** ("Palermo"= an accessible harbour) where slightly to the N.W. the remains of a Byzantine basilica have been discovered. **Balion,** enclosed in one of the coast's many turquoise bays, and protected by the rocky coast was, together with *Fodhele* was one of the ports serving the ancient town of *Axos*.

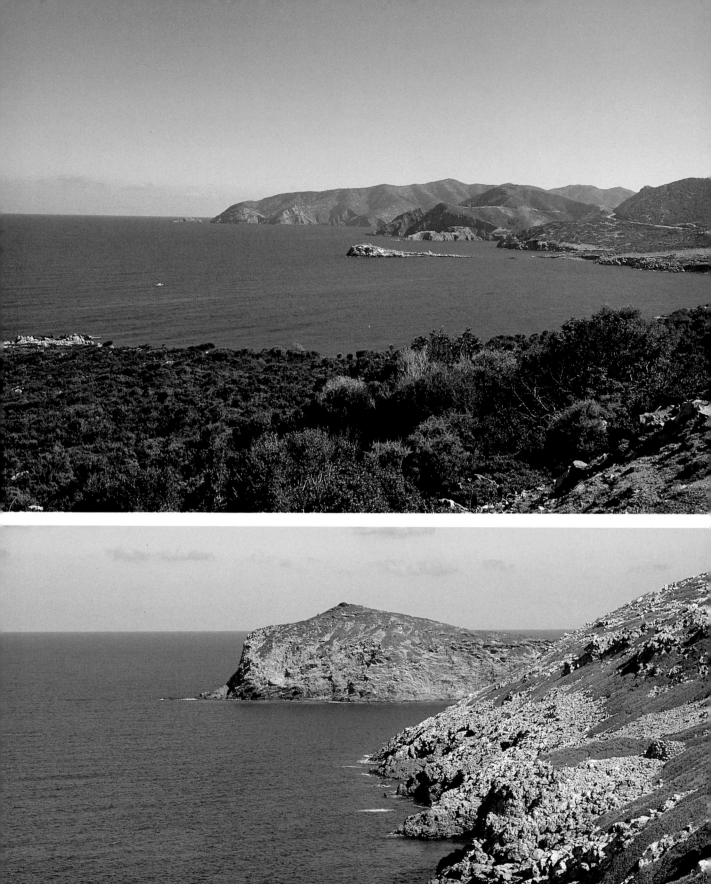

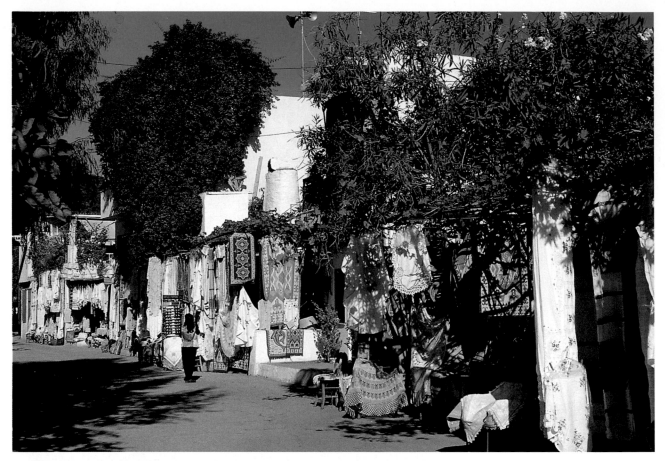

Fodhele: a village street and the Byzantine church.

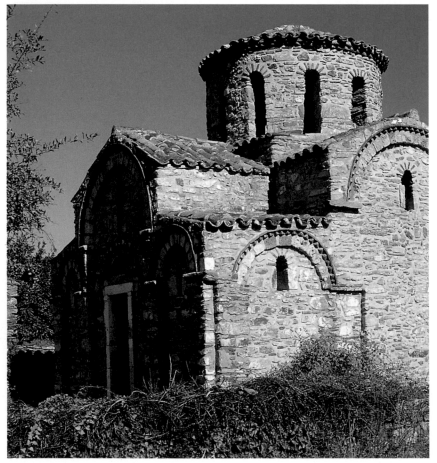

FODHELE

This picturesque village was probably one of the ports, together with *Balion*, serving the ancient town of a *Axos*. The village has a small but delightful **Byzantine church** with the architectural elements enhanced by decorative brick work.

The village is traditionally the birth-place of Domenikos Theotokòpoulos, better known as El Greco, in 1541.

Despite his conversion to Roman Catholicism, he always remained conscious of his roots, signing his name in Greek, and adopting the elongated figures of the Cretan School of Painting.

IRAKLION

The city of *Heracles* (one of many named after the Greek hero), *Heraklion*, or Iráklion, with 90,000 inhabitants, is the largest city on the island and also its capital. It was the main port of the ancient Minoan centre, then of the Greeks and the Romans at *Knossos*. Iráklion survived various vicissitudes until the Arabs took the city in 823 from the Byzantine Emperor Nicephorus.The Arabs expelled from Cordoba in Spain and set towards Alexandria in Egypt were led by the mercenary captain Abu Ka'ab. On route they had already captured part of Sicily but in Crete they made no attempt to integrate into Cretan society, as had originally been done in Spain but imposed their own customs on a highly civilized city. They also forced the conversion of the population to Islam and transformed the island into a flourishing slave market with pirates controlling a terrifying commercial centre and extorting enormous levies from ships plying the Aegean sea. The city was fortified surrounded by an enormous defensive *Khandak* (*ditch* in Arabic), which the Byzantines called *Chandax* and the Venetians *Candia* which became the name of the city throughout the Middle Ages and beyond. Reconquered in 961 by Nicephorus Phocas, a general and later Emperor of Byzantium, after a brief but difficult siege the city prospered during the late Byzantine period.

During the long years of Venetian rule from 1204 to 1669 it became the island's capital and principal fortification. In Iráklion, or Candia, as it continued to be known a representative directly appointed by the Venetian Doge ruled as Duke of Crete, surrounded by Counsellors elected by the Great Council in Venice. To increase the prosperity of the city Venetian nobles on the island and aristocratic Greek families were compelled to build houses in Candia and to live there for a certain length of time

Iráklion: the port fortress called the Rocca al Mare.

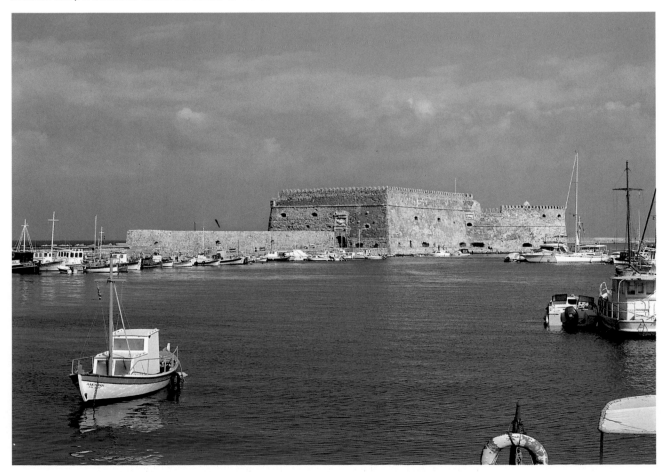

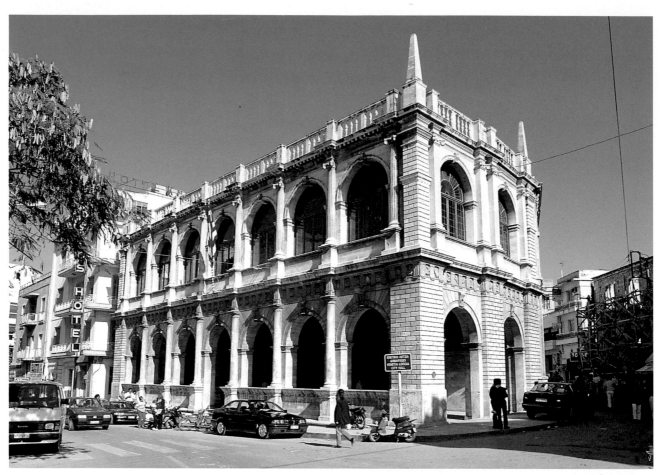

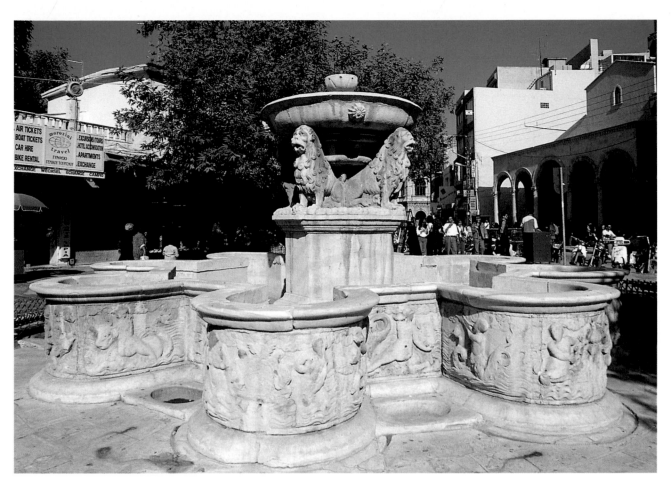

The Venetian Loggia and a detail of the interior.

The Morosini Fountain (1628).

each year. It was also the seat of a Roman archbishopric while the Orthodox clergy depended on the Patriarch of Constantinople. The Venetian occupation gave rise to sporadic revolts and resistance; in 1274 the Duke of Crete was assassinated together with many nobles and after the fall of Constantinople to the Turk in 1453 there was further unrest encouraged by those Greeks who had fled Constantinople. The revolt of 1458-1460 was quashed by the Venetians as were many successive attempts at resistance. The external threat of the Turk became increasingly menacing and in 1526 the fortifications were redesigned by the architect and engineer Michele Sanmicheli.

One of the most dramatic events in the history of Candia was the siege by the Turks which began on 1 May 1648 after they had completed their conquest of the rest of the island. Three unsuccessful attempts were made on the city's bastions before Candia came under prolonged siege. In 1660 Louis XIV, the Sun King, and the Duke of Savoy sent reinforcements to the besieged city, which also suffered an earthquake in 1664, while the Turkish forces at this time were severely depleted by an attack of the plague. In 1667 the Venetians sent captain Francesco Morosini, and in 1668 and 1669 further reinforcements arrived from the King of France. All attempts at resistance were hopeless however and after tremendous loss of life (more than 100,000 Turks, 30,000 Italians, 3,000 French and an unknown number of Greeks) the city was lost to the Turk. During the long Turkish occupation the city was called *Megàlo Kastro* (Great Fortress) and became a *Pashalik* (District governed by a Pasha). The city, badly damaged by the siege, soon fell into decline whereas nearby Khaniá began to flourish.

In architecture and the visual arts Candia was closely linked to the developments of the Renaissance in

55

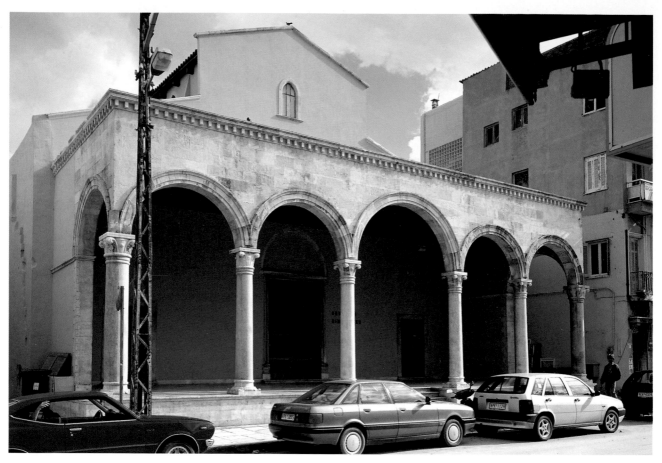

Entrance to the church of Ayios Markos (St Mark).

A Turkish fountain converted into a small café.

The Bembo Fountain (1588).

Venice and became, under the Venetians, the principal social, political, commercial and cultural centre of Crete. Many buildings survive from this prosperous period, notably public ones. Walking within the city walls in the lively streets surrounding **Plateia Eleutherias** (Liberty Square) **Plateia Ekatherini** and **Plateia Nikephòrou Phoka**, one constantly comes across these remarkable old monuments.

The elegant, arcaded **Venetian Loggia** in the Palladian style, directly inspired by the Basilica in Vicenza, was begun in 1626 and completed in 1628 as the Venetians' mercantile exchange. It was destroyed during the last world war but rebuilt with some not altogether justifiable modifications. Beside it stands the **Dhimarkhìon** (Dimarchos: Greek for Captain of the people), once a Venetian **Armoury**, restored in 1932. The church of **Ayios Markos**, built in 1239 (or in 1303) with subsequent alterations has nave columns in *pietra verde* taken from the Graeco-Roman buildings at Knossos. The church was later converted into a mosque, with a minaret, now destroyed, built alongside it. The

building is now used as a conference centre and has on display *copies of late-Byzantine frescoes and the carved doorway* from the Ittar Palace. The celebrated **Fontana del Morosini** stands in the centre of Plateia Venizelou surrounded by cafés. It was built by the Venetian Governor, Francesco Morosini who began work in 1628. The eight basins are decorated with reliefs depicting mythological marine creatures: Nymphs and Tritons riding bulls, dolphins and sea-monsters; the upper basin is supported by four seated lions probably taken from an earlier monument. It is well worth strolling through the **bazaar,** even if its oriental appearance is only a faint reminder of its hay day, to reach **the great church of Ayios Mìnas**, built in 1862 as the Cathedral of Iráklion with its extremely light façade, made airy with magnificent archways and windows. It stands beside the smaller and more ancient **chapel of Ayios Mìnas** housing icons by the famous painter *Mikhailis Dhamaskìnos*, who worked in Crete, the Ionian islands as well as in Venice. His works reflecting a strong Italian influence, include

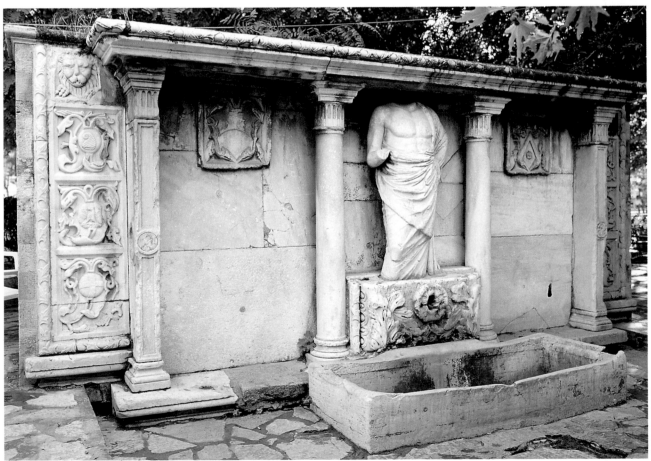

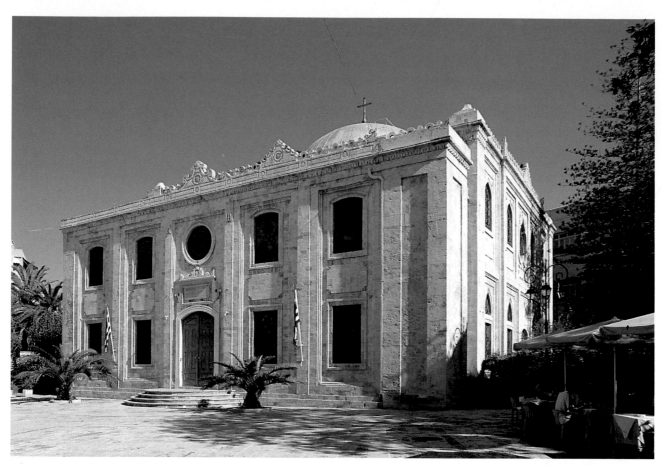

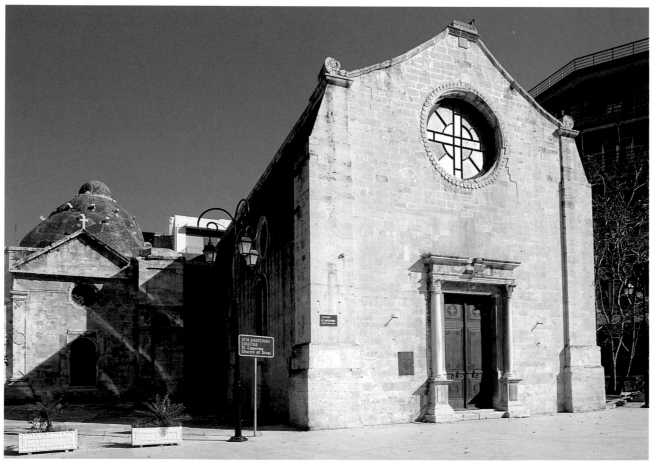

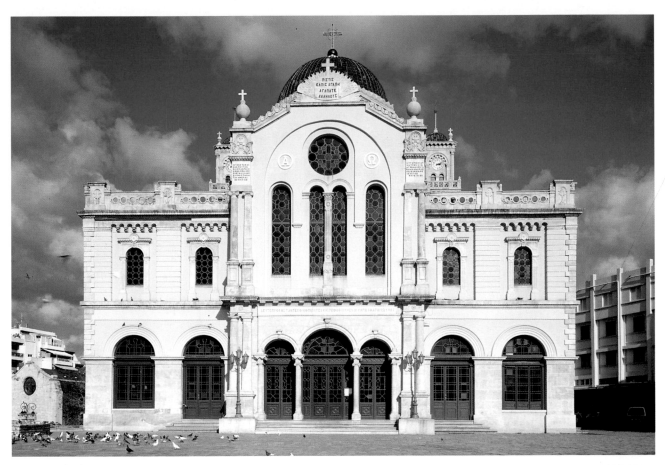

Cathedral and smaller church dedicated to Ayios Mìnas.

Church of Ayios Titos.

Churches of Ayia Aikaterini (St Catherine) and Ayioi Dheka (The Ten Saints).

the *Last Supper*, the *Council of Nicaea* (dated 1591), the *Adoration of the Magi* and the *Nativity*. The unusual **church of Ayios Titos**, built in 961 after the Byzantine liberation of the island, and dedicated to its patron saint was reconstructed many times before being converted into a mosque by the Turks in the second half of the 19th century. Reliquaries of St Titus were returned by the Venetians from St Mark some thirty years ago. Of interest too are the **church of Ayioi Déka,** the Ten Saints, dedicated to Cretan martyrs killed at *Gortyn* and the adjacent chapel of **Ayia Aikaterini** built for the nuns of St Catherine of Mt Sinai which, later, like so many churches, was converted into a mosque with a free-standing minaret of which today only the base survives.

Strolling through the streets in the centre one comes across **Turkish fountains**, the domes of the many small **mosque** converted from Catholic churches, the occasional Venetian **doorway** and, more rarely a **house** built **in the Turkish style**, the largest and finest of which is now owned by the Italian State and is the base of the Italian School of Archaeology of Athens during the excavation season.

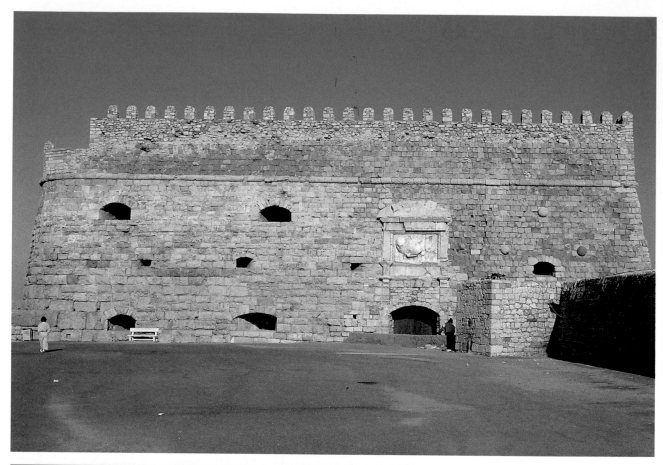

Iráklion: view of the Rocca al Mare.

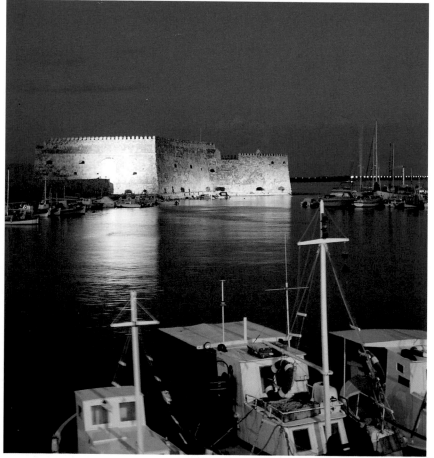

THE FORTRESS AND THE VENEISERO PORT

The fortifications surrounding Candia, built after the design of the Veronese Michele Sanmichele with seven well-preserved, enormous bastions, a deep trench and four arched gateways or *Porte*, took over a century to build.

While the **Porta di San Giorgio** no longer exists as it was destroyed by the troops of Louis XIV during the final Turkish siege the fine Doric **Porta di Gesù** (now the *Porta Nuova*), dated 1567, with an inscription on the inside dated 1587, commemorating the Governor Mocenigo, still survives. Impressive too are the **Porta di Chania**, and the

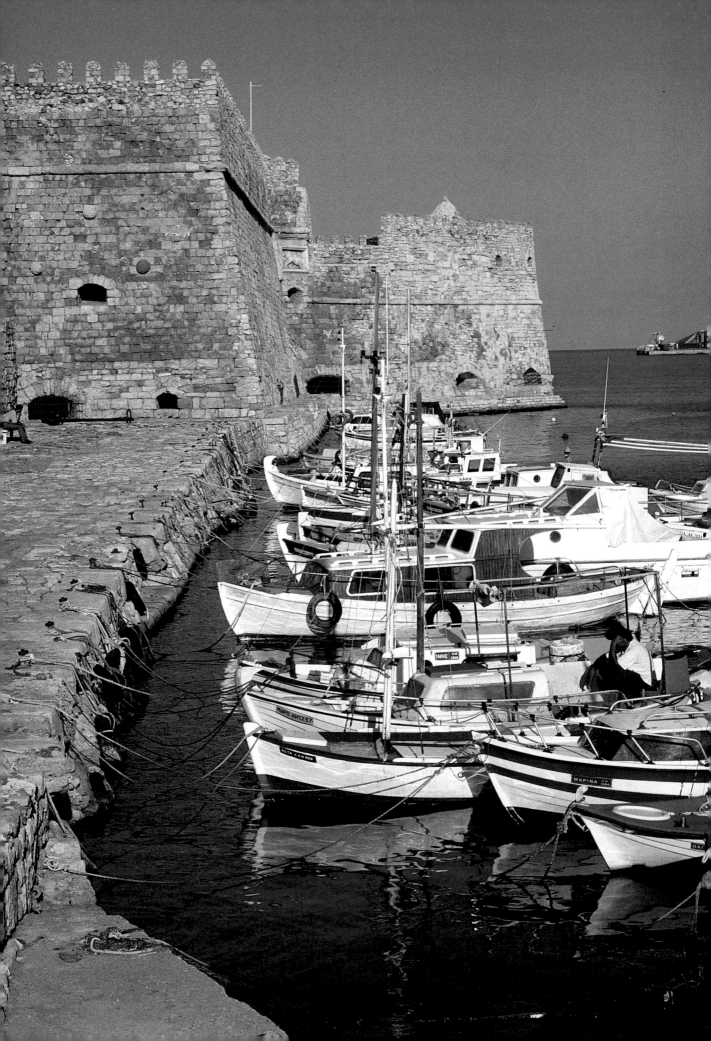

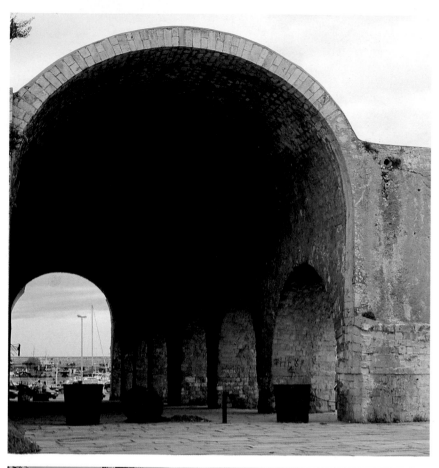

Bastions: the *Martinengo* one now supports the tomb of the writer *Nikos Kazantzakis* who died in 1957; the others are called *Pantokrator*, or *Panigra; Betlemme; Sabbionara; S. Andrea.* In addition to the main fortifications the Venetians built a strong defensive system to protect the small but strategically important harbour, the **Porto Veneisero**, which is still of commercial and touristic importance. Beside the fortress stands the enormous **Arsenal** with magnificent vaulted ceiling, now used as warehouses. The compact fortress of **Rocca al Mare** (better known by its Turkish name of *Koules*) was built 1523-1540 and its recently restored interior is open to visitors. It is also possible to walk around the battlements.

The Arsenal.

A stretch of bastion wall.

The monument dedicated to Eleutherios Venizelos which stands not far from Plateia Eleutherias (Liberty Square).

The tomb of Nikos Kazantzakis on the Martinengo Bastion.

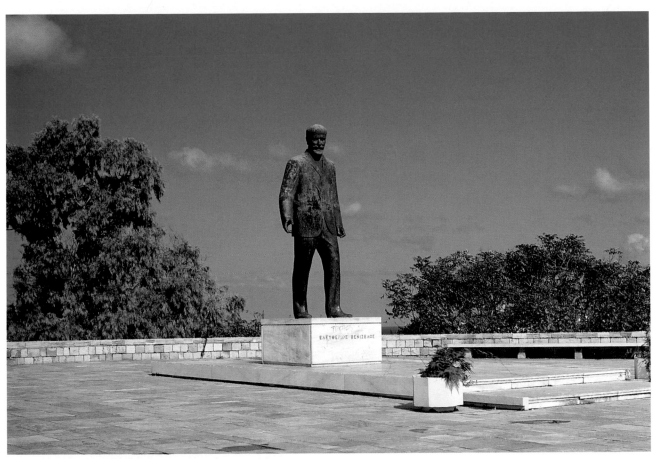

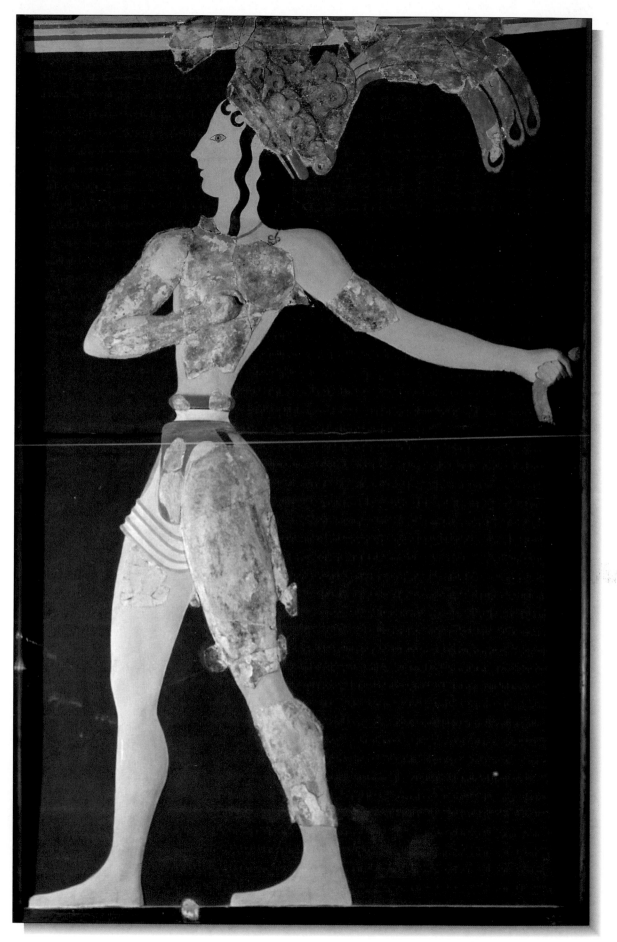

ARCHAEOLOGICAL MUSEUM

The Archaeological Museum in Iráklion, founded in 1883 and built on the site of the Catholic church of St Francis which was destroyed by an earthquake in 1856, is the most important museum in Crete, and the second most important museum in Greece after the National Museum in Athens and one of the finest museums in the world. It is unique in its range of Minoan artefacts and the light it shows on Cretan civilisation. The pieces are displayed in a strictly chronological order according to discoveries made during excavations in Crete by Greeks and outsiders. The exhibits range from the Neolithic to the late-Roman period and therefore cover some 6000 years.

The exhibits in **Gallery I** are mainly vases and fragments from the Neolithic (6000-5000 B.C.) and Pre palatial or Early Minoan period (2600-2000 B.C.), before the building of the great palaces which typified later Minoan civilization. There is a remarkable collection of *vases* made of semi-precious stone from the island of *Mochlos* in the Gulf of Mirabello (Eastern Crete), of marble *figurines*, terracotta figures of *deities*, animals and worshippers, carved cylindrical *seals*, imported from the East and discovered in circular, domed tombs (*tholos*) on the plain of *Mesara*. The gallery also includes some fine *jewellery* in gold, precious stones and ivory and *weapons*. The *Vassilike pottery* is of especial interest (named after the locality in which most of the pieces were found) with its mottled decoration caused by the uneven baking of the clay.

The most striking exhibits in **Gallery II** are the Middle-Minoan (2200/2000-1580 B.C.) Kamares vases, named after the cave sanctuary on Mt Ida

where they were found, with their rich polychrome floral decoration on a black ground. There are also some figurines of various kinds, seals, vases (including some that are eggshell thin) and jewellery from the early palaces at *Knossos, Mallia* and other early Cretan sites. It is interesting to study the *model shrine* with three columns surmounted by doves, birds probably sacred to the deities, and the *mosaic of the city*, made up of maiolica plaques depicting two-storeyed houses with closed barred windows and flat roofs.

The exhibits in **Gallery III** cover the same period as Gallery II. Here we find outstanding pieces of *Kamares ware*, named after the cave sanctuary, dedicated to the great Minoan goddess, on Mt Ida, where they were originally found. The greatest attraction is however the famous *Phaistos Disk*, a small terracotta disk discovered in the Palace of Phaistos and dateable between 1700 and 1600 B.C. It is covered on both sides by some 122 undeciphered hieroglyphics in seven groups arranged in spiral form towards the centre.

Gallery IV houses some of the finest pieces in the museum from the Neopalatial epoch (the second period of the palace building from the end of the Middle Minoan to Late Minoan: 1700-1400) from *Knossos, Mallia* and *Phaistos*. This astonishing collection of vases and terracotta ware includes the fine *vase of the lilies*, decorated with typical floral motifs, designed with great delicacy and fine naturalistic feeling. Other vases are enlivened with octopus and fantastic sea creatures while others were destined for libations and ceremonial use. The room also includes jewellery and several examples of the

The "Prince of the Lilies", painted relief from the Palace at Knossos.

Precious Minoan jewellery.

Bronze dagger with a damascened hilt.

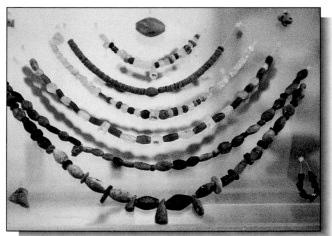

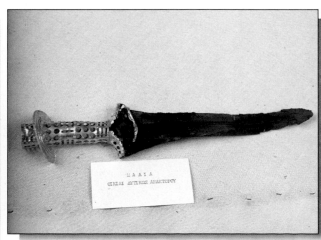

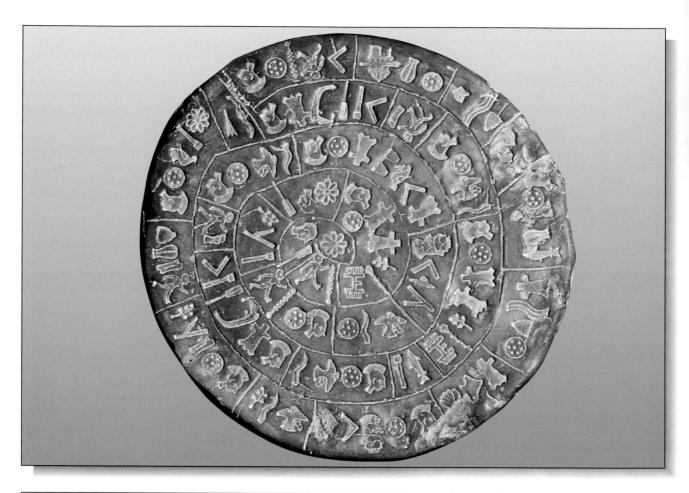

The Phaistos Disk (1700-1600 B.C.)

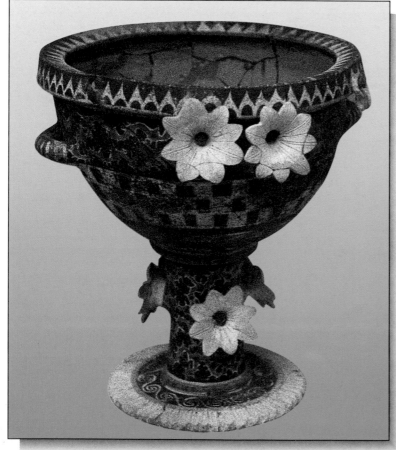

Crater with flowers in relief (in imitation of a metal vase), from the palace at Phaistos (Kamares ware).

Minoan symbol *par excellence*, the double axe. Also on display are vessels used in worship of the *Sacred Snake*, the *Bull's Head Rhyton*, carved in serpentine, from Knossos, *a ceremonial sword* from Mallia with a gold and rock crystal hilt, an ivory *acrobat* and a splendid *Draughtboard* inlaid with ivory, gold, silver, rock crystal and lapislazzuli from *Knossos*.

Gallery V is filled with discoveries from the second Palace at Knossos including various vessels, figurines, lamps and seals in semi-precious stone. The room includes an extraordinary collection of clay tablets, of immense historical interest, from several Cretan palaces recording the entry and exit of goods and merchandise, recorded in both Linear A and B script, in which the origins of classical Greek can be traced.

Gallery VI houses finds from tombs around Knossos and from the plain of Mésara, recording funeral practices and covering the period from the end of the

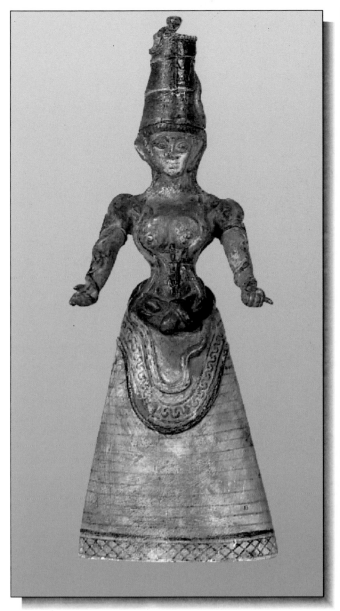

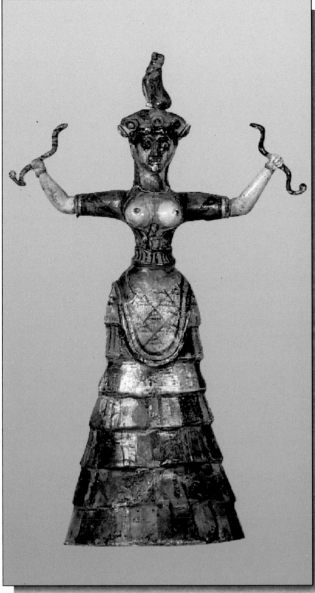

Majolica Goddesses with serpents from Knossos (1600-1580 B.C.).

On the following page, serpentine bull's head rhyton from Knossos: restored gilded wooden horns, rock-crystal eyes and white tridacna-shell nostrils.

Neopalatial epoch to the Mycenæan civilization (1500-1100 B.C.) and the cultural impact of the arrival of Greeks from the mainland. Here we find an interesting shrine with two columns and a banqueting scene documenting both a precise building type and a ceremonial, probably funereal, ritual.
Gallery VII deals with the Neopalatial settlements of Central Crete. Together with the *monument with the double horns* are a series of *double axes*, symbols of the dual power over life and death exercised by the sovereign both in political and religious affairs. Displayed here are the celebrated serpentine *relief vases* from the royal villa of *Ayía Triádha*, known as the *Harvester Vase* and the *Chieftain Cup*, showing scenes of harvesting and bull-fighting and reflecting scenes of Minoan life and culture. Before

leaving the room notice the copper ingots incised with Cretan or Minoan symbols, the range of jewellery with carved pendants including two of the most famous, the two gold bees from the palace at *Mallia* and the lion cubs from *Ayía Triádha*.
Gallery VIII includes finds from the Mycenæan period and from the second palace at *Kato Zàkros*, on the eastern most point of the island. The *superb vase carved in rock crystal* has a gold band around its neck and a handle of beads threaded on a copper wire which has turned them green. Note also the magnificent *Peak Sanctuary Rhyton* in green stone once covered in gold leaf with a relief decoration showing three altars and goats looking over the roof and all around the sanctuary while doves circle above it.

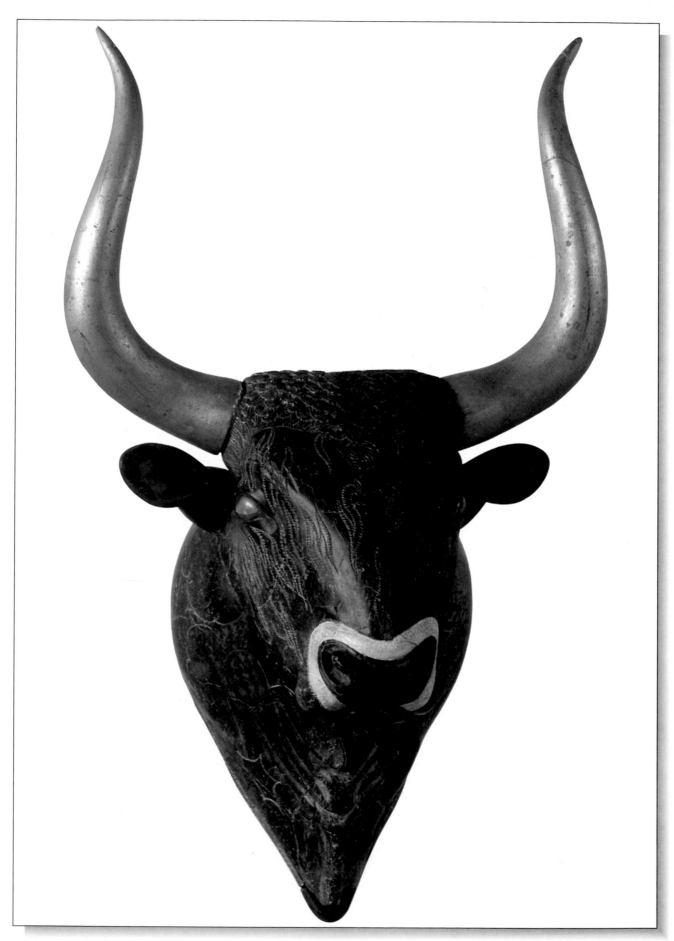

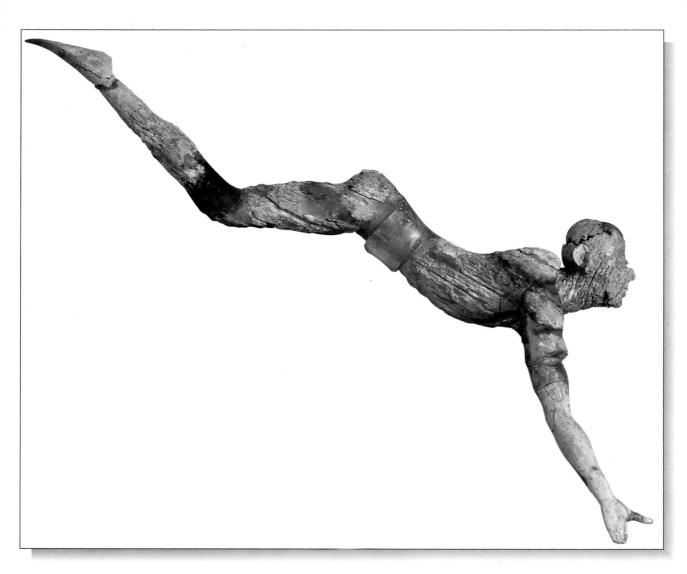

Ivory acrobat, originally gilt, from Knossos: part of a group depicting bull-leaping (1500 B.C.).

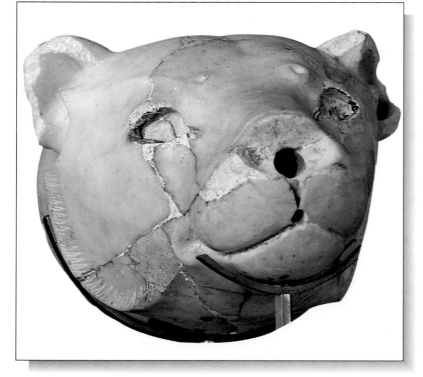

Lioness-head rhyton in white limestone, from Knossos (1550-1500 B.C.); nose and eyes once filled with red jasper and rock crystal.

Gallery IX houses objects from the Neopalatial sites of Eastern Crete, such as *vases*, the most notable being an amphora with naturalistic octopus decoration, a potent reminder of the importance of the sea to Minoan and Mycenæan civilization, together with figures of deities and supplicants, semi-precious stone *seals* as well as *weapons* and *instruments*. There is also a collection of *beetles and sacred insects* including many examples still found on the island.

The advance of Mycenæan civiliza-tion is progressively documented in

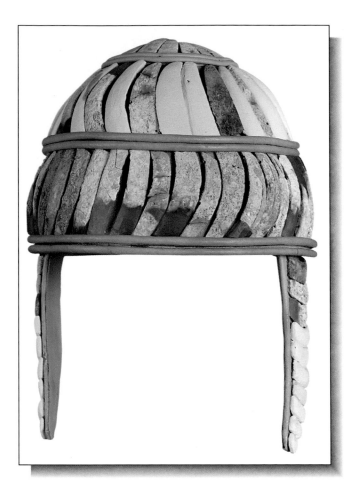

the later rooms with an extraordinary number of objects offering the visitor a wide artistic panorama of this period.

Gallery X is crammed with idols, clay and bronze statuettes, everyday utensils and tomb and sanctuary offerings all illustrating *Mycenæan life and culture.* Among the most remarkable of these are the *large clay idols* with their arms raised in adoration to the gods.

Reconstructed helmet with cheek-pieces (1500 B.C.) made of wild boar tusks; from a tomb near Knossos. In the Iliad, Homer describes the Cretan hero Merino wearing a helmet of this kind.

Nine-handled crater, decorated with sea creatures: an octopus appears to be clinging to the vase with his tentacles (Marine style: 1400 B.C.).

Rhyton in rock crystal decorated with gold and bronze beads on the handle, from Káto Zákro (1450 B.C.).

Jug with a lip (probably for ritual use 1400 B.C. with painted relief decoration from a tomb at the mouth of the Kératos (near the port of Knossos).

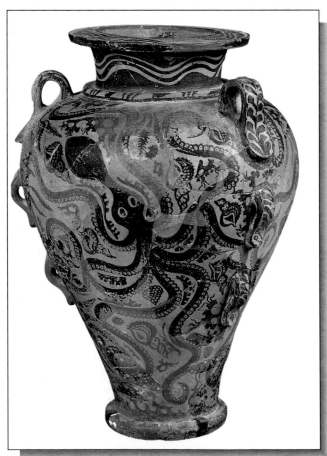

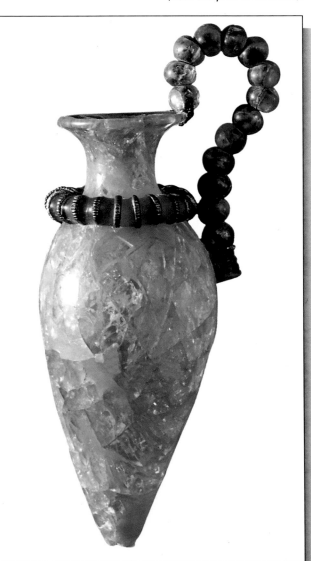

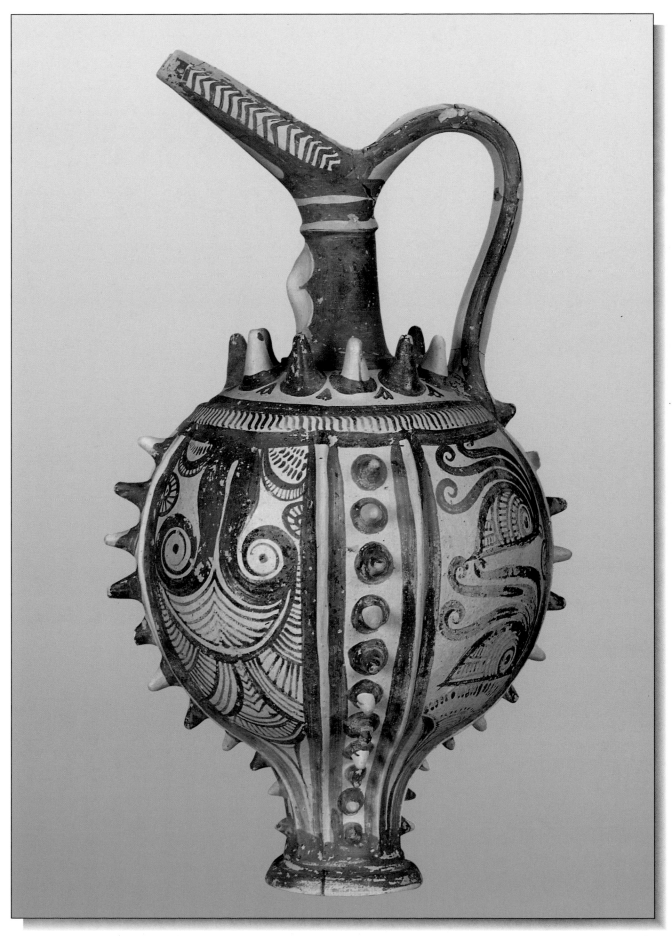

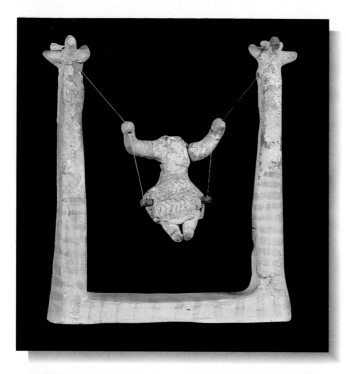

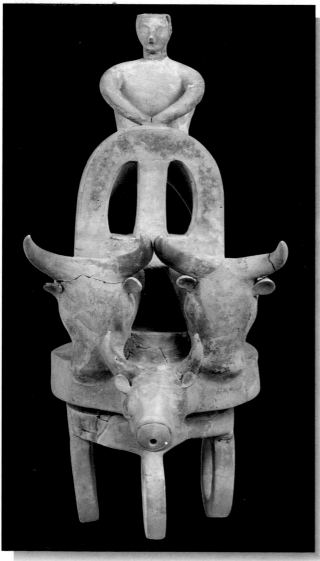

In **Gallery XI** we move to pieces from the close of the Mycenæan period and from the beginning of the geometric phase (1100-800 B.C.). with *idols with raised arms* from Karphì which bear witness to the persistence of certain types and cultural practices and a *Rhyton* in the shape of a chariot drawn by ox heads. As is so often the case in archeology small differences denote important changes: during this period the number of buckles and pins used in Minoan dress noticeably diminish reflecting the different style of dress adopted by the new population.

Gallery XII is dedicated to the geometric and the later archaic or oriental period (800-650 B.C.), so called because of the influence of eastern cuvilinear motifs and scenes with human figures and animals which broke up the rigourous geometric decoration immediately preceding it. The effect created is quite different from that created by the imaginative naturalistic motifs of Minoan art of which all trace has now vanished. The availability of Phoenician products via Anatolia (now Turkey) injects a new repertory of realistic and fantastic figures into Cretan art: sphinxes, lions, sirens, panthers, etc are seen in *ceramic and metal ware*, never interpreted in slavish imitation but with imaginative local variations.

Gallery XIII houses a fine selection of late-Minoan and Mycenæan *làrnakes*, small painted terracotta sarcophagi, from various Cretan sites but reflecting a similar figurative tradition based on naturalistic motifs interpreted with imaginative stylization.

The first floor is chiefly dedicated to the pictorial art of the Minoan period.

Gallery XIV is filled with important frescoes from *Knossos, Ayía Triádha* and other important centres in central and eastern Crete. Of particular interest are the fresco of a religious or *Libation procession*, headed by a figure playing a lyre with seven strings, from the royal villa of *Ayía Triádha*, and the *Prince of the Lilies*, discovered in the Corridor of the Procession at *Knossos*, by Sir Arthur Evans, who called it the Priest-King, is a most perfect example of the elegance of Minoan art. The Procession fresco, with some 500 figures including dancers, musicians, priests and supplicants converge on a goddess in celebration of a rite and came from the entrance corridor of the palace at *Knossos*. The vivid *Toreador Fresco*, with a leaping bull is also from Knossos where the fresco with dolphins came from the Queen's chamber. The *painted sarcophagus* found in a small tomb in the villa at Ayía Triádha (1400 B.C., perhaps belonging to a member of the royal family) is of outstanding historical interest. It is carved in stone with scenes of a funeral rite: the sacrifice of a bull, the offering of fruit and libations, the offering of the priestess to the deceased, appear-

Terracotta "Girl on a swing", probably a votive offering (1500-1400 B.C.).

Terracotta chariot drawn by three bulls (11th century B.C.).

Larnakes *(clay sarcophagi), late-Minoan, various shapes and types (1450-1350 B.C.).*

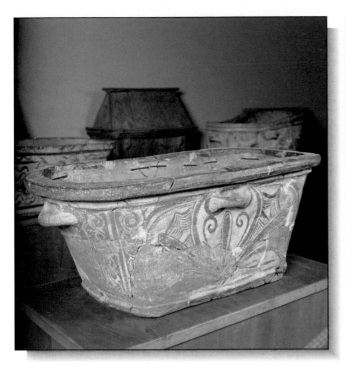

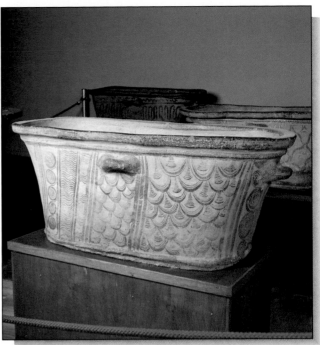

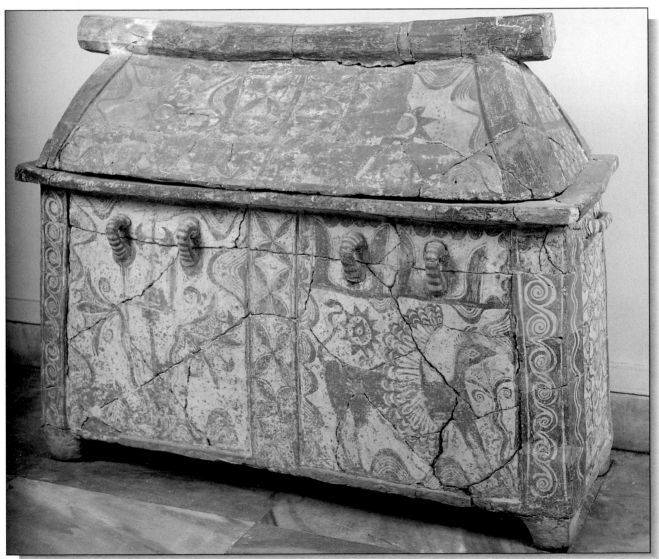

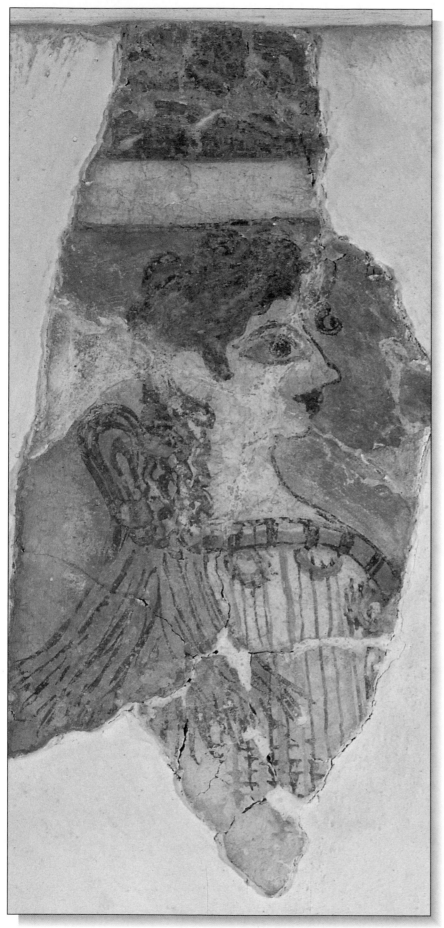

ance of the dead man himself, a chariot drawn by horses and one by winged griffins (an explicit reference to the connection between terrestrial life and the life beyond).

Galleries XV and XVI are also devoted to Minoan frescoes of great artistic and historical interest, especially for the light they shed on Minoan society. We are given the depiction of *a sanctuary with three columns* with devotees gathered in front of it; *Miniature frescoes from the palace at Knossos*; the famous *La Parisienne*, a young priestess with elegant features and a stately pose; the *Saffron Gatherer*, the fascinating depiction of a dog-headed monkey gathering saffron from croci in the garden at Knossos; the *Captain of the Blacks* leading a group of moors, mercenaries and slaves.

The extremely rich *Giamalakis Collection* of Minoan and Greek antiquities is housed in **Gallery XVII** and includes: precious jewellery, delicately carved seals in various stones, instruments and weapons in bronze and iron and a dazzling collection of ceramics and terracotta of the Minoan and Greek geometric, archaic and classical periods. One of the collection's finest pieces is a small, archaic bronze statue of a *kriophòros*, a supplicant carrying a sacrificial ram on his shoulders. It is also worth noting the terracotta *model of a sanctuary*, enclosing the figure of a goddess with raised arms, according to Minoan religious custom.

Gallery XVIII is devoted to what by convention are called the minor arts but which in this case include some outstanding masterpieces. These are generally on a diminished scale and often miniature like the *bronze statuettes* of the Hellenistic period (III-I centuries B.C.).

"La Parisienne", fresco from Knossos (1500-1450 B.C.).

74

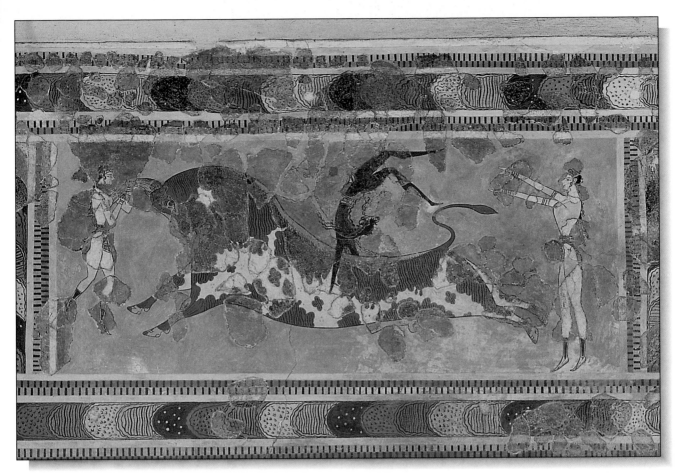

Palanquin, or bull-leaping, fresco from Knossos (1500B.C.).

Fragment of fresco showing male figures running.

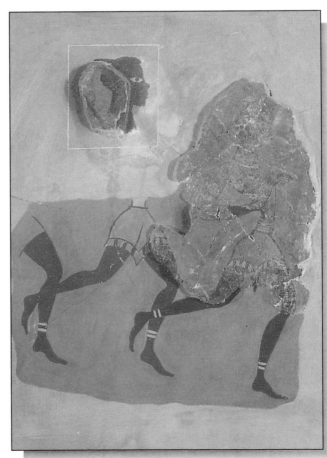

Returning to the ground floor in an area to the right of the entrance to the Minoan collections we reach the galleries dedicated to Cretan sculpture from the Greek archaic, classical, Hellenistic and Roman periods (VII century B.C. - III century A.D.). **Gallery XIX** offers the most wonderful panorama of the development of Greek sculpture with pieces of outstanding quality. In the centre stands three ritual statues from the sanctuary of Apollo at Dréros, (made with the ancient sphyrélaton technique-bronze beaten onto a wooden model) of Apollo, his sister Artemis and their mother Latona. Jealous Hera (Juno), betrayed by Zeus, had forbidden Earth to offer refuge to Latona who was about to give birth. After much wandering Latona gave birth to the heavenly twins on the island of Delos which thereafter became the sanctuary of Apollo. Antique sculpture of the VII century A.D includes the *frieze*

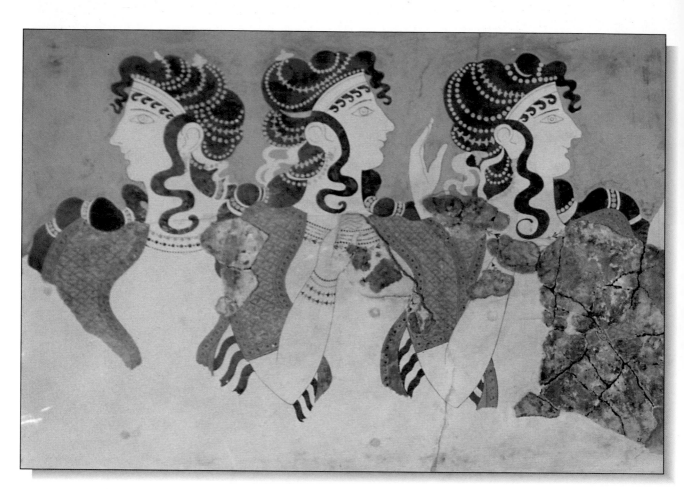

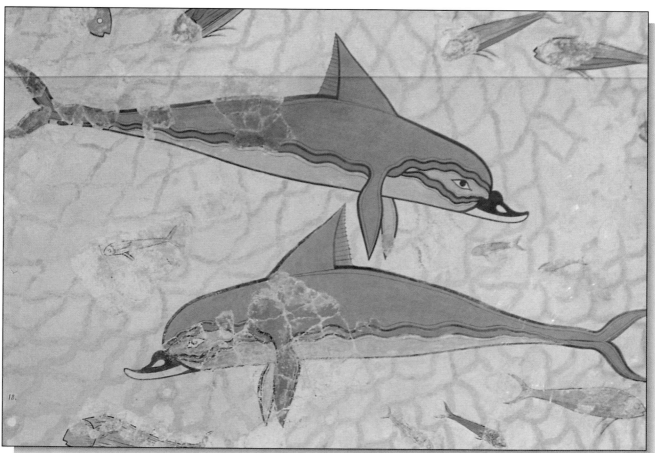

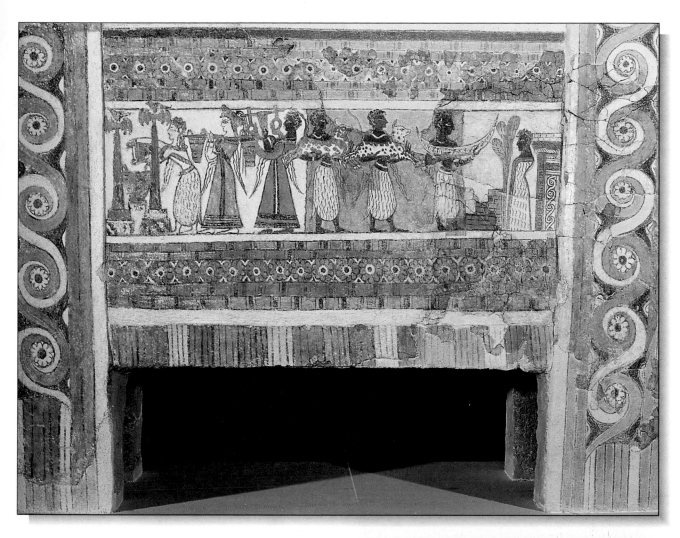

Sarcophagus from Ayía Triádha (1400 B.C.): offering of libations (on the left) and the presentation of gifts to the departed (on the right).

Model of a Minoan house from Archànes (1450-1400 B.C.).

Fresco of the three goddesses (1450 B.C.).

Frieze with dolphins, from the queen's chamber at Knossos (1450 B.C.).

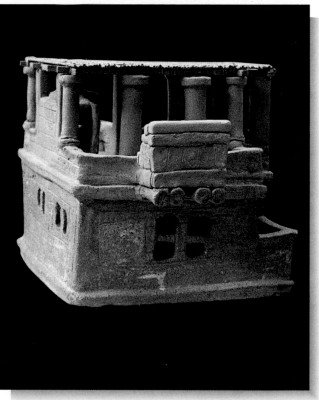

of horsemen and the *architrave with seated figures* from a temple at Priniàs (Central Crete). The *archaic sculpture* from *Gortyn* and *Eleutherna* and splendid *bronzes* from the Idaian cave, including some pieces from the east and some made in Crete but inspired by the orient reflect the progress in sculpture towards the oriental period.
Gallery XX is crowded with Roman sculpture from the main Cretan sites, nearly all copies of Greek bronze pieces which are now lost so making these copies valuable historical documents: they include copies of works by Praxiteles, Skopas, Policletus, Pheidias and their pupils. The original Roman works are public and private portraits, carved sarcophagi and reliefs.

HISTORIC AND ETHNOGRAPHIC MUSEUM

This museum, in the north part of Iráklion to the west of the Venetian ruins, illustrates the history and culture of Crete in the Byzantine period and the time of the Venetian and Turkish occupations. It complements the Archaeological Museum and completes the visitor's understanding of Cretan history. Eleven rooms on three floors contain important collections of *sculpture*, *painting* and *ethnography*, arranged both chronologically and thematically: funerary steles, Latin and Venetian inscriptions, early-Christian and Byzantine antiquities, sacred sculptures and reliefs of the sixth to the eleventh century, architectural fragments from the *Venetian Loggia* and pieces of Venetian heraldry, Turkish and Jewish antiquities, frescoes, textiles, a choice selection of icons and enamelled ceramics from the fourteenth to the eighteenth century, liturgical vestments, coins, Byzantine and Venetian seals and jewels, manuscripts of the tenth to the fourteenth century, documents regarding local history, and a section devoted to the modern poet and writer *Nikos Kazantzakis*.

Iráklion, Historic and Ethnographic Museum of Crete: some rooms and details of the collection of woven fabrics.

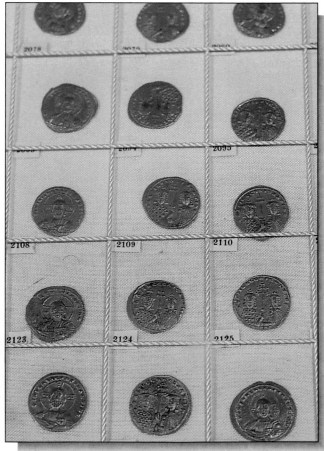

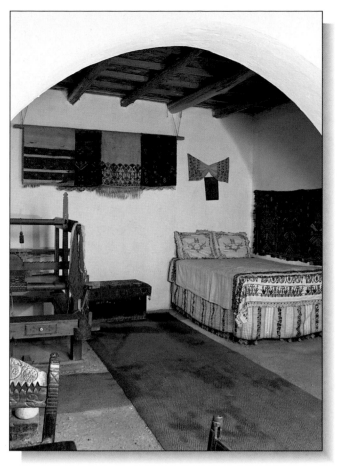

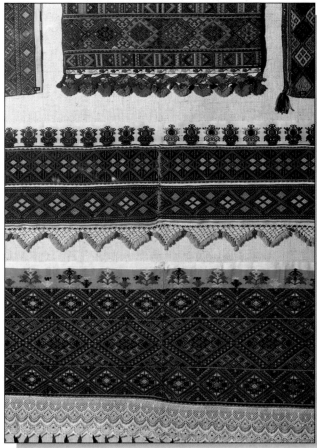

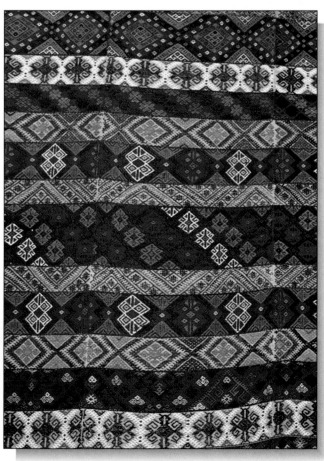

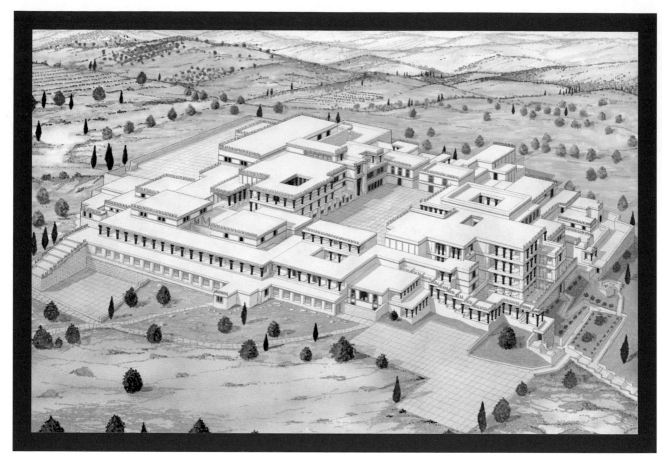

Reconstruction of the palace at Knossos.

THE PALACE OF KNOSSOS

The Palace of Knossos, located 5 km east of Iráklion, is the largest and most impressive Minoan site on the island, and one of the best known archaeological excavations in the world, an essential port of call for all Mediterranean cruises. Its fame is well deserved, not only because the vast area that has been excavated (the main palace, villas, paved roads, courtyards and colonnades) gives the visitor an unforgettable impression of being immersed for a few hours in the ancient world, but also because of its close connection with the deepest roots of Western culture: the name Knossos inevitably evokes the idea of the labyrinth (which probably had its origins in the elaborate and complex plan of this very palace), recalling the sanguinary myth of King Minos and his son the Minotaur, the enslavement of the Athenians youths and maidens, the heroic deeds of Theseus and the pathetic love of Ariadne, who betrayed the trust of her father the King in order to save the stranger whom she adored.

Discovered and identified on the evidence of the ancient sources by the great German archaeologist Heinrich Schliemann (using the same methods as for the discovery of Troy), the palace of the kings of Crete was excavated by Sir Arthur Evans from 1900 onwards. Knossos had been inhabited since Neolithic times by a flourishing community, and the first palace was built there around 2000 B.C. The kings who lived there exercised absolute power over a large territory and over the lives of the inhabitants, as appears from archaeological evidence and from a comparison with similar sites in the Near East; the riches and produce of the land were concentrated in the palace. Incoming goods were recorded on clay tablets (with regular updating of the "balance"), and whenever fire broke out these tablets were baked and so have lasted down to our own days. The centralised authority also saw to the redistribution of goods, perhaps in proportion to production. The economic, political and cultural activity of the lords

of Knossos was fed by maritime traffic, fishing, and commercial contacts with the East, with Cyprus, with the Phoenicians and the Egyptians. Destroyed by an earthquake in about 1570 B.C. (like Mallia and Phaistos), it was rebuilt on the same site and prospered for another 300 years, until the arrival of the Achaean peoples (from the Peloponnese), and especially until another earthquake, possibly caused by the eruption of Santorini, in about 1450-1400 B.C.

From then on Knossos shared the fortune of the whole Mycenæan world, the fertile humus from which the civilisation of classical Greece was to grow.

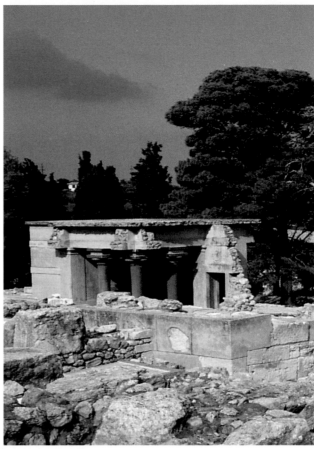

North entrance with colonnaded porticoes (partially reconstructed).

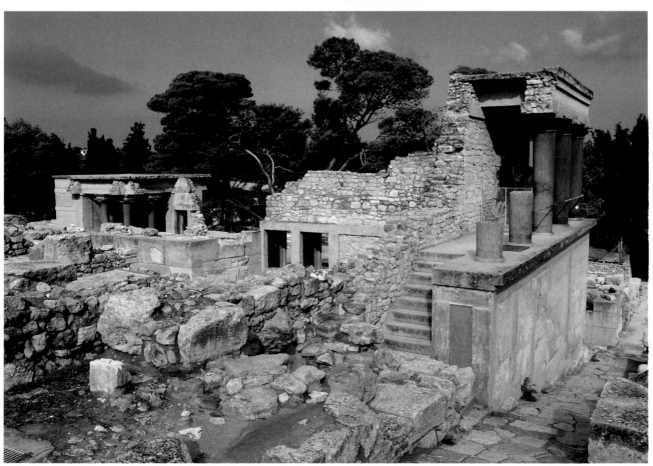

VISITING THE PALACE

The largest and most important Minoan palace, today somewhat spoiled by alterations and rendered unduly picturesque by Arthur Evans's over-zealous restoration, consists of a vast labyrinthine complex almost rectangular in lay-out, measuring about 150 metres on each side and occupying an area of almost five acres (20,000 square metres), the various wings surrounding a large central courtyard. The apartments and storerooms so far discovered amount to about 800, though it is thought that the palace was originally much larger and may have totalled 1300 rooms in all. Although apparently jumbled together higgledy-piggledy, the rooms are in fact carefully planned and arranged according to the intended function of each one.

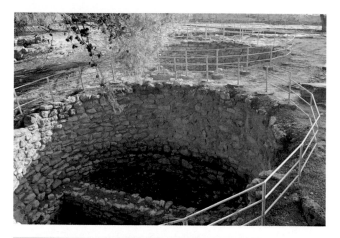

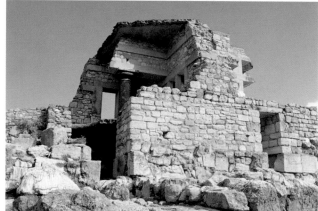

Paved west courtyard: circular well for votive offerings.

First floor: upper propylæum with copies of frescoes; opposite, the double horns, symbol of royal power.

The upper floor (called the Piano Nobile *by Sir Arthur Evans) with the upper propylæum.*

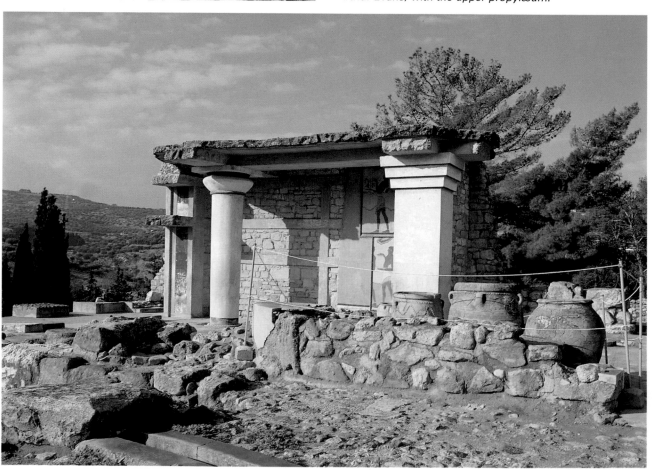

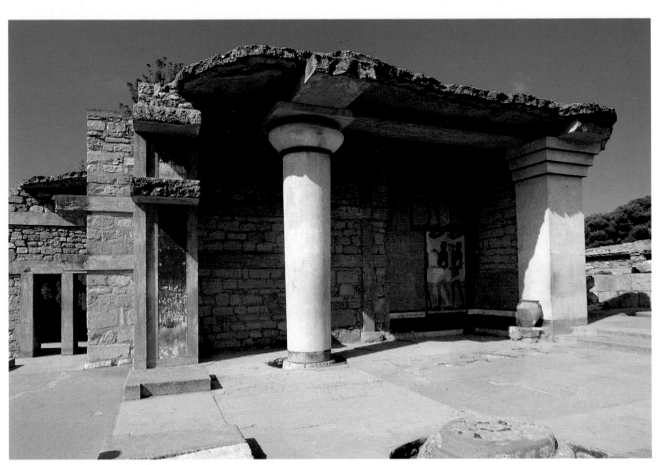

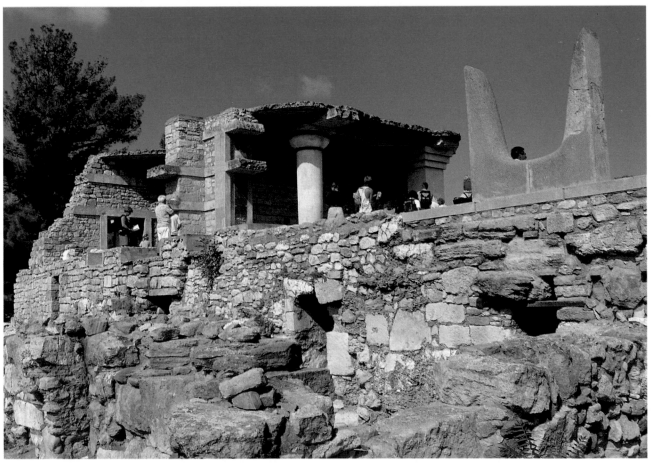

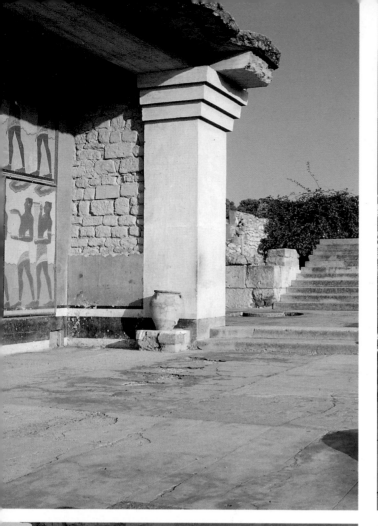

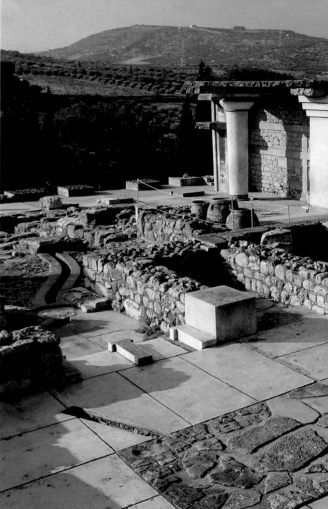

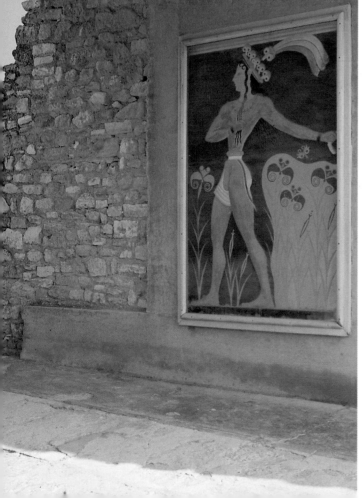

Partly reconstructed buildings with fresco copies in the positions of the original discoveries.

To the west of the palace (and of the modern entrance) there is a large **paved courtyard**, recognisable from the paths in light relief which cross it and which were probably intended for processions or cultic ceremonies, as is suggested by the presence of two altars discovered at the sides of the **communication trenches**, and by the three circular wells for sacred offerings, inside which there are still traces of the stairs used to place gifts to the gods. The trenches end in front of the important **theatre**, one of the earliest theatral buildings in the ancient world. It consists of two ramps with steps arranged beside the road leading to the port, and was intended for noble spectators (there is a "royal box" or loggia). Sacred drama and ceremonial were performed here.

From the west court we come to a small **propylæum** ("entrance") in the complex façade of the palace, with its pilasters and angulations that cast shadows in the bright Cretan sunlight (as in the contemporary Egyptian palaces); next to the propylæum there are storerooms and outbuildings which were later restructured as living quarters.

From the propylæum the long **corridor of the procession** leads to the heart of the palace. It was adorned with frescoes in about 1400 B.C., showing groups of men and women, priests and priestesses, musicians, bearers of offerings (ritual vases and libations), no less than 800 figures converging from both walls towards a central female figure, probably a goddess or a queen, in ceremonial attire.

The corridor leads to the **large south propylæum**, with a skylight giving light to the main entrance into the public area, a monumental doorway articulated by four pilasters and decorated with frescoes (partially restored *in situ*) showing bearers of offerings, ritual vases and sacred horns.

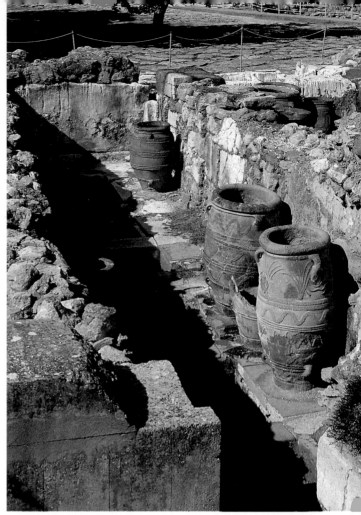

A magazine with the large pithoi *in place.*

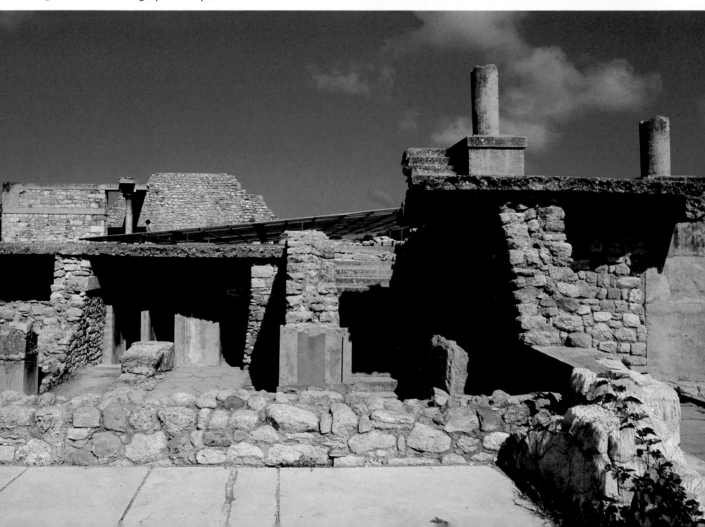

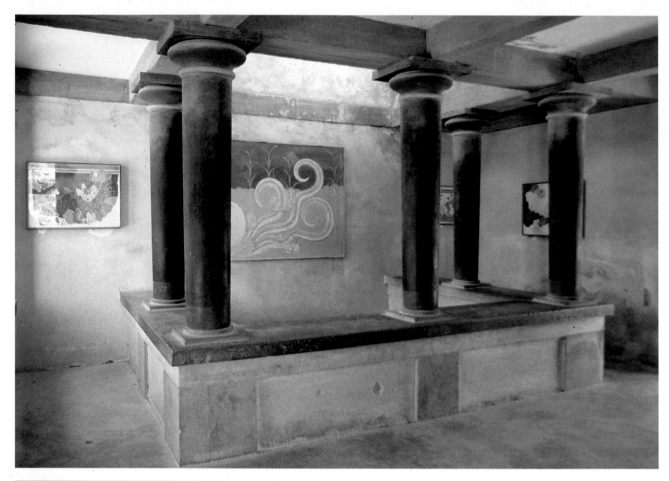

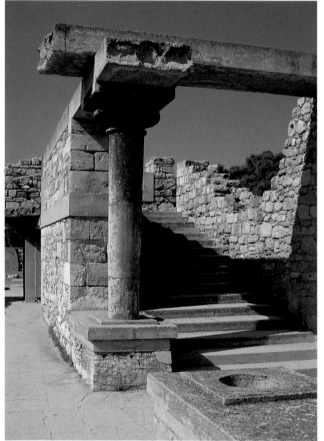

Skylight surrounded by columns.

A staircase between two levels: note the construction technique.

Views of the north-west area of the palace.

The large south propylæum leads to a **large staircase** flanked by colonnades backing onto massive supporting walls and with two verandas at the sides, giving access to the first floor (Arthur Evans's restoration is at least partly justified by the fact that at *Knossos* the levels of the various floors have been preserved as in very few other sites in Crete).

On the **first floor** we pass through the **upper propylæum**, its **vestibule**, and other areas (a corridor lit by a window giving onto a skylight, a small vestibule) until we reach the large **hypostyle** ("supported by columns"), known as the "Shrine with three columns" and having indeed three columns and three pilasters. It is decorated with frescoes, and leads into a room called the **treasury** by its discoverer. The hypostyle is flanked by the **upper long**

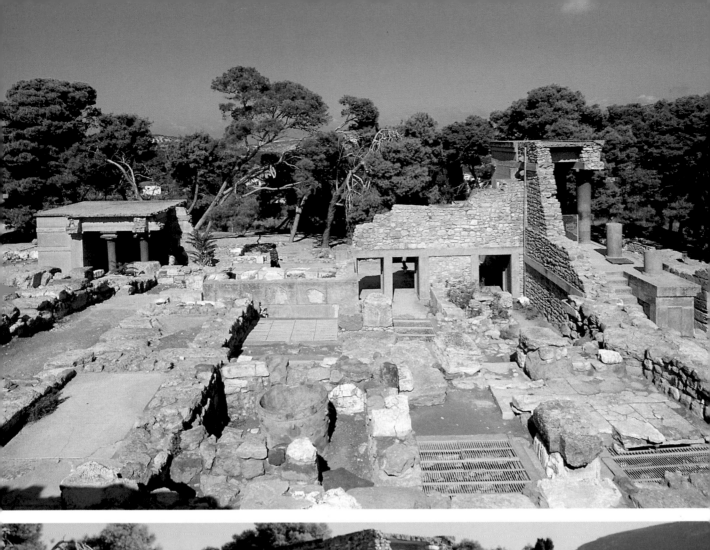
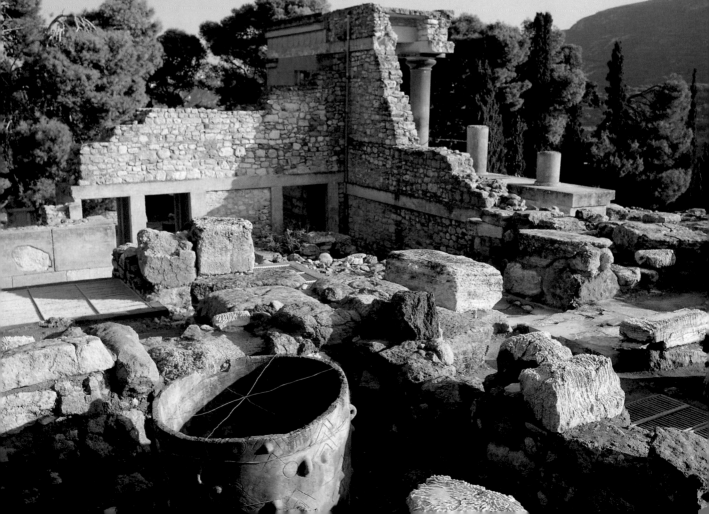

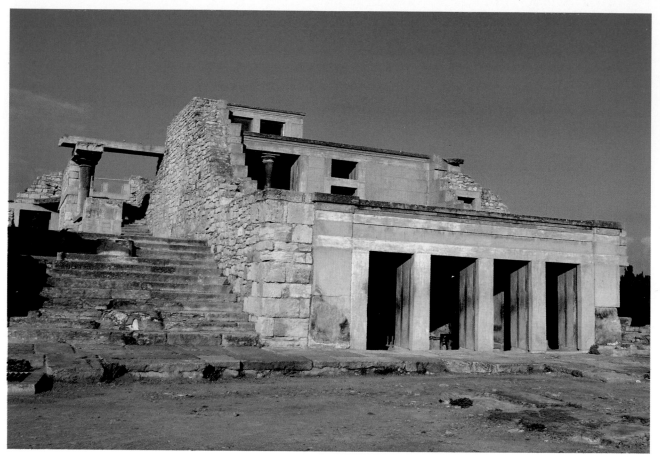

View of the wing containing the throne room from the main courtyard.

The throne room.

Antechamber to the throne room.

corridor, from which we can see from above the small kitchen on the ground floor. To the left of the corridor is a series of **storerooms**, long and narrow, and then a large **vestibule with two columns**, giving access to a **shrine** with two rows of columns. From here one could climb the stairs to the second floor, or descend to the great west court.

By means of a veranda and a series of staircases (on one of which there are copies of frescoes) we go down from the first floor to the ground floor. The **antechamber** (with a limestone basin and a wooden model of a throne) leads into the celebrated **throne room**, with the so-called **throne of Minos**, simple and elegant, standing against the end wall. It was discovered just as we now see it, a potent symbol of authority sculpted in gypsum, flanked by frescoed griffins. The benches along the walls have places for sixteen noble counsellors. Stairs lead down to a small **lustral basin**, probably used for sacred ablutions by the king and his court.

From the throne room we enter the large **central court** where much of the daily activity in a Minoan palace would have gone on. It was probably here that the famous bull-jumping and bull-fighting games took place. There are many rooms leading off this court, including (on the left) a small **tripartite shrine**, with a colonnade, an antechamber leading to the **chamber of the tall *pithos*** (which is still preserved) and the **chamber of the snake goddess**; beside the stairs leading to the upper level we can visit the **bath room** which has a small tub with an arrangement for inflow and outflow of water.

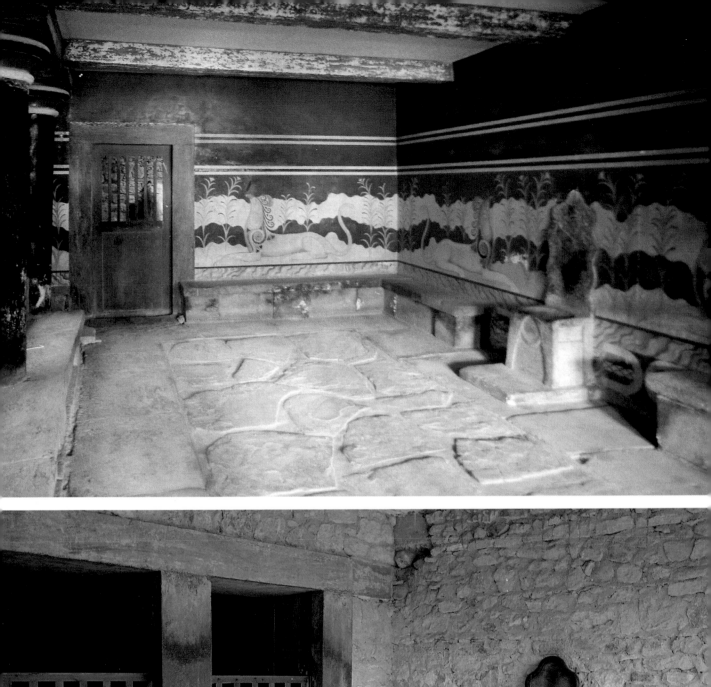
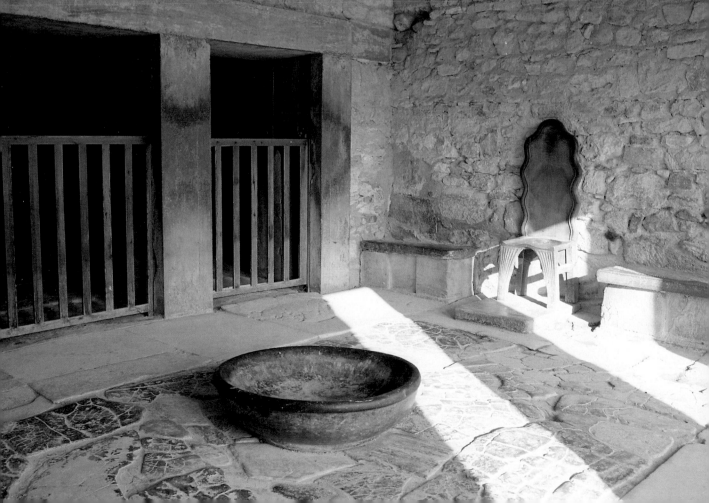

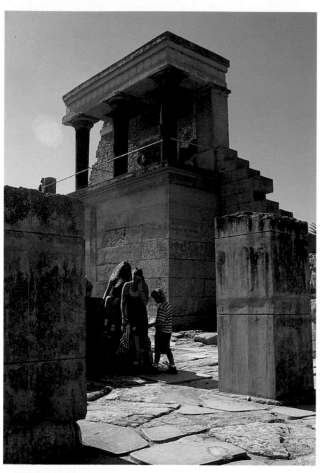

To the west of these rooms we find the famous series of twenty-two **magazines**, with their large partly-buried jars (*pithoi*) for storing the produce of the surrounding countryside. Some of the magazines have cists dug into the floors, so as to make the maximum use of storage space, and there are double axes carved on the walls, indicating that the magazines were controlled by the nearby shrine.

On the south side of the court is the **corridor of the Prince of the Lilies**, with a copy of the fresco now in Iráklion.

Crossing the court eastwards, we reach the **grand staircase** which gave access to the royal apartments. Its five flights are illuminated by a light well, and it was defended by sentinels posted on the verandas flanking the stairs; the verandas were decorated with frescoes, some of which have been reconstructed (the **fresco of the shields**).

North entrance.

Pillars in the hypostyle hall.

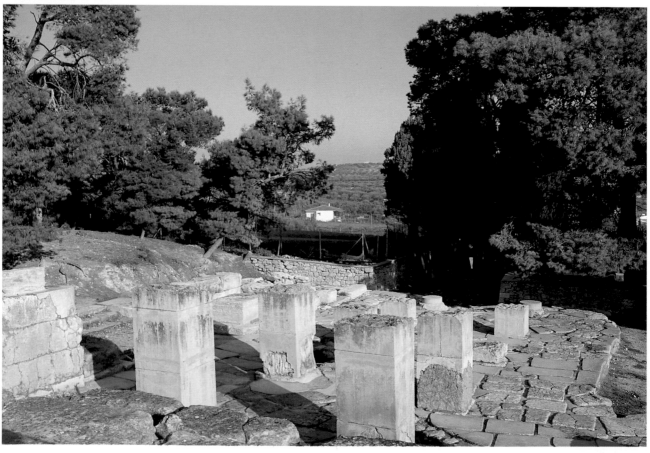

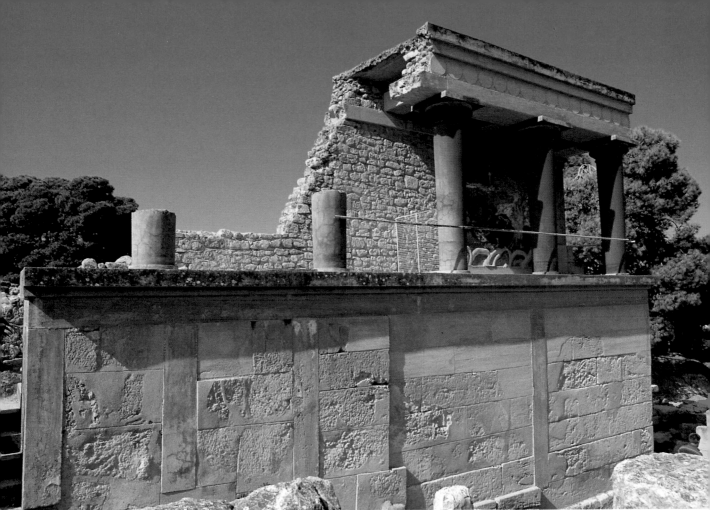

*Part of the colonnaded vestibule along
the north corridor.*

Detail of a restored fresco in situ.

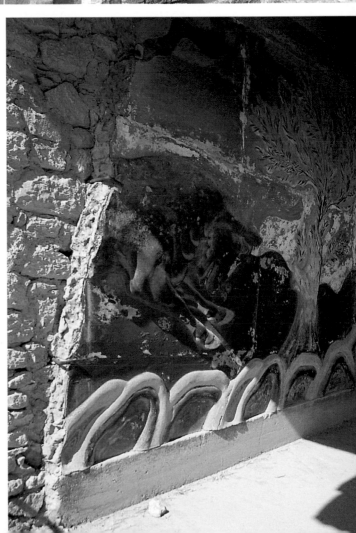

From this area we move to the elaborate and well-preserved **royal quarters**, with the room of the **king's treasure**, the **room of the bench**, the **court of the distaffs**, the **queen's rooms** with her chamber, bath room with a terracotta tub for bathing children (still in place), and the so-called **queen's toilet** with a flushing lavatory, etc. These rooms were all decorated with frescoes, and the floors are of alabaster or stone tiles; the walls and architectural elements are plastered and painted in bright colours. On the same east side, but to the south of the court, is the important **shrine of the double axes**, a religious area later than the rest of the palace, in which were found idols, sacred horns, vases and a table with offerings. From the queen's apartments we pass under the architrave decorated with the *fresco*

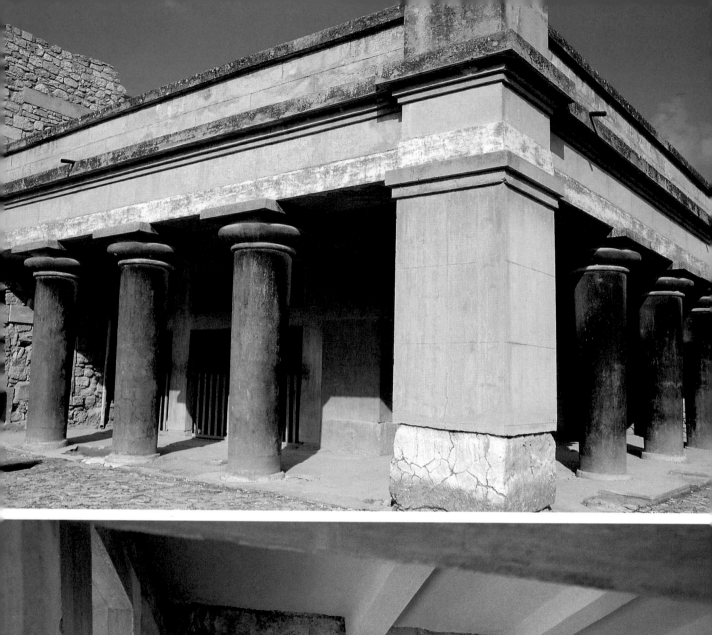

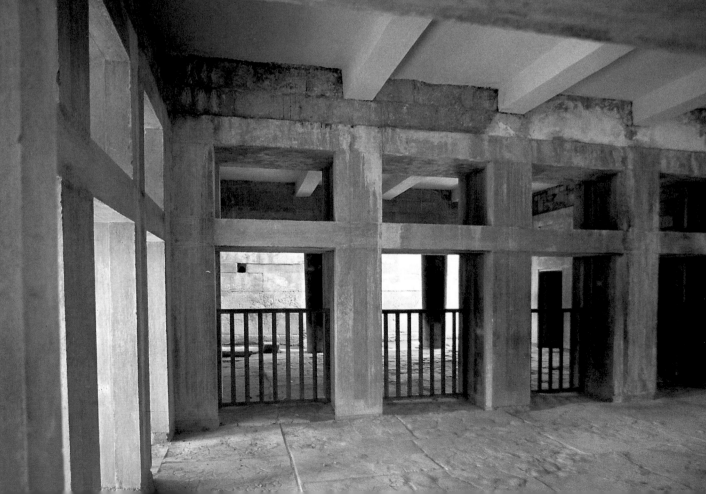

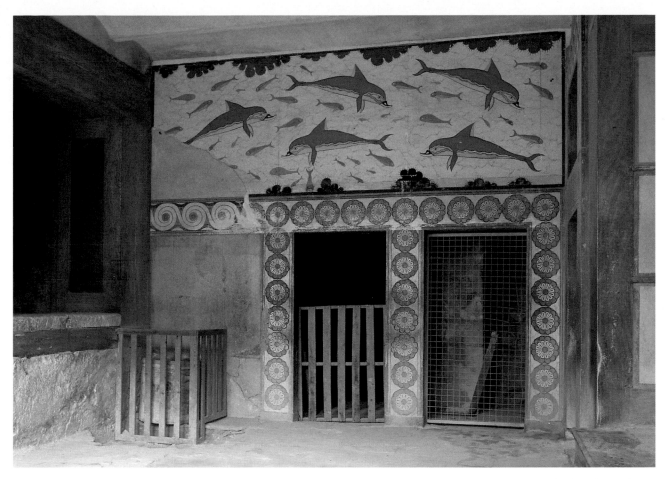

Shrine of the double axes (exterior and detail of interior).

Megaron *of the queen, with dolphin fresco (note the two stages of fresco which are superimposed).*

of the dolphins and reach the **king's *megaron*** (the *megaron* or main room of a house was a large space entered between two columns or pilasters, and was the original architectural nucleus from which the Greek temple developed). The king's *megaron*, entered through the **door of the double axes**, is illuminated by a skylight and has a throne in the middle beneath a baldaquin (protected by glass), on which the king exercised his religious authority: 8-shaped **shields** and **double axes** are carved on the walls. Next to the megaron are the rooms of the royal apartments and some magazines, probably for storing precious objects.

Taking the long **corridor of the draught-board** we come to the **domestic quarters**, a series of narrow rooms intended for servants but also used as workshops and storerooms. We can recognise the **jeweller's workshop**, where precious stones were cut and set for the king, and where the delicate work of cutting his personal and official seals was carried

out. We can also visit the **potter's workshop**, the **court of the workshops**, and the **magazine of the giant *pithoi***, a small room containing four enormous jars dating from the time of the first palaces.

From the magazine of the giant *pithoi* a staircase descends to the **east bastion**, built to protect the valley and to control the road on that side (note the arrangement of the drains).

To the north of the court is the north wing of the palace, consisting of **servants' apartments**, and of a long **ramp** linking the central court with the road leading to the port. This ramp, called the **north entrance passage**, is flanked by bastions with verandas (one has a stucco relief of a bull, a copy of the original now in the museum in Iráklion) and leads into a **large hypostyle hall**, with eleven pillars. From here the road to the port is reached through a propylæum.

At the north-west corner of the palace a **lustral bath** (similar to the one in the throne room) was discov-

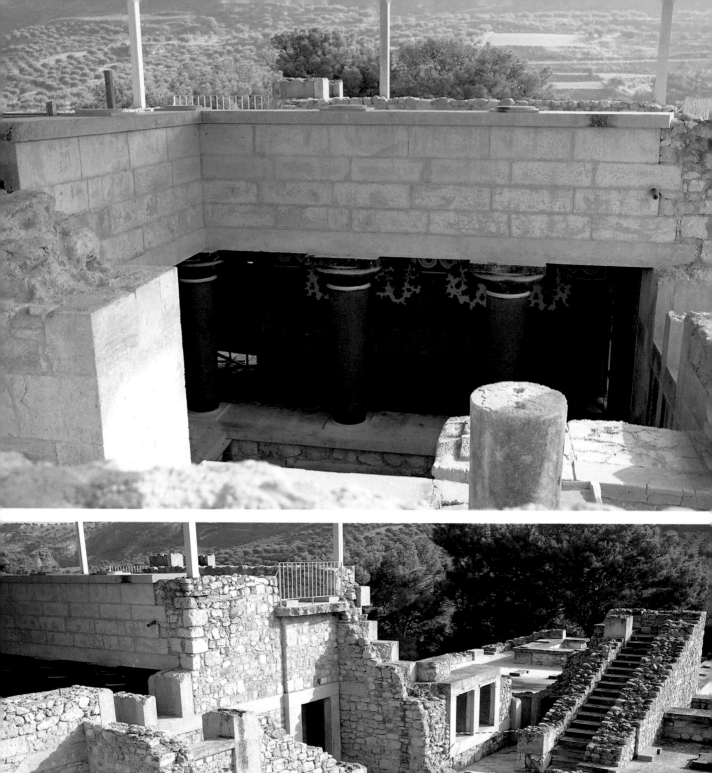
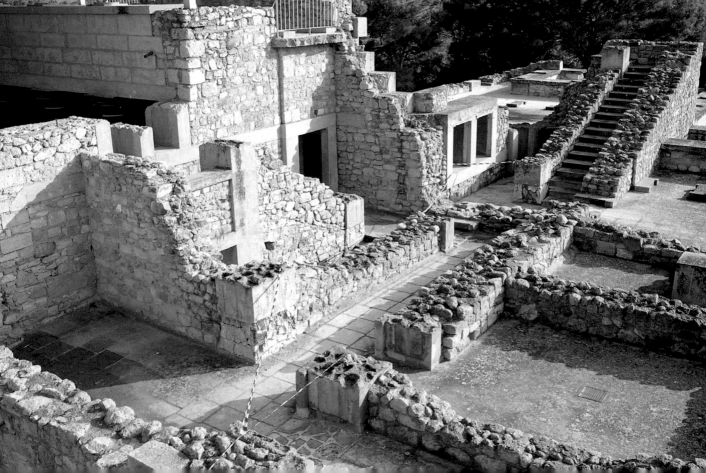

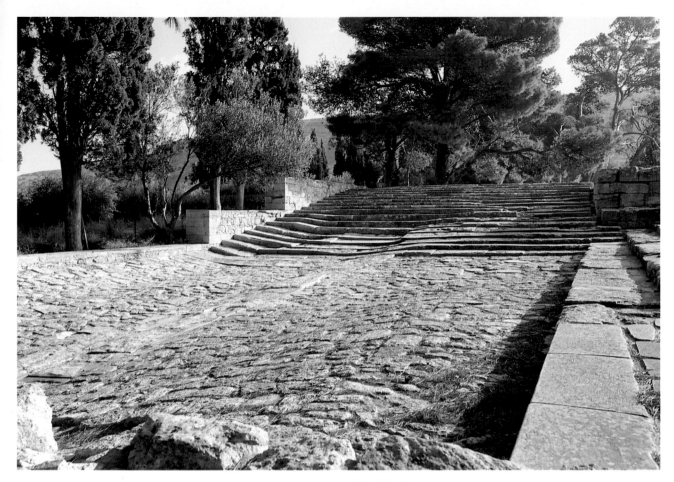

The theatre.

View of the main colonnaded stairway on the Piano Nobile.

The Piano Nobile: the queen's apartments.

Raised walk in the theatre area.

ered and reconstructed from original pieces: a large area with, to one side, a small room for ablutions at a lower level, reached by steps and having a well light surrounded by columns.

Near the palace a number of dwellings were discovered, such as the **house of the sacrificed oxen**, the **house of the fallen blocks** and the **house of the high priest**, partly reconstructed, which were certainly owned by palace officials, as also were the so-called **caravanserai**, an enormous building with a hall decorated with frescoes, and the **little palace**, the second-largest building in *Knossos*.

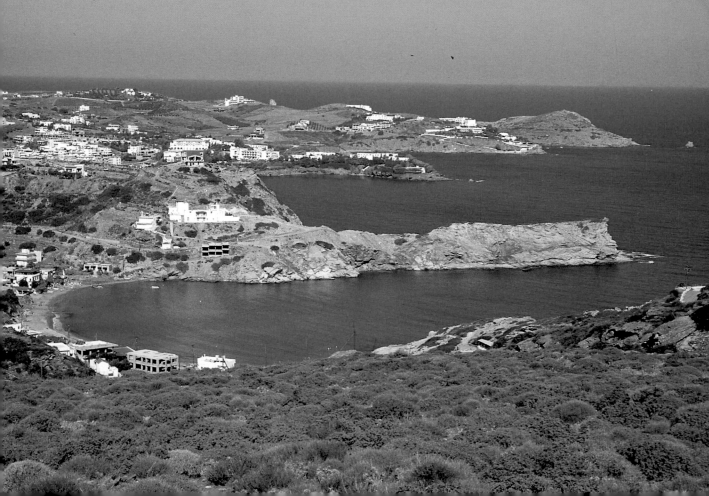

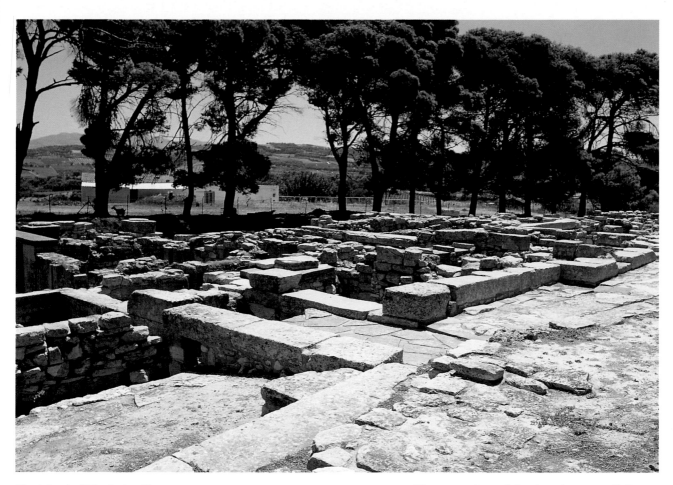

The island of Dia, facing Knossos.

The excavations of the three houses at Tylissos.

The beach of Ayía Pelaghía, 13 km south-west of Iráklion.

TYLISSOS

Next to the remains of some modest dwellings of the Early Minoan period (2800-2200/2000 B.C.), Greek archaeologists excavated between 1909 and 1913 three luxurious villas in a village to the west of Iráklion which still keeps its ancient name, Tylissos, identified as the *Tu-ri-so* recorded in the inscriptions on clay tablets. In Greek times the city was allied to *Knossos*, of which its inhabitants were probably vassals; in 450 B.C. a treaty was signed between the two cities, mediated by the powerful Peloponnese city of Argos.

The three large villas, cooled by breezes from Mt Ida, were contemporary with the second palace and flourished between 1800 B.C. and about 1450 B.C., when they were destroyed. Later they were rebuilt, but the new buildings were dismantled in Greek times.

House A, the central of the three villas, is a typical example of a Minoan residence of a certain level, with at least two storeys. The main entrance, indicated by two pillars and a deep L-shaped portico, led into the south part with the residential quarters, including a hall paved with alabaster; inside are two raised platforms, the exact purpose of which is unclear, and the usual light well (a skylight surrounded by three columns). What is probably a bath room is reached from the south side of the same room; there are traces of plumbing arrangements. On the north side there is a lustral basin. The large room with a central pillar was the shrine of the villa, within which was found a pyramidal base for the double axe symbol; it is surrounded by magazines and servants' quarters. In the room with a window opening onto the skylight three gigantic bronze cauldrons were found. The adjacent rooms were bed chambers. To the north there are large magazines

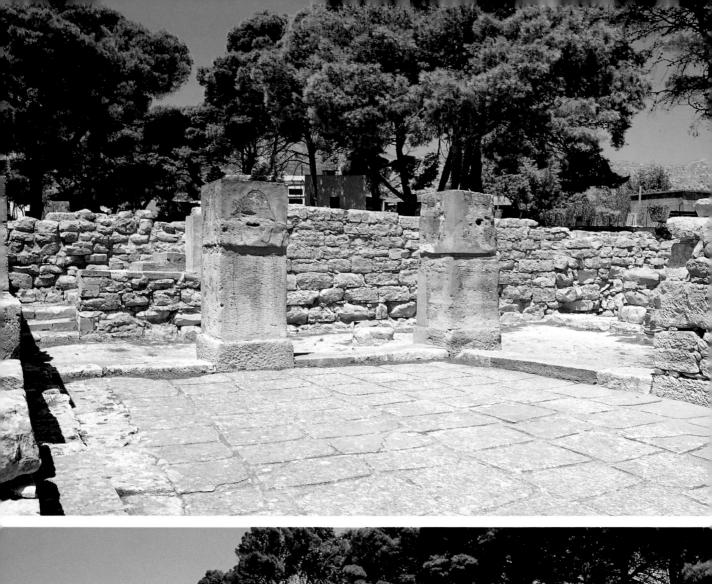

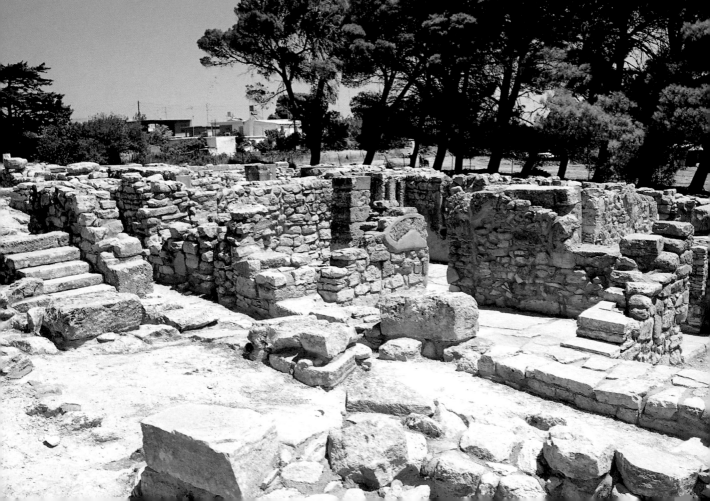

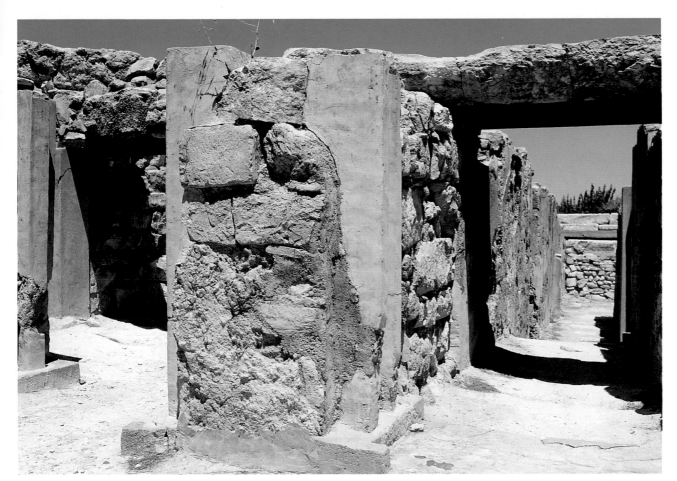

The residential quarters of House A.

Detail of a magazine (House A) showing pithoi.

with jars (*pithoi*), each with two supporting pillars; above these there was once a large banqueting hall. **House B**, immediately to the west is the smallest and less well preserved, and has a main room, a paved area and a staircase which led to the upper floor. It has a rectangular plan, more regular than the other two villas.

House C, to the north-east, is, on the other hand, well preserved: groups of rooms, linked by an intricate system of corridors, form jutting wings. To the north is the main room in the residential part, divided by pillars and with a skylight surrounded by columns and a large window, near a lustral basin; to the south, the room with a central pillar was devoted to cult. There is also a cistern, a bath room and some magazines. The upper floor was used at night time.

Monastery of Paliani: the church and the
small doorway with frescoes.

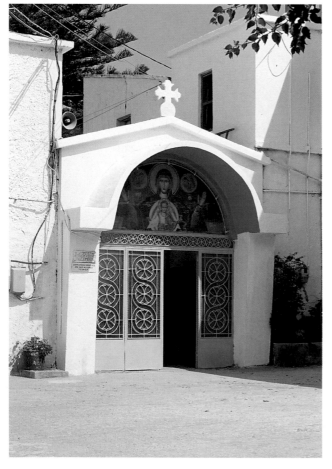

MONASTERY OF PALIANI

Near *Venerato* in central Crete, half way along the
road which leads from Iráklion to the fertile plain of
Mésara, stands the Monastery of Paliani, isolated on
a hill. The monastic complex at one time belonged
to the Patriarch of Constantinople, and remained
under his direct jurisdiction at least until the four-
teenth century.

Now home of an order of nuns, the little Monastery
is grouped around the church, which is in Byzantine
style but shows the influence of Renaissance Venice
(note the Venetian-style bell-tower, decorated with
brickwork in the Byzantine manner).

To the side is a small gateway decorated with fres-
coes, leading to the nuns' cells. The nuns weave and
embroider in the traditional way, and offer their
handiwork for sale.

MONASTERY OF VRONTISSION

Also in the central-south part of the island, between the modern villages of *Zarós* and *Vorizia*, in the district of Iráklion, stands the Monastery of Vrontission (or of Vrondìsi, according to the modern local pronunciation). From here there is a superb view over the principal plain of southern Crete, the *Mésara*. Founded in the fourteenth century, the Monastery became a centre for religious education under the Venetian occupation. There is a small church with two apses and an impressive square belfry, decorated inside with frescoes attributed to fourteenth-century artists. Outside the entrance to the monastery is one of the loveliest Venetian fountains on the island, dating from the fifteenth century and carved with the figures of Adam and Eve, and personifications of the four rivers of Paradise.

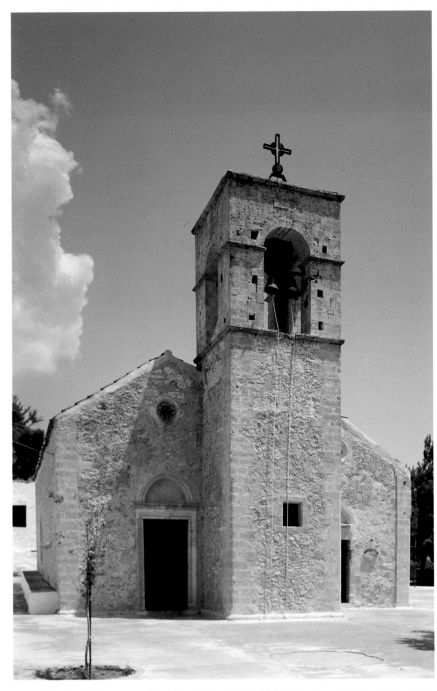

Monastery of Vrontission: views of the church, the two small apses and the Venetian fountain.

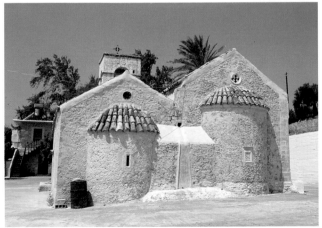

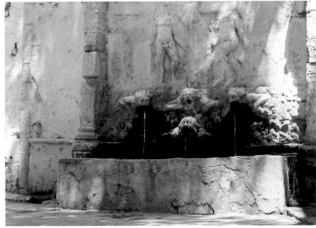

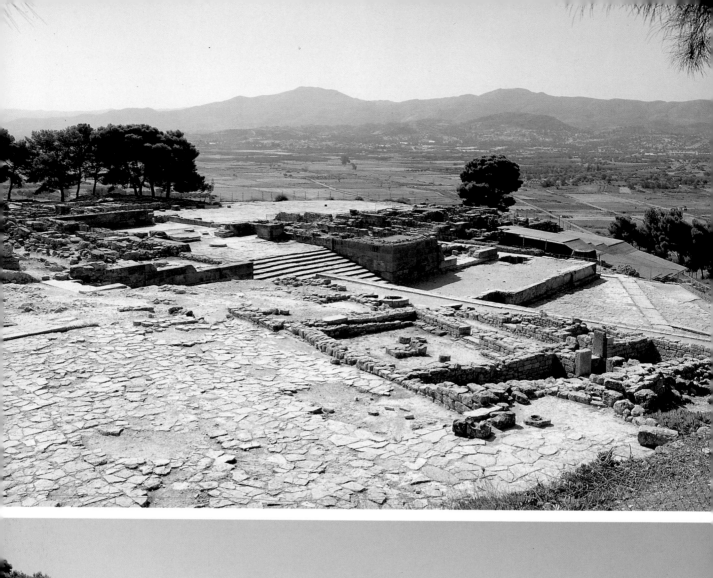
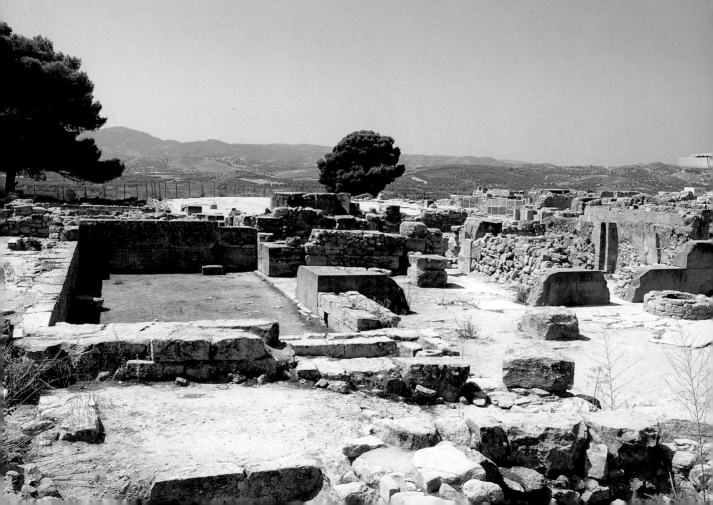

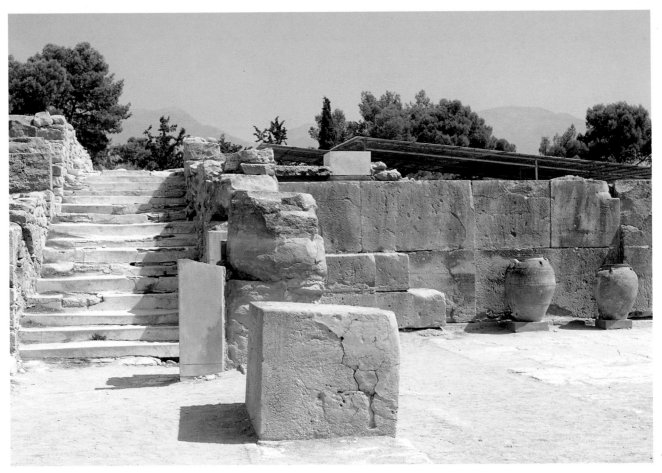

The Palace of Phaistos with the staircase leading to the great propylæum; in the foreground the remains of Hellenistic-Roman dwellings.

Room of the two columns and adjoining staircase; to the right, corner of the centre courtyard with pithoi.

View of the quarters to the east of the central courtyard.

THE PALACE OF PHAISTOS

Built on a plateau overlooking the surrounding valley and structured on various levels connected by stairs and passages, the Palace of *Phaistos* (the second-largest of Minoan Crete) was excavated at the beginning of the century by the Italian School of Archaeology. Since 1952 Doro Levi, the Director of the School, has made further excavations.

The palace was built in the Middle Minoan period (2000-1650 B.C.) and was destroyed by the disastrous earthquake that shook the whole island. It was rebuilt between the end of Middle and the beginning of the Late Minoan period, i.e. between 1650 and 1400 B.C., with the same centralised plan as the Palace of Knossos, though perhaps a little more regular. The ruins of the second palace are the more important and the better preserved.

Having passed through the entrance court, where traces of Hellenistic and Roman dwellings are still visible (though unfortunately mostly removed to reveal the Minoan remains), we come to the **theatre area**, in the **west court**, with eight tiers attached to the adjacent palace. To the left the courtyard is flanked by a wall of limestone slabs, which conceals a **sacred edifice** with benches in gypsum for idols and ritual objects. Above, the great **propylæum** is reached by an imposing **staircase**; from it we descend by another staircase to the **central court**, surrounded by a colonnade with many rooms leading off it, including the large **room of the two columns**, a **crypt** with two pillars, and a **lustral basin**. The room of the two columns has elegant gypsum slabs typical of Minoan architecture. The adjacent magazines have an ingenious system for collecting oil poured out of the jars. From the room of the two columns we pass to the large **room of the ceremonies**, a kind of *megaron* (the main room of a place and the seed of the future Greek temple) which leads to the monumental stairs of the propy-

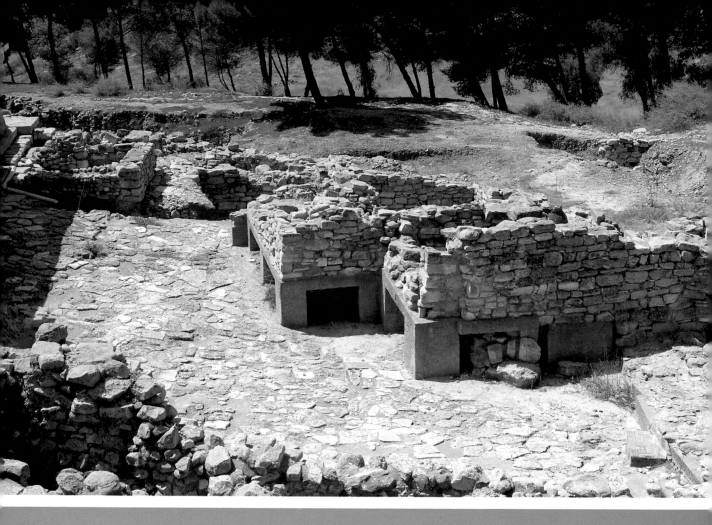
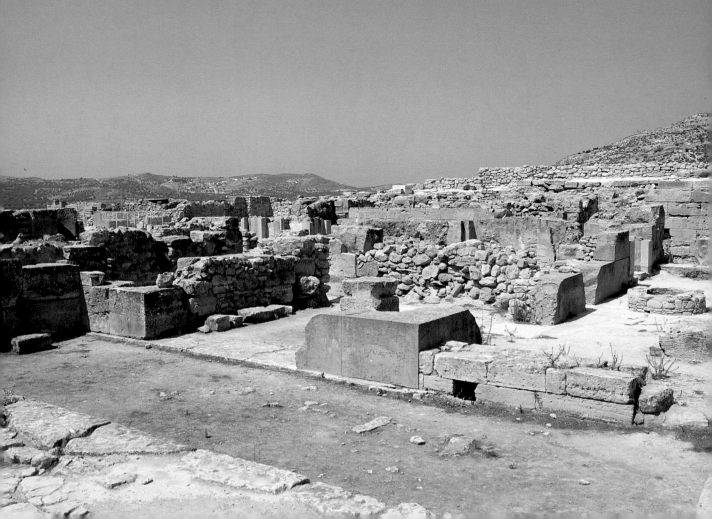

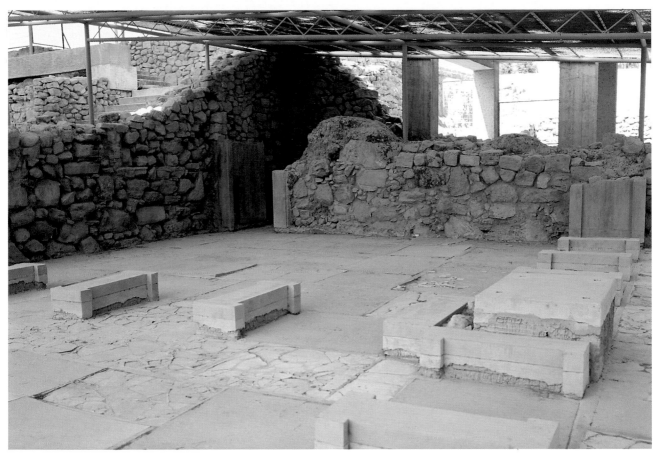

The king's Megaron (under protective roof).

View of the northern quarters.

Rooms in the princes' quarters.

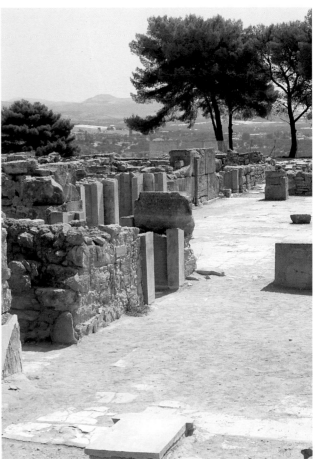

læum. Further on, on the same side, is the **hypostyle** (with a colonnade), in the middle of the royal quarters and surrounded by the apartments of the king and queen, each with its *megaron*. In this part of the palace there are elaborate bathing facilities with **bathtubs** and conduits, pavements of gypsum slabs, and colonnaded **skylights** that let in refreshing breezes as well as natural light. In the west area, beyond the central courtyard, are what were probably the **princes' apartments**, where we can recognise a central courtyard flanked by porticoes on two sides. In the whole area, but especially at the west end of the palace, almost opposite the theatre, it is possible to distinguish the underlying remains of the first palace with its magazines, and also a part of the stratigraphy which induced Doro Levi slightly to modify Arthur Evans's chronology.

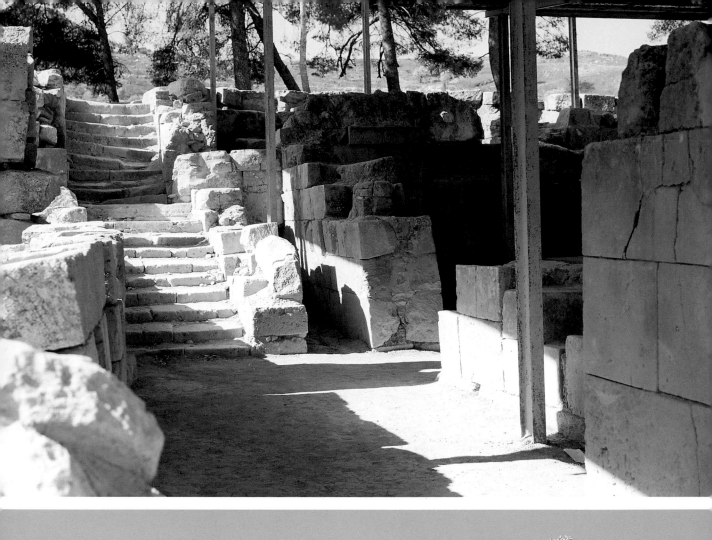

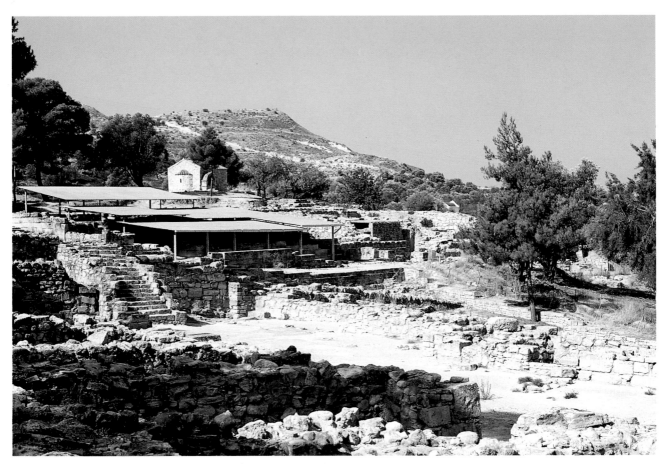

Villa of Ayía Triádha: entrance stairway with slate pavement.

View of the excavations with the church of Ayios Yeóryios Galatas.

Byzantine church of Ayios Yeóryios Galatas.

VILLA OF AYÍA TRIADHA

On a little hill overlooking the plain of *Mésara*, not far from the great Palace of Phaistos, stands the Minoan villa of Ayía Triádha, a small palace surrounded by a village. The villa's proximity to Phaistos suggests that it was the residence of one of the king's vassals or relations.

It was discovered by the Italian archaeologist Luigi Pernier and excavated at the beginning of the century (the Italian School of Archaeology is still conducting excavations there). The villa stands near the Byzantine church of **Ayios Yeóryios Galatas**, with apse and external side chapels, built in the fourteenth century. Its single nave has beautiful frescoed decoration. The complex of Ayía Triádha has an L-shaped plan, one arm of which is a large open space flanked on one side by a regular series of magazines with a portico in front, and on the other by the modest village dwellings; the other arm is formed by the palace itself, built at the same time as the second palace of Phaistos and destroyed in the same period. The large space of the **"rampa del mare"**, with a **portico** at the end, flanks the perimeter **wall** of the villa (with its typically Minoan indentations), reached by a **staircase** and a **paved road**. Along this road there is a magazine and the ruins of a Minoan **temple** (circa 1550 B.C.), destroyed together with the villa but rebuilt and used in later centuries (in Mycenæan times). The large roughly triangular area nearby is the **court of the altars**, where sacrifices were certainly performed, opposite which are the ruins of an impressive

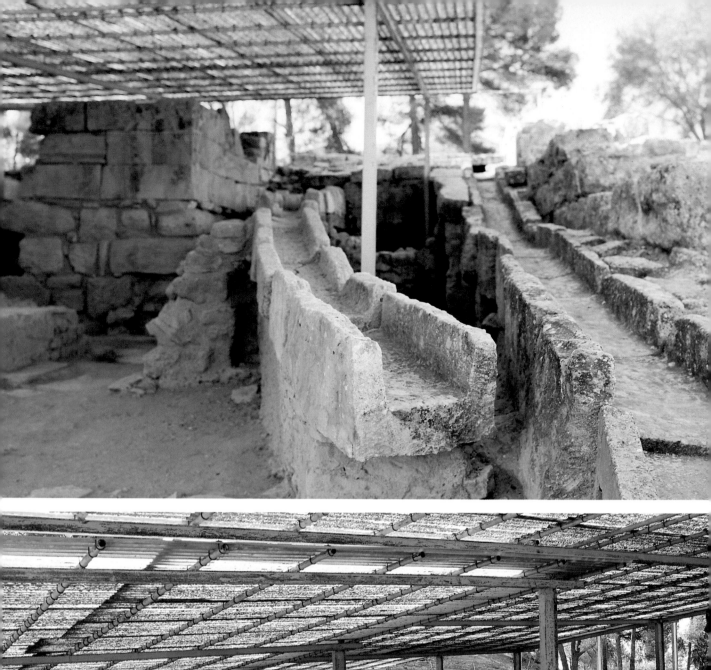

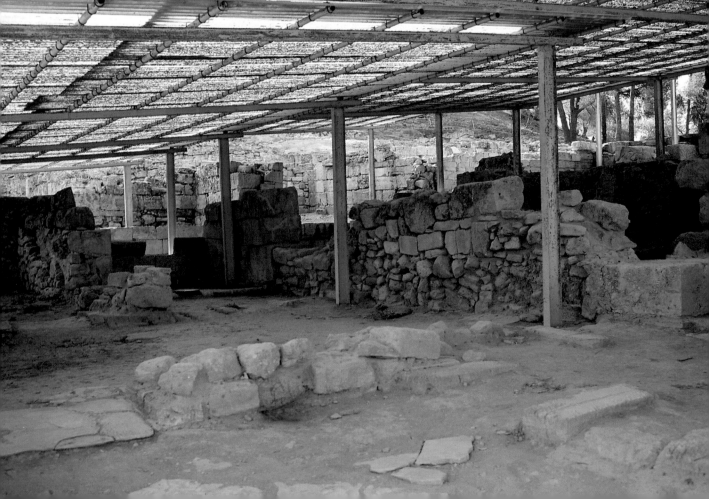

Residential quarters in the
central area of the villa of Ayía Triádha.

Mátala: the rock containing the necropolis.

Mátala: the rock containing the necropolis.

Mycenæan *megaron*. With its tripartite structure the *megaron* anticipates the form of the Greek temple, but it also had a **loggia** which gave onto the courtyard.

Beyond the *megaron* stretched the west wing of the palace, equipped in later times with a **staircase** backing onto the façade but also accessible by means of a short flight of **steps** with a well preserved **door** (partially restored), through which we reach a **courtyard** with a **fountain**; the stone basin once had a water-jet. The courtyard is flanked on two sides by a small portico with columns leading into a room with frescoes (now in Iráklion), and then into a larger one paved with slate and having a gypsum seat. After a portico and some poorly preserved rooms we come to a **chamber** (today protected by roofing) the walls of which are covered with gypsum slabs which seem to anticipate the metopes and triglyphs of classical Greek architecture. At the end of the terrace, on the west side, there is a small group of **service rooms**, with cellars, magazines and kitchens, one of which has an oven.

MATALA

The picturesque fishing port of *Mátala*, on the south coast of the island, is near the ancient site of ***Kommos***, the Minoan port of *Phaistos* and of Greek *Gortyn*, where the Canadian School has been excavating for years and has discovered a small but important Minoan and Mycenæan residence, which seems to have lasted into Greek times. Mátala is separated from *Kommos* by an attractive sandstone rock into whose geological strata a great number of small **tombs** have been cut, some with carved arched niches. These tombs formed a necropolis in Roman and early-Christian times, part of which is now underwater with the rise in the level of the sea. According to Homer, who describes Mátala accurately, Menelaus was shipwrecked on this coast as he was returning to Sparta from Troy. The strength of the currents which hinder navigation in these seas is attested by the wrecks of Imperial Roman ships (first to fourth century A.D.), sunk with their cargoes of wine and oil jars, and recently located in the bay.

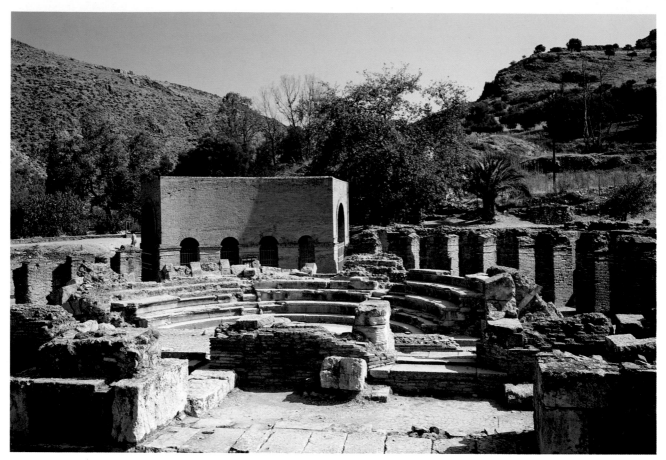

Above and top right: Gortyn, view of the odeion *with a modern roof over the "queen of inscriptions".*

Basilica of Ayios Titos: the remains of the nave.

The "queen of inscriptions", the famous codex of laws inscribed in Doric dialect on blocks of stone used to build the odeion *at Gortyn.*

GORTYN

Excavated by the Italian School, *Gortyn* was an important centre both in archaic Greek times (as a rival to Knossos) and more especially in the Roman period, when having been forgiven for sheltering Hannibal it was made the capital of the province of Crete and Cyrenaica (Libya). The excavations really are worth visiting, particularly the large *odeion* which was a hall for musical performances with walls made out of the blocks from some public building of the sixth century B.C., one of which is carved with the **"queen of inscriptions"**, a code of laws still perfectly preserved. Nearby are the remains of the impressive church of **Ayios Titos**, an early-Christian basilica of the seventh century. The large surrounding area of the Roman provincial capital (and the later Byzantine additions) is still being excavated, with its aqueducts and hundreds of fountains, **praetorium**, colonnaded roads, paved squares, nymphaeum and baths, **temples** to Egyptian deities and to Pythian Apollo, gates and an amphitheatre. On the high **acropolis** we find a theatre, the foundations of an archaic temple, and some large Roman cisterns.

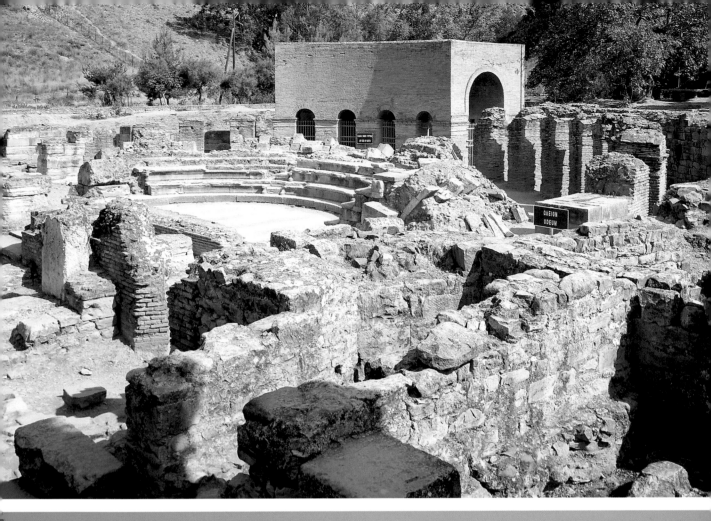

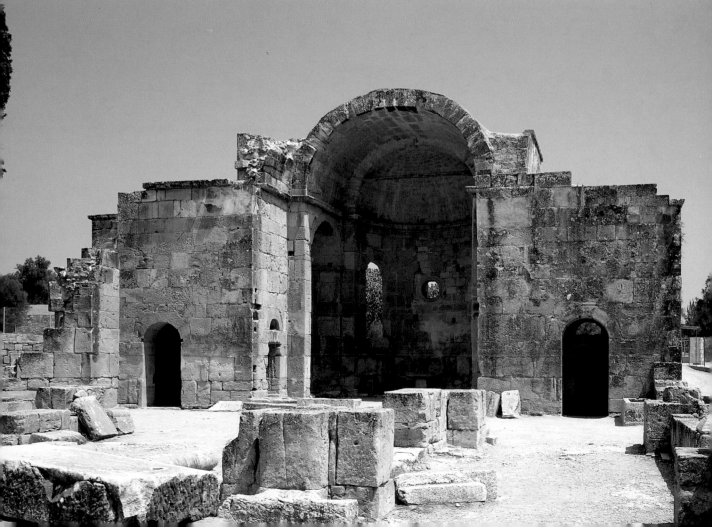

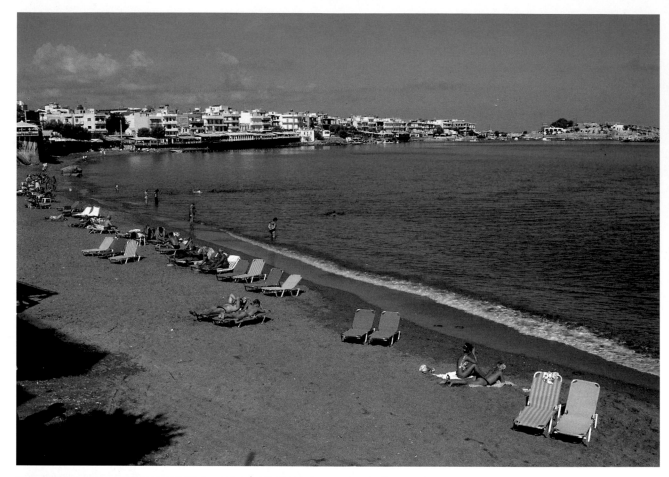

Limín Khersonísou: views of the coast, the port and the beaches.

LIMIN KHERSONISOU

On the north coast of Crete, on the western side of the gulf of Mallia, lies the picturesque bathing resort of *Limín Khersonísou* ("the beach of the peninsula"), which stands on the site of the ancient port of *Lyttos*, a powerful Greek city mentioned by Aristotle, the bitter enemy and deadly rival of nearby *Knossos*. The modern town is well equipped with tourist facilities (hotels, thermal baths, a very busy harbour) and attracts many visitors with its pleasant climate and beaches in use for many months of the year.

The Imperial Roman walls were rebuilt in Byzantine times. The remains of an early-Christian basilica of the sixth century have been discovered on a little promontory. Its apse and part of the outer wall can still be seen, but most of it lies beneath the later church of **Ayios Nikólaos**, built in the Byzantine style between the seventeenth and eighteenth century, with some mosaics still visible in the narthex and nave.

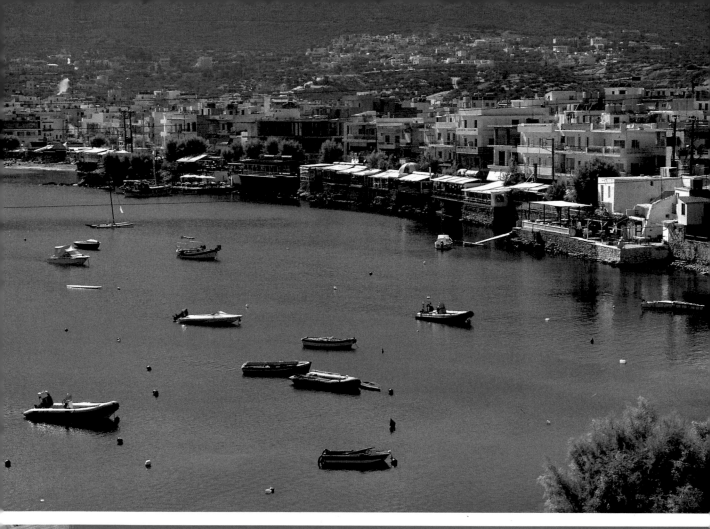

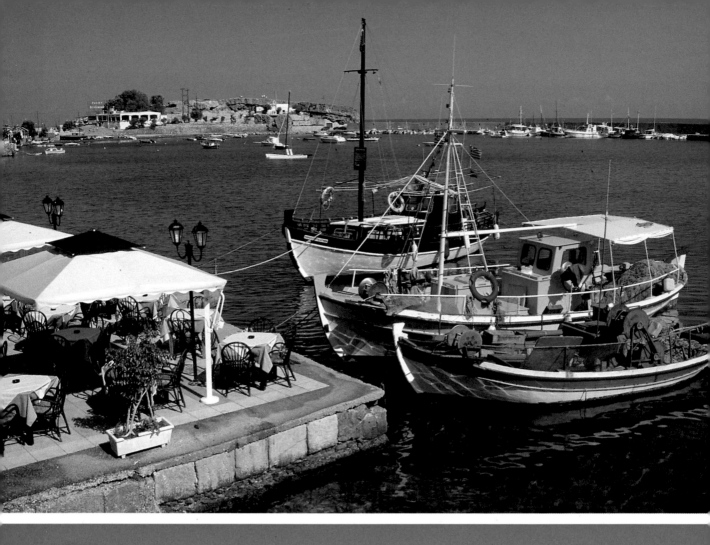

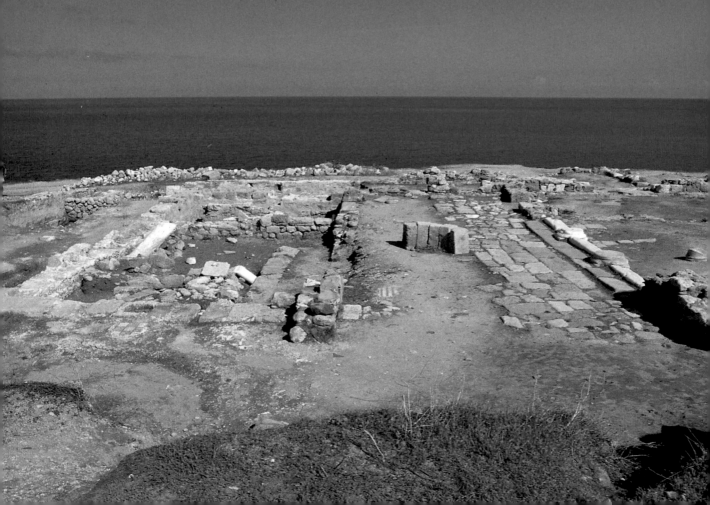

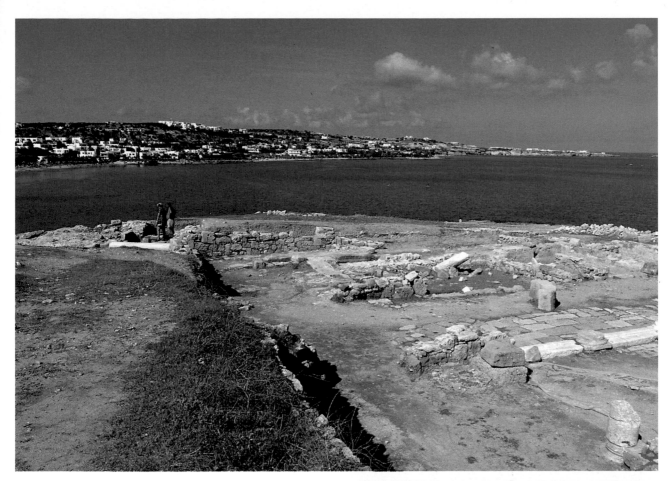

Remains of the large early-Christian basilica.

The modern port of Chersonesos, whose waters conceal the impressive Roman port with its moles and harbour facilities.

BASILICA OF CHERSONESOS

In the area of *Kastri*, on a promontory parallel to the one with the church of Ayios Nikólaos, recent excavations by Greek archaeologists have revealed the remains of another early-Christian basilica, dating from the seventh century. Only the base of the walls and a few columns remain *in situ*, but the plan with a nave and two aisles can clearly be seen, indicating a building of considerable size. The rich pavement mosaics at present being excavated attest the importance of the church and of the diocese of Chersonesos, founded by St Paul's disciple Titus.

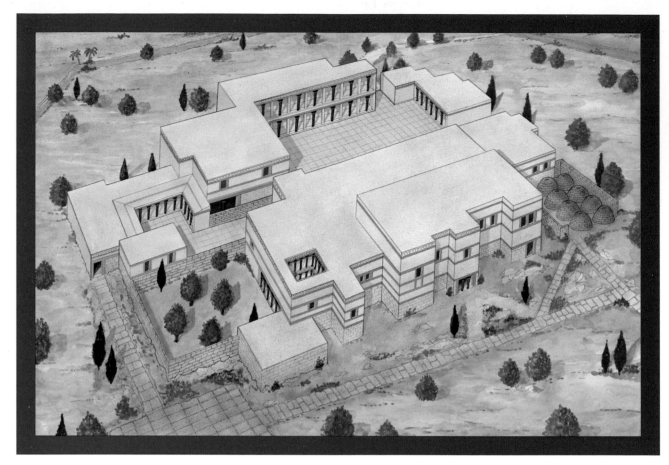

Reconstruction of the Palace of Mallia.

PALACE OF MALLIA

The palace of Mallia is the third-largest of the Minoan palaces and is considered the most "provincial" from the architectural point of view. It covered about 7500 square metres, equal to three and a half acres. It stood on the north coast of the island, in the gulf of the same name; we cannot be certain what it was called in antiquity, because the community which lived there no longer existed in Greek times, but its name may have been *Milatos*. It was excavated in the early part of this century by Greek archaeologists, and between the two world wars by the French School of Archaeology.

The site was inhabited in the Neolithic and early Minoan period (6000-2000 B.C.), but very little trace remains, just as there is little trace of occupation after the destruction of the palace in about 1450 B.C.

The palace was completely lacking in fortifications, but was surrounded by dwellings (only partly explored) and had a harbour. The plan of the first palace dates from the middle Minoan period (2000-1800 B.C.). Its buildings were destroyed by a severe earthquake which devastated the island in about 1700 B.C., and a second palace was built which unlike those of *Knossos* and *Phaistos* respected the original plan (at least in general outline), so that few changes were made.

We approach the entrance from the large **west court**, paved with slabs of blue limestone and crossed by pathways of *ammuda*, a local stone. A well preserved **pathway** leads to the north wing of the palace; the **entrance vestibule** gave onto a **portico with three wings**, beneath which were various **magazines** and which flanked a small **internal courtyard**; opening of this were a **deposit for archives**, a **treasury** and a narrow corridor leading to the **royal apartments**.

In the sovereigns' quarters is the **queen's *megaron***, communicating with the **king's *megaron***; between the two is a **bathroom**, reached through a columned vestibule.

The architecture of the palace is arranged, according to the usual Minoan system, around a large **central court**, at one time flanked on two sides (north and

east) with colonnades. The west side was composed of **sanctuaries** and **official buildings**, including the **royal loggia**, the **vestibule of the crypt** with pillars, stairs which led to the upper floors, a **monumental staircase**, and a *kérnos* or round table for offerings, having little cavities around the edge for the votive gifts, probably first-fruits, standing on a base. From the pillar crypt we reach two rows of **magazines**, the area of the palace's economic activities, which culminated in the eight enormous circular *silos* discovered in the south-west corner of the palace. At the east side of the central court, with a pillared portico, was the palace's eastern entrance, near which were the rooms of the **royal treasury**. On the same side was a row of **magazines**, narrow cells leading off a communal corridor and occupied by *pithoi* (jars) standing on bases, with an arrangement for gathering liquids (channels and vases for oil and wine). Further on, on the same side, were the kitchens.

On the north side the great court ends in a **portico** with cylindrical columns. To the right was a staircase which is today only partially preserved, and above was a large **hypostyle** with two rows of three columns.

Having completed our visit to the palace itself, we should spend a few minutes in the important **hypostyle crypt**, discovered during the recent excavations and today protected from the weather by a large modern roof. The large underground room, whose ceiling was supported by columns, has been identified as a counsel chamber for the political deliberations of the lords of Mallia, separate from the dwelling quarters and the official buildings. Surrounded by annexes, this room was built at the time of the first palace but with a different orientation. It is a forebear of the classical Greek prytaneion, which had a similar function.

The crypt was connected to a rectangular courtyard, known as the **court of the orthostats** on account of the vertically positioned blocks ("orthostats") which formed the base of the elevation. Bordered by porti-

Palace of Mallia: the monumental stairway in the large central courtyard.

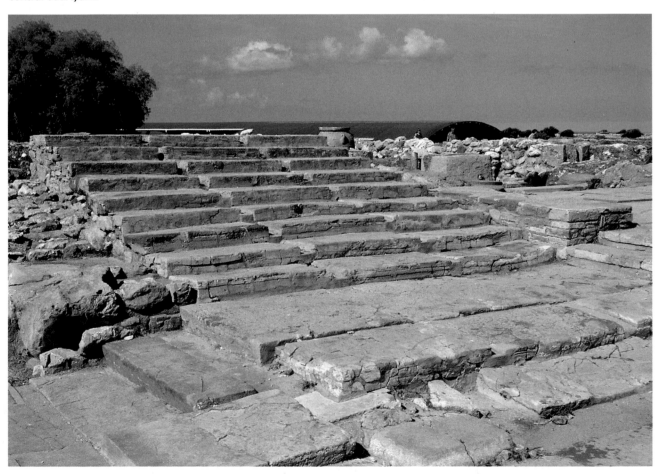

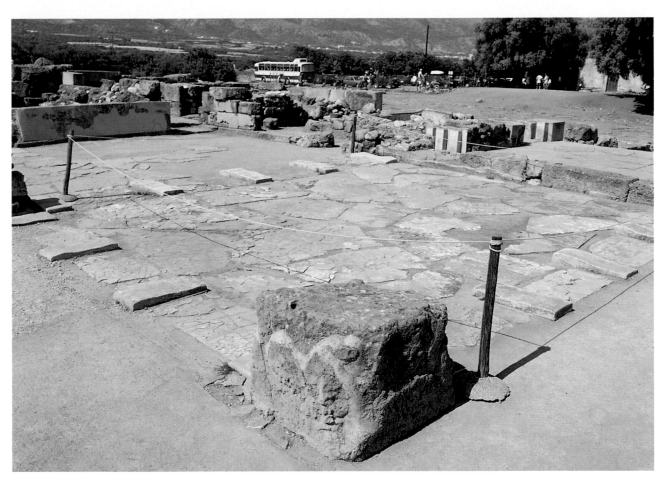

The king's Megaron.

Residential quarters in the central courtyard.

The south-west magazine silos.

The large stone kernos, *used in fertility rites.*

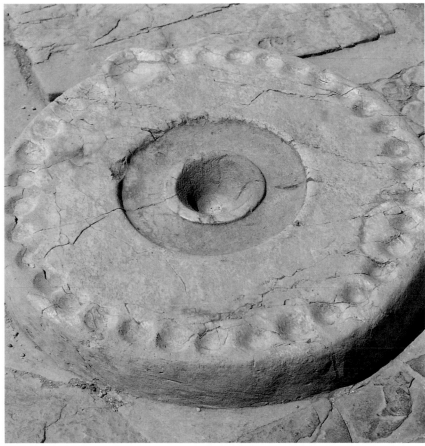

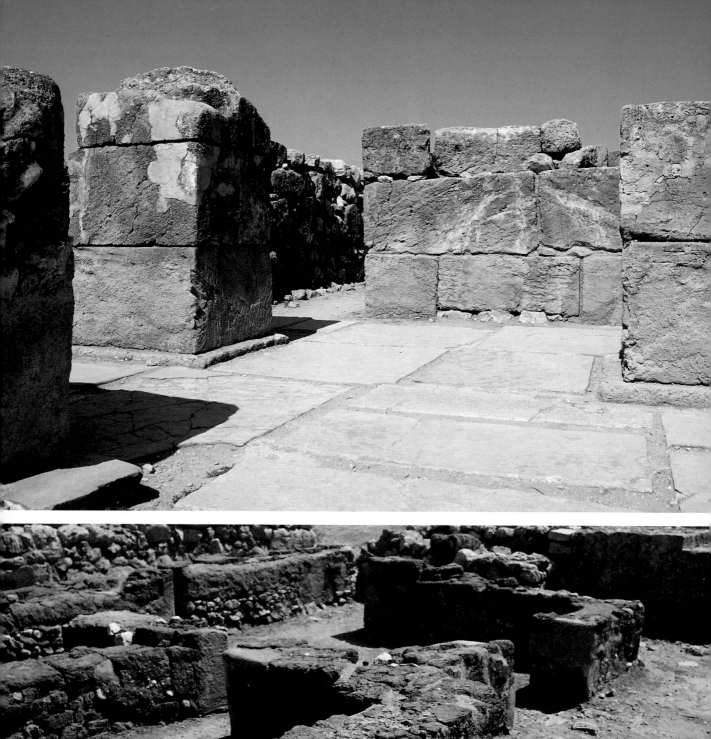

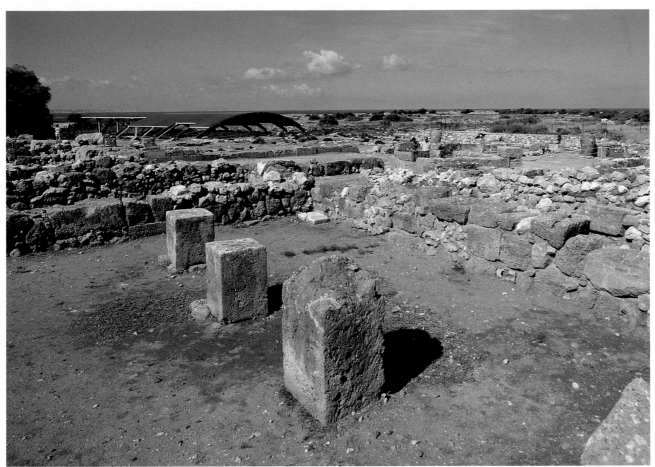

The hypostyle on the north side of the central court.

View of a room, with enormous pillars,
paved in gypsum and alabaster.

Rooms in the north-east area.

A pithos *(a jar for storing oil, wine, grain and other
food products)* with relief decoration.

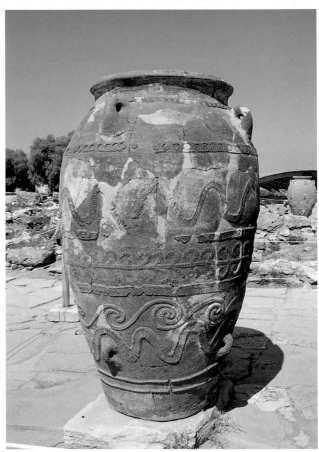

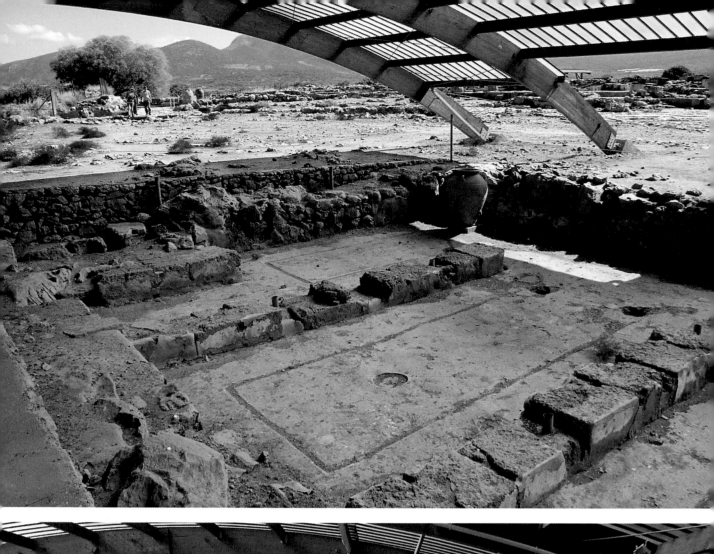
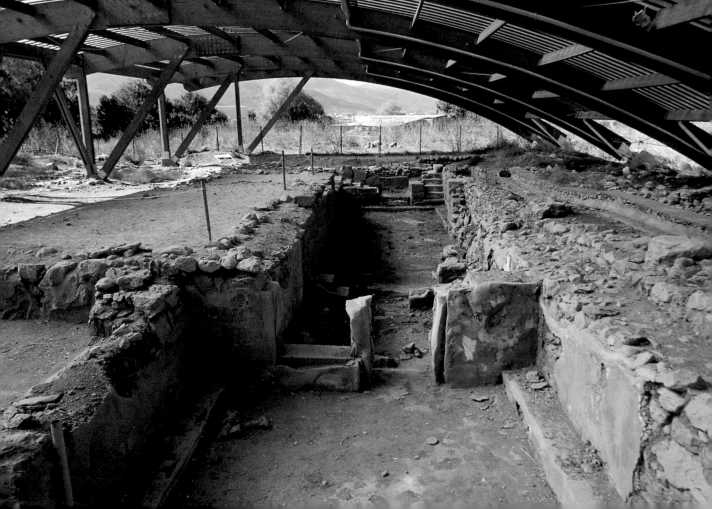

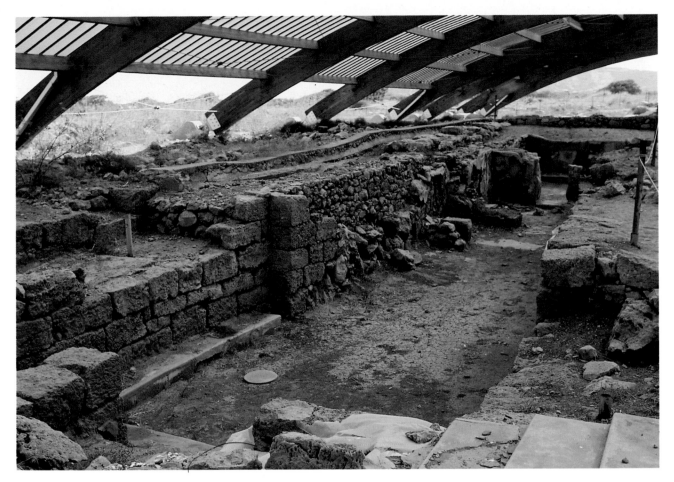

*The enormous hypostyle crypt under
a protective roof.*

coes and connected by a pathway to the necropolis, the courtyard has been interpreted as an arena or as an ancestor of the *agora*, the mercantile square of classical Greece. The entire complex was provided with a kind of monumental propylæum, a door (called the **door of the magazines**) which led into the courtyard. Even bigger than the courtyard of the palace itself, the courtyard of the orthostats was bordered on its west side by a colonnaded portico. In the north-east corner there is a pillar, part of the **monumental door** which led to the **necropolis**.

The necropolis was about 500 metres north of the palace, in the area known as *Khrysolakkos* ("Pit of Gold", evidently referring to the precious objects which farmers used to find there). It was a royal burial enclosure, certainly belonging to the lords of Mallia, surrounded on all four sides by levelled areas and perhaps by porticoes (at least on the east side). The enclosure was divided by small walls separating the tombs, covered with wide slabs of stone. From the archaeological evidence it appears that the tombs were the original nucleus, later enclosed by the sacred precinct, perhaps at the end of the middle Minoan period (1580-1500 B.C.).

The cult of the dead took place around a sacred hearth, placed in the centre of the area, and in the funerary chambers along the east side of the enclosure, rooms dedicated to the cult of the Great Goddess, as is shown by the discovery of idols representing her.

Also to the north of the palace, following the pathway leading out of the northern entrance, we come to some **dwelling quarters** of the type which gravitated around palaces. One of the houses has been restored, and the door opens onto a paved vestibule leading to a corridor which divides the house into two areas, the service rooms and magazines on one hand and on the other the main room with its annexed bath room reached by a stair.

Beyond, a public building with skylights, portico and megaron is organised around a large **lustral hall** dug out of the ground. Another **public building**, on the west side, has a complex of rooms, also dug out of the ground, and remarkably well preserved walls. It must have been of a certain importance since valuable objects were found there, including stone vases worked in relief and a dagger with a golden handle.

Milatos: shrine inside the grotto with natural geological formations.

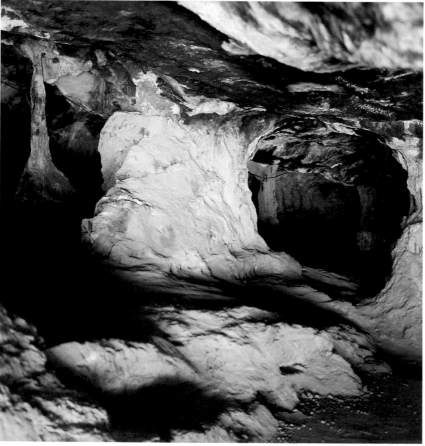

GROTTO OF MILATOS

The modern fishing village of Milatos, east of Mallia, bears the name of the ancient city which was inhabited in Minoan times and was destroyed and absorbed by *Lyttos* in the third century A.D. There is a very famous natural grotto with interesting geological formations, at the foot of Mt Kadistos, in which hundreds of women and children took refuge during the revolt against the Turks in 1823; they were discovered and massacred by Turkish soldiers. The grotto was subsequently transformed into a shrine and a small church was built inside it.

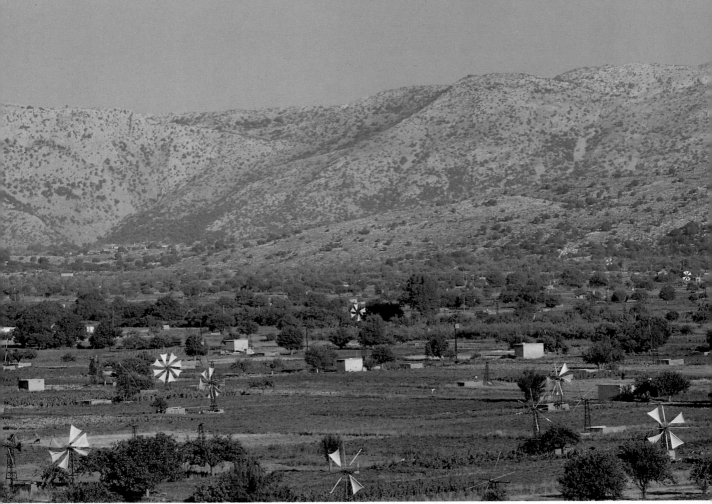

The Lasithi plateau, with mountains in the background.

Characteristic windpumps.

THE LASITHI PLATEAU

The vast upland plain of Lasithi, a plateau enclosed by mountains up to 2100 metres high and constantly buffeted by winds, rises to the south of the Gulf of Mallia to a height of over 800 metres, covering an area of about thirty square kilometres. More than once its naturally protective position offered the Cretans refuge against foreign attacks. The fertile plain produces a great deal of fruit, especially apples, and is extremely picturesque: the western part is somewhat bare, but divided up into numerous multi-coloured orchards, allotments and tiny fields for the cultivation of cereals, while the eastern part is covered with beautiful shrub vegetation among which graze a great many herds of goats. The landscape of the plateau, which today comprises seventeen villages, is dominated by the white sails of some 10,000 wind-pumps, used for irrigation during the summer.

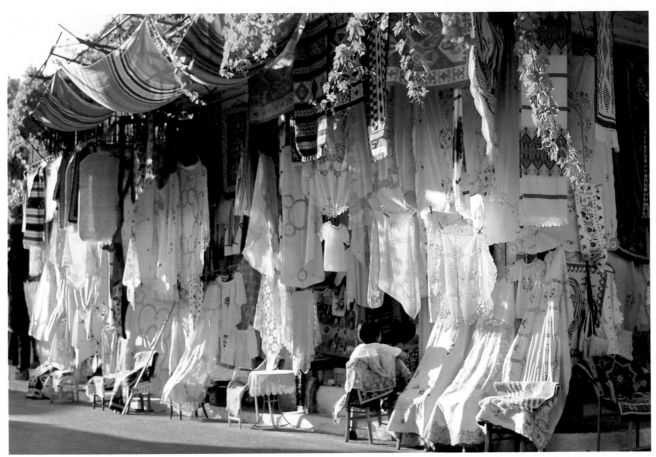

Textiles are still produced with traditional techniques.

Remains of ancient constructions against the Lasithi landscape.

Inhabited since Neolithic times and densely populated throughout antiquity, Lasithi has a number of important archaeological sites (small centres and inhabited caves) dating from Minoan times. Later the plateau fell into the hands of the powerful nearby Greek city of *Lyttos*, but the ingenious chessboard irrigation or drainage system probably dates from Roman times. It has been cleaned and renewed, and still works perfectly.

During the Venetian occupation Lasithi became an important centre of Cretan resistance; in 1263 it was depopulated by the Venetians, and cultivation and pasturage were forbidden. Later, when Venice was short of grain in the fifteenth century, Lasithi was reopened to farming and has been farmed ever since. As centres of revolt under the Turks, the villages suffered at least two terrible destructions in the course of the nineteenth century. Today the principal village of the eparchy is **Tzermiádhon**, where beautiful textiles and traditional embroideries are for sale, still made according to ancient traditions and techniques.

The beautiful landscape of the rich plain, with an economy still based on pasturing and agriculture, together with peasant industries and the harvesting of wild produce (figs, prickly pears, almonds, lavender, thyme and the characteristic bush with leaves akin to sage, the dyktamon, commonly used for infusions and known as tzai tou vounou or mountain tea).

129

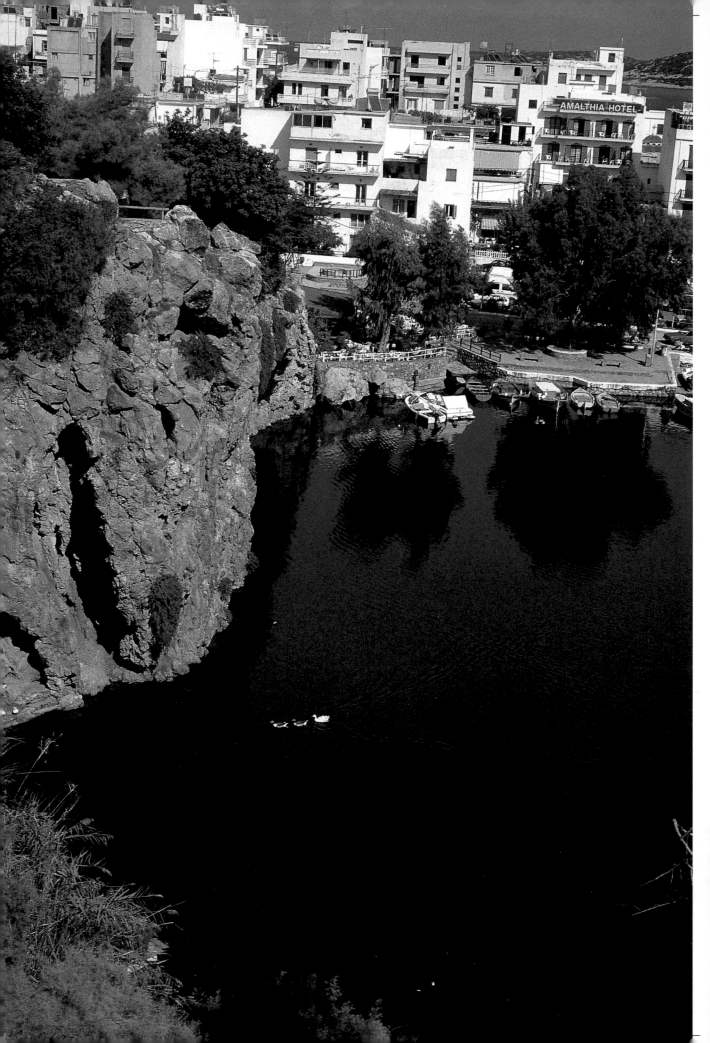

AYIOS NIKOLAOS

MUSEUM OF AYIOS NIKOLAOS - SPINALONGA - KRITSA - GOURNIA
IERAPETRA - SITEIA - PALACE OF KATO ZAKRO

Splendidly situated at the west end of the Gulf of Mirabello, protected to the south by the plain of Lasithi and by Mt Diktys, blessed with a delightful climate, the modern town named after St Nicholas (*Ayios Nikólaos*) is the chief town of the nome of Lasithi and one of Crete's principal tourist attractions. Its lovely beaches are extremely popular, and it is very well equipped for visitors: there are comfortable and even luxurious hotels, good restaurants, typical tavernas, cafés and numerous small bars around the harbour, which in the evening sparkle with agreeable and convivial street life.

The town is almost entirely modern, apart from a very few Venetian remains and the Byzantine church of Ayios Nikólaos. It stands on the site of the ancient port of the Greek city of *Lato*, once known as *Lato pros Kamara* (Lato of the arches), referring to some unidentified vaulted structure (*kamares* in Greek). Around the port various statues, tombs and inscriptions have been discovered, and are now preserved in the important **Archaeological Museum**, another of the town's attractions.

During the Venetian occupation, the town of Ayios Nikólaos, its harbour (called *Porto di San Niccolò* after the chapel dedicated to the Saint on the west-

Ayios Nikólaos: the Limín Voulismèni in the midst of modern buildings.

View of the city and the port.

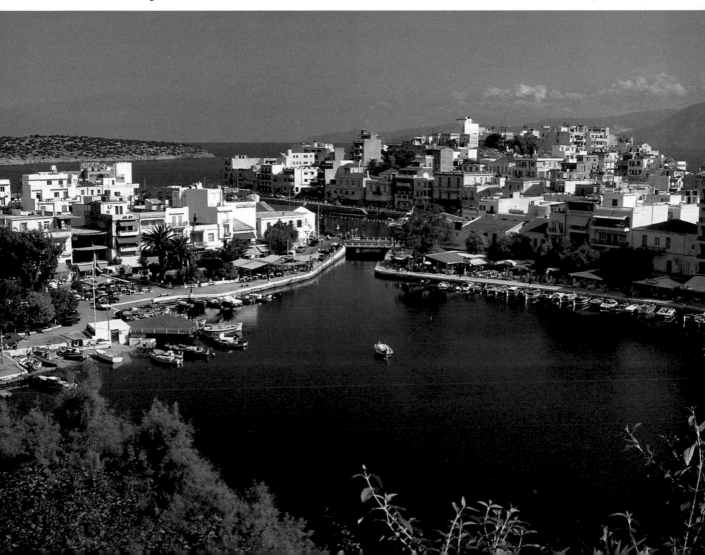

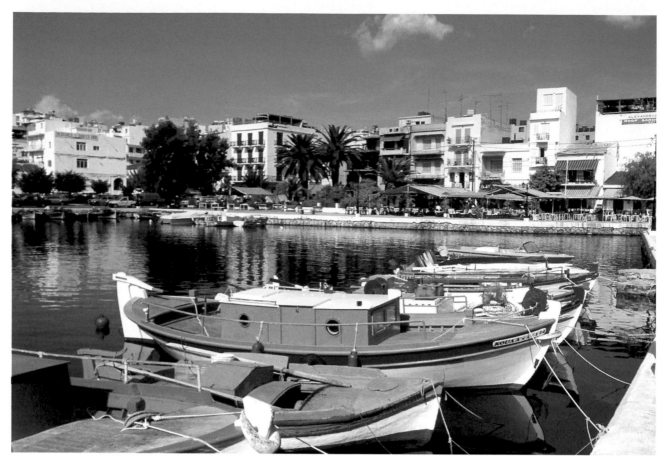

A view of the port.

Kaikia *(typical Greek boats) anchored in the well-protected, calm waters of the Limín Voulismèni.*

ern peninsula) and its mainly maritime commercial traffic were protected in the thirteenth century by the imposing but unfortunate **Fortress of Mirabello**, built on the highest hill on the coast, which gave its name to the gulf.

Castel Mirabello, as the Venetians called it, was first severely damaged by an earthquake in 1303 and then burned by the Turks in 1537, but it was later rebuilt; during the fighting in 1645 the fortress was surrendered to the Turks by its commander, but the Venetians recaptured and destroyed it completely.

The church of **Ayios Nikólaos** was founded in the eighth or ninth century and dates from the time of the Iconoclasts; its walls are decorated with "aniconic" frescoes (showing no figures); the original frescoes are under the layers of more recent wall painting.

The modern town of Ayios Nikólaos developed around an existing village, mostly in the last century, and is centred on a lake, *Limín Voulismèni*, which is said to be bottomless but is actually 64 metres deep (extremely deep for its size). Since 1870 the lake has been linked to the sea by a canal, which keeps its waters fresh and provides a very beautiful and well protected harbour.

MUSEUM OF AYIOS NIKOLAOS

The Archaeological Museum of Ayios Nikólaos, situated in the upper town, is fairly recent (1970), and preserves the finds of eastern Crete. The collection includes material of various periods, such as ceramics, Neolithic idols (note the very unusual **Neolithic idol**, roughly carved out of stone, perhaps a phallic symbol, from the Grotto of Plekita at Zakro), Minoan and geometrical pieces, Hellenistic terracottas, jewellery, weapons, and the contents of Roman tombs found in the area.

Archaeological Museum of Ayios Nikólaos: a room in the ceramics department.

The "Myrtos Goddess", terracotta idol of a woman with a jug from the Minoan settlement of Myrtos (2400 B.C.).

Minoan terracotta ointment jar decorated in the "Marine style" (1500-1400 B.C.).

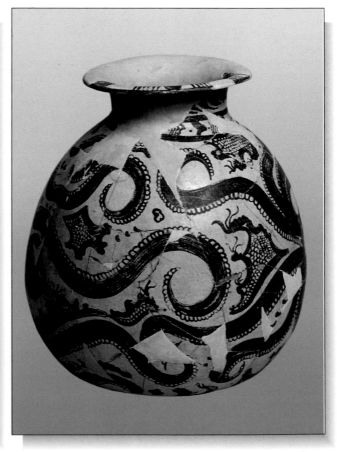

Spinalonga: view of the fortress with the bastion of Mezzaluna Barbariga *in the foreground.*

Panoramic view of the sea from the top of the fortress.

SPINALONGA

The small island of Spinalonga is one of many off the coast of Crete, but it had exceptional strategic importance; its fortress defended the Greek city of *Olous* (later *Elounte* or *Elounda*). In 1579 the Venetians built one of their strongest fortresses there, capable of resisting Turkish attacks even after the rest of Crete had fallen, until after a protracted siege the garrison spontaneously surrendered in 1715. The name is a corruption of the Modern Greek expression *stin Elounda* ("to Elounda"), which the Venetians transformed into Spinalonga on the analogy of the island of the same name near Venice. Enormous **bastions** (such as the massive semi-circular **Mezzaluna Barbariga**, with its row of gun emplacements) enclose various partially preserved buildings, including some sixteenth-century chapels. After the Turks left in 1903, the island became a leper colony for a while.

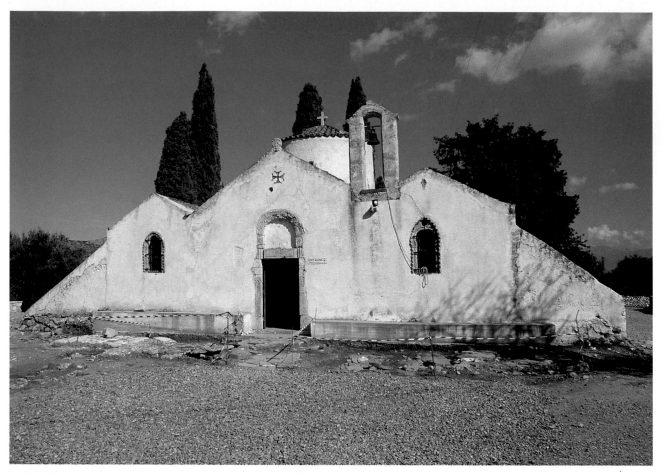

Kritsá, church of the Panaghia Kerá.

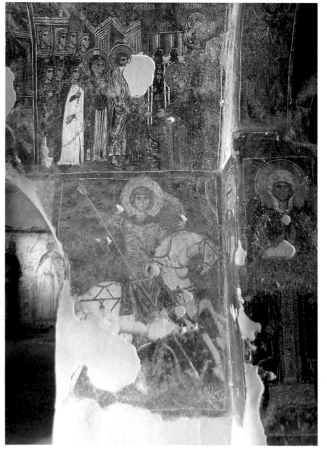

KRITSA

An important example of the art which developed in the area of Ayios Nikólaos during the Byzantine period is provided by the village of Kritsá, 11 km along the road leading south-west to the Plateau of Lasithi.

In a beautiful and peaceful landscape of thickly-wooded mountains, isolated and surrounded by olive groves, stands the stupendous church of the **Panagyia Kerá** (Our Lady "bright as wax"). Built in the third century with a nave and two aisles, the shining white of the walls contrasting with the red roof, the church has an unusual triangular façade surmounted by a bell, and a cylindrical drum protecting the central dome.

The small building is decorated with important

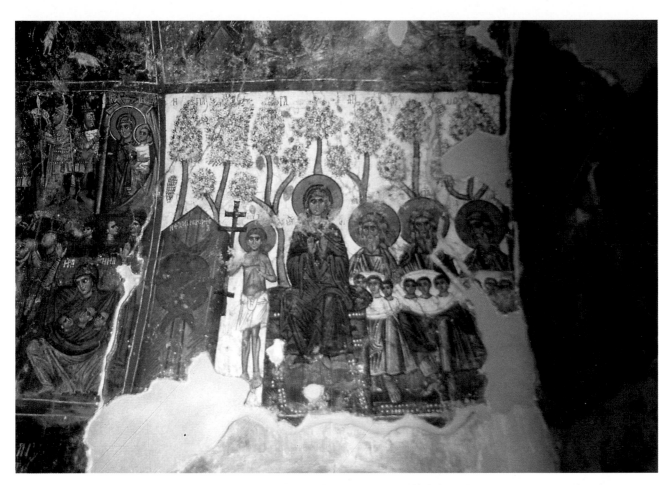

On this and the facing page:
14th- and 15th-century frescoes
with scenes from the life of
St Anne and Mary, and showing
the Ascension, Christ, Saints,
Angels and Prophets.

frescoes which allow us directly
to compare the styles and figura-
tive repertories of two celebrated
schools of painting within the
Greek Byzantine tradition: first,
the frescoes in the side aisles
(the more beautiful, with bril-
liant colours contrasting with the
dark background) painted by
artists of the Macedonian School
of the fourteenth and fifteenth
century; second, the frescoes in
the nave, by painters of the
Cretan School of the sixteenth
century.

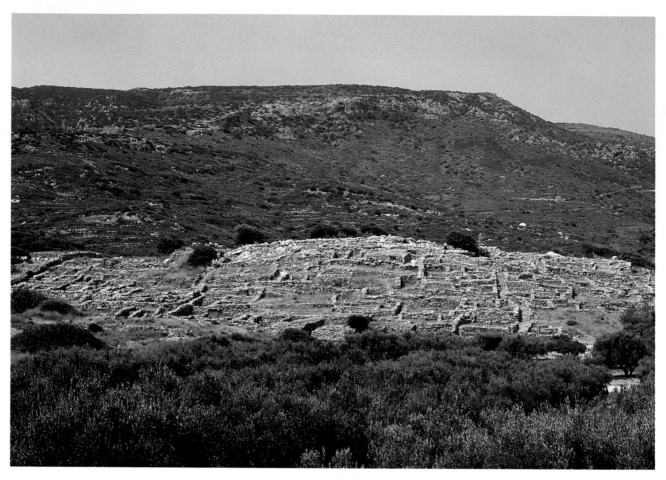

Gourniá: the excavations with the paved streets flanked by houses (for the most part only surviving at cellar level).

Slope on the north-east side of the city.

GOURNIA

The Minoan city known as Gourniá, lying on the Gulf of Mirabello, is the only example of a fair-sized town far from the great palaces and in some sense independent of them, and so it is of particular interest for its domestic aspect and for the evidence it provides of everyday living (almost a Minoan Pompeii).

The city (about 40,000 square metres) seems to have been built around a central palace, on a rocky hill overlooking the sea, with houses and streets following the lie of the land as it slopes down towards the sea. The houses, almost all quite modest, were of limestone up to a certain height and then of rough brick. Gourniá flourished towards the end of the Middle Minoan period (1600-1550 B.C.), and was destroyed by earthquake in about 1450 B.C.

Initially, a **small palace** (about a tenth the size of the one at Knossos) was built on top of the hill, in a panoramic and strategic position imitating those of the island's great palaces, at Crete's narrowest point. It was probably the residence of a local governor. The central rectangular courtyard had a portico of pillars and columns; the main façade, with blocks of limestone, gave onto a small west court. As in other places, the "great" central court was also the city's public square, and could be reached by at least two paved public roads with steps.

Where the courtyard meets the palace there is a small **theatral area**, a typical and inevitable feature of Minoan religious life. A double-horned monument was found nearby. In the palace there are **magazines**, still with their *pithoi* (jars), and a **lustral basin**, as well as a **shrine**.

The town grew around the palace with houses of several storeys built to a square plan, about five metres by five, with stone thresholds and paving

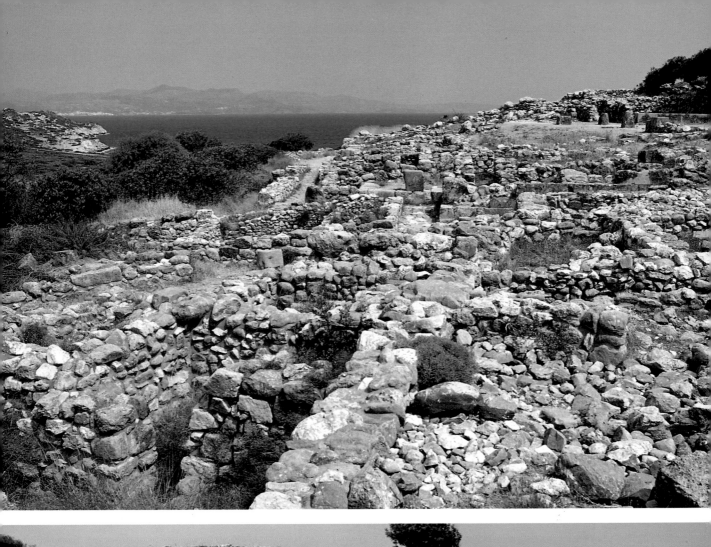

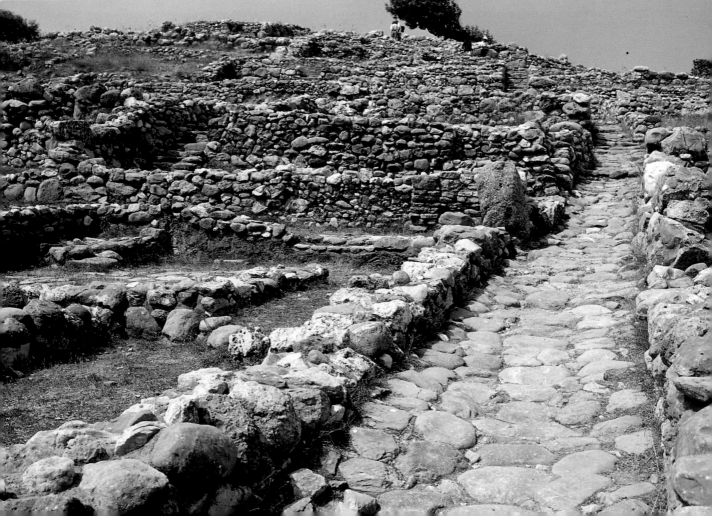

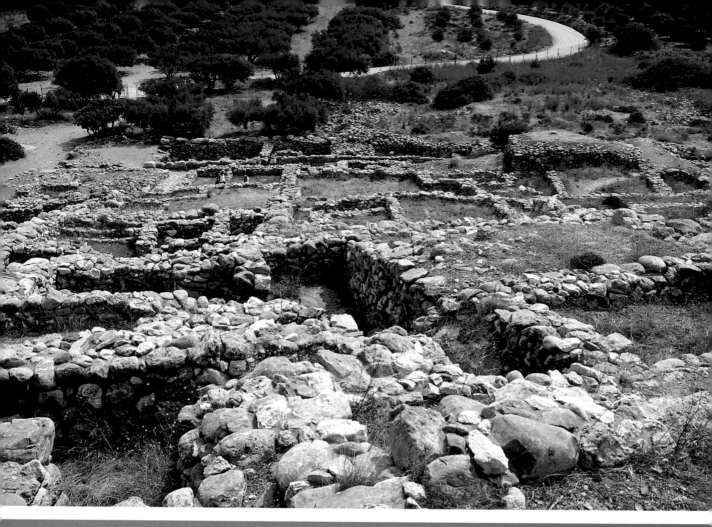

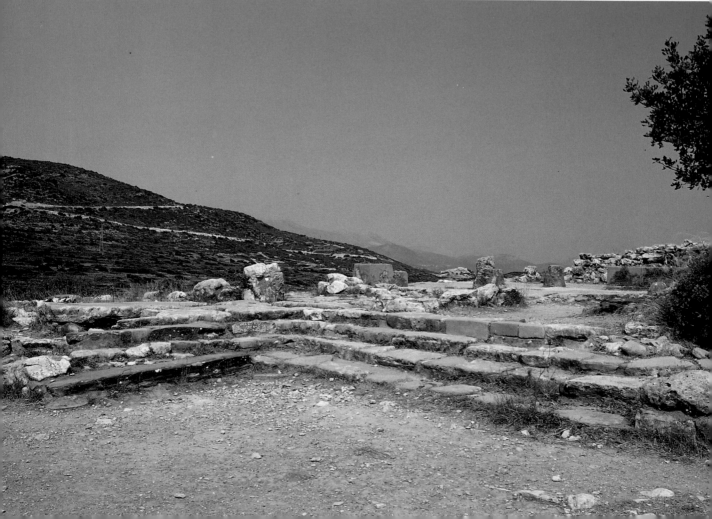

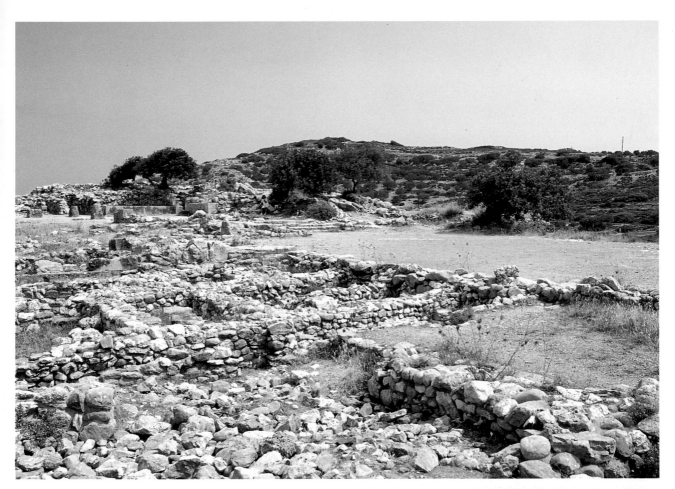

The central courtyard.

The village as seen from the palace.

The theatre area in the centre courtyard.

A side street.

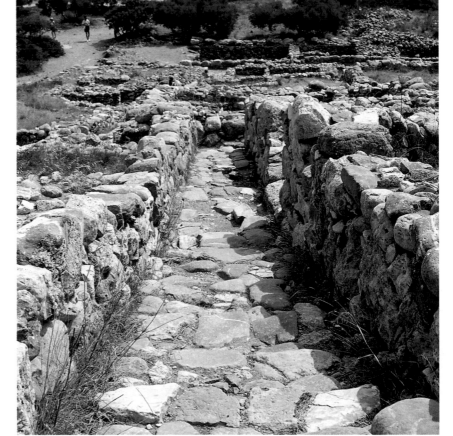

inside; the blocks of houses are subdivided into six groups by two main streets and a number of smaller ones (paved, or with steps and thus inaccessible to wheeled traffic) intersecting at right angles. The system of public drainage indicates a surprisingly high level of town planning, probably on the part of the local government, whatever its form might have been.

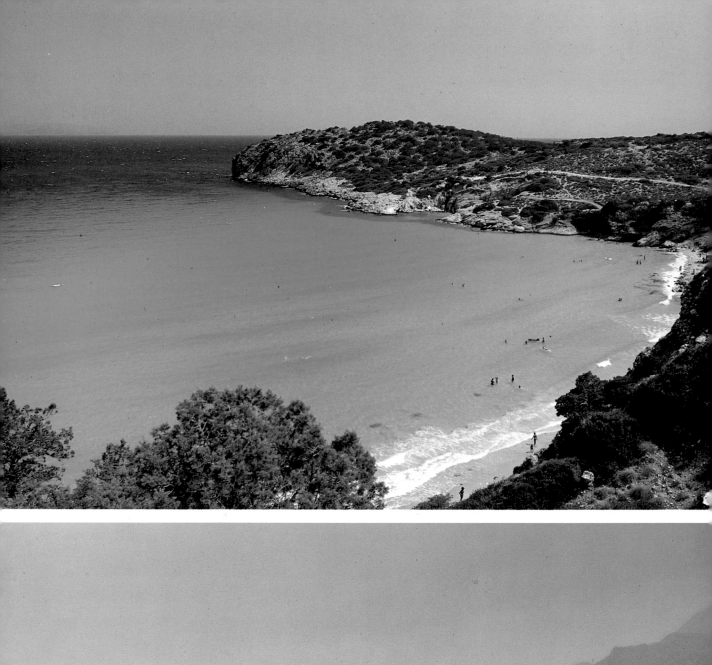
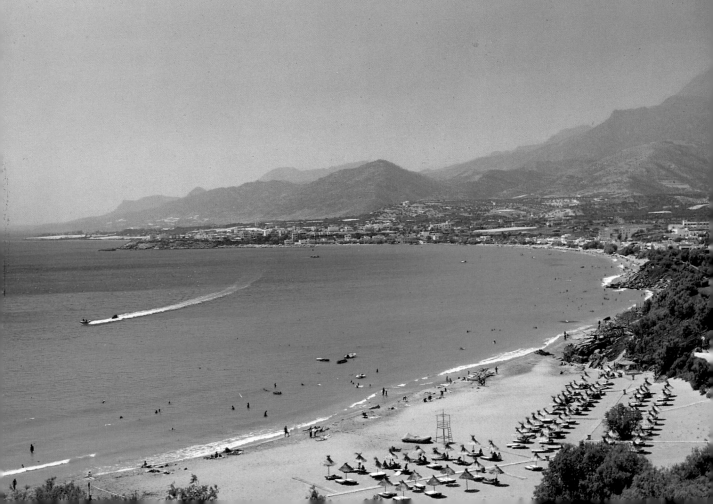

Ierápetra: view of the port and the cathedral bell-tower.

South coast of Crete: the bay of Istros and the beach at Makriyialós.

IERAPETRA

The modern city of *Ierápetra* (literally "sacred stone", but in fact merely the corruption of the ancient name *Hieraptyna*) is the most southerly city in Greece and in all Europe. It lies on the south coast, at the island's narrowest point, among some of the most beautiful scenery in Crete: the sandy beach **Makriyialós**, and the lovely bays of **Istros** and **Tertsa**.

Hieraptyna was a bitter enemy of the nearby city-states, with which she strove for dominion over the surrounding territory and sea. Her great ally was Rhodes, pleased to have the use of a port for her maritime traffic, half way between North Africa and Italy. The city flourished even more under the Roman Empire, when she was one of the principal eastern ports for the rich province of *Cyrenaica* (Libya), whose capital was *Gortyn*.

Later, the city with its Byzantine fortress was occupied by the Venetians, who built the present

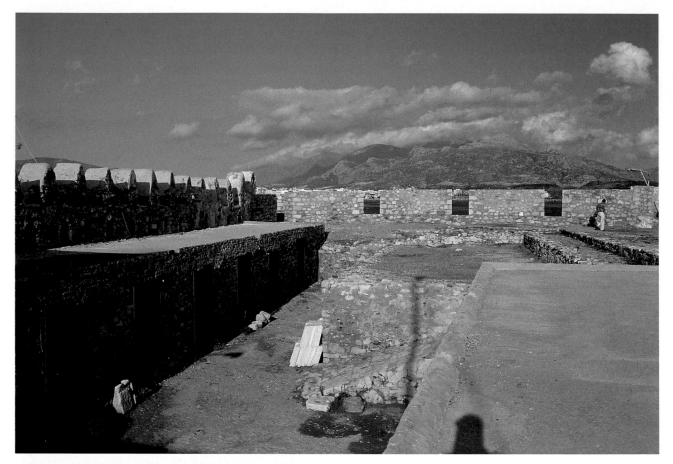

Venetian fortress bastions.

Typical Cretan costume.

fortress on the same site, perhaps in the first year of their occupation (1204). It was remodelled by the Venetian governor Francesco Morosini in 1626 and conquered by the Turks in 1647; today it is the main attraction of Ierápetra, together with the few remains of the Turkish occupation, such as a **minaret** and a **fountain**. There is also a small **Museum** with sculptures and important Minoan *larnakes* (painted terracotta sarcophagi).

It is said that on 26 June 1798 Napoleon stopped at Ierápetra on his way to Egypt, and a house in which he is supposed to have slept stands in the centre of the town.

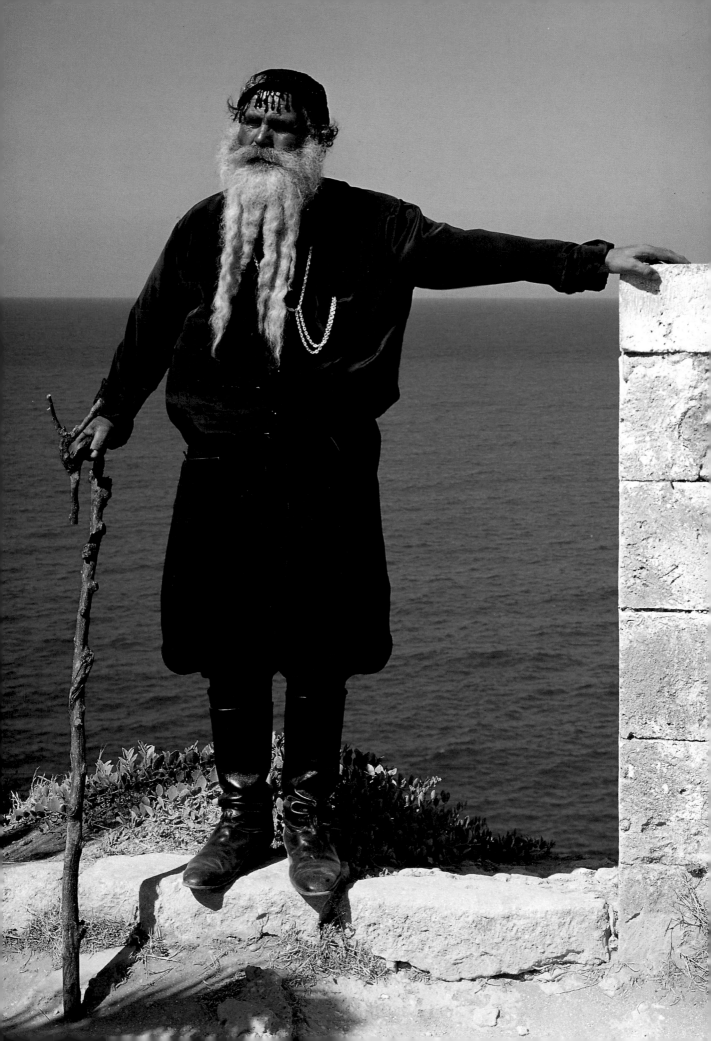

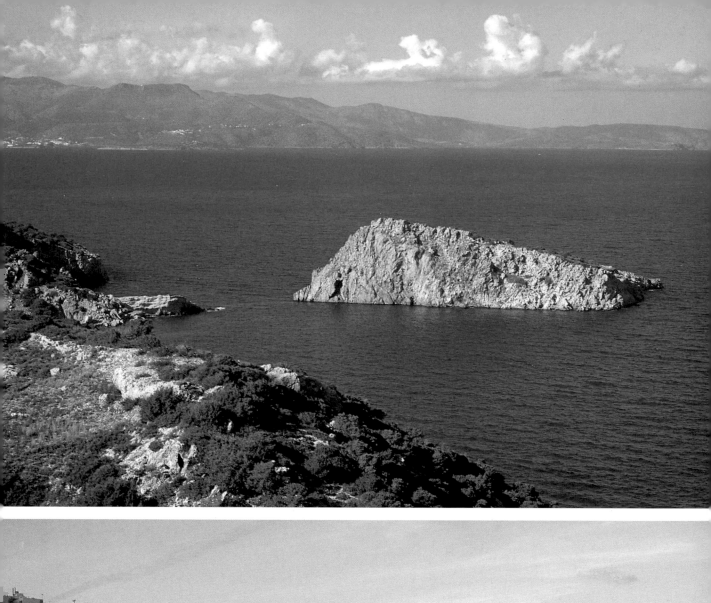
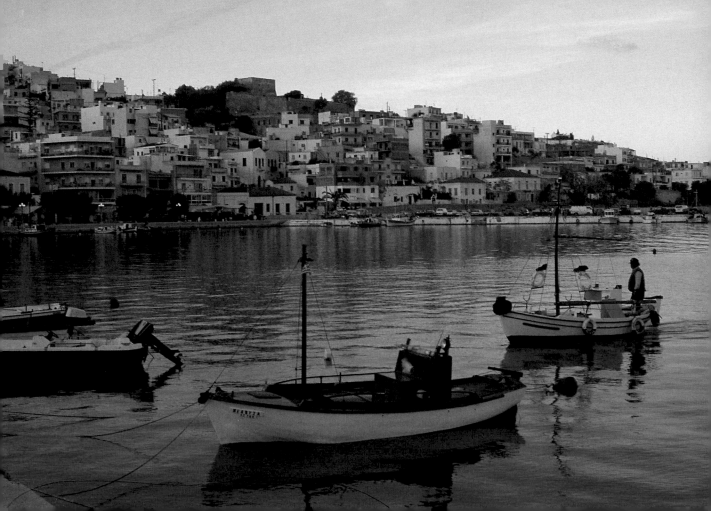

SITEIA

Identified with the ancient city of *Eteia* (or *Setaia*), port of the city of *Praisos* and home of Myson, one of the Seven Sages of Greece, Siteia lies in a picturesque bay on the north-east coast of Crete, between the Gulf of Ayios Nikólaos and the Gulf of Grandes. It is the chief city of its district, the most easterly on the island.

Inhabited since Neolithic times, Siteia took in refugees from *Praisos* when it was destroyed by *Hierapytna* in 146 B.C. Art flourished in the city in classical times, as is shown by the beautiful series of terracottas from the seventh century B.C. (in "Daedalic" style) found in the modern town, and Siteia passed through the Roman, Byzantine and Venetian periods until it was destroyed by an earthquake in 1508.

In 1538 its remains were sacked and burned by the sea rover Barbarossa. It declined until 1651 when it was finally abandoned completely, and its **fortress** known as the "Casarma" was partially demolished by the Venetians.

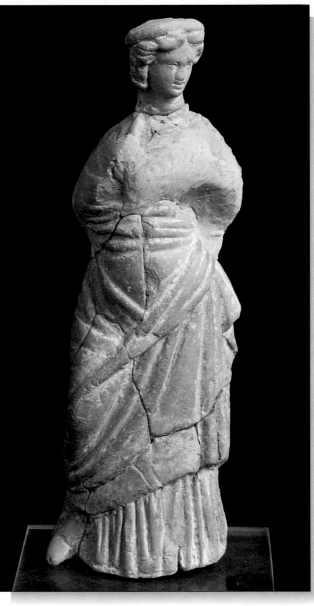

View of the coast between the Gulf of
Ayios Nikólaos and the bay of Siteia.

The port of Siteia.

Archaeological Museum: Hellenistic terracotta statue
from Xeròkampos, near Siteia.

Inside the Archaeological Museum.

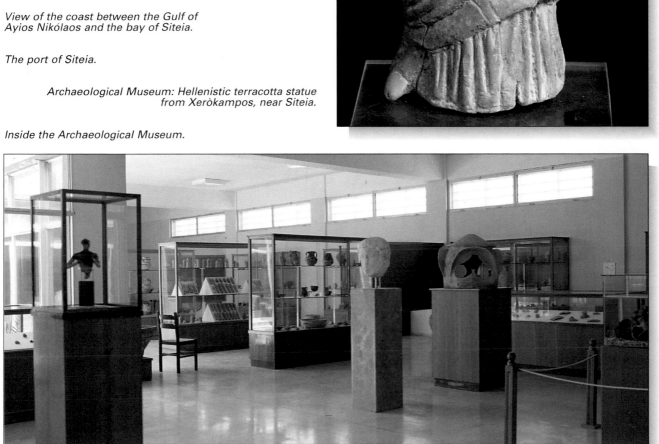

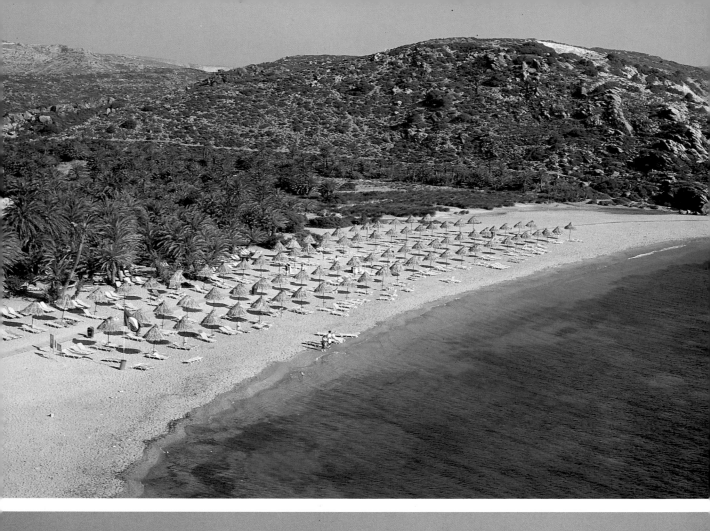
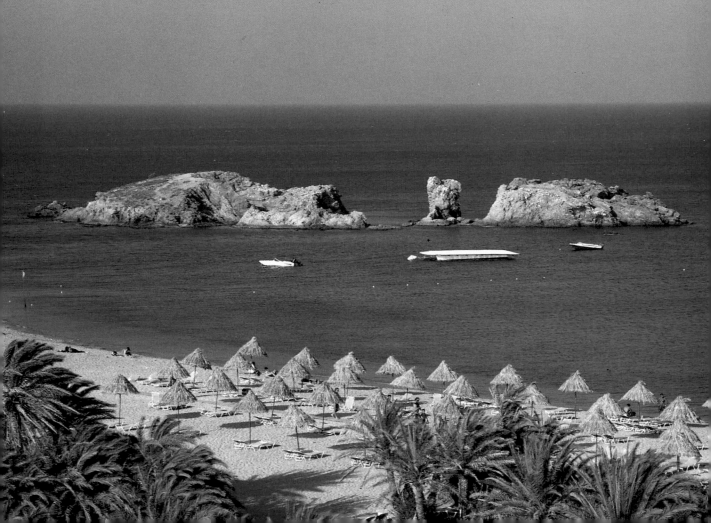

The bay of Zákro.

The beach of Vai.

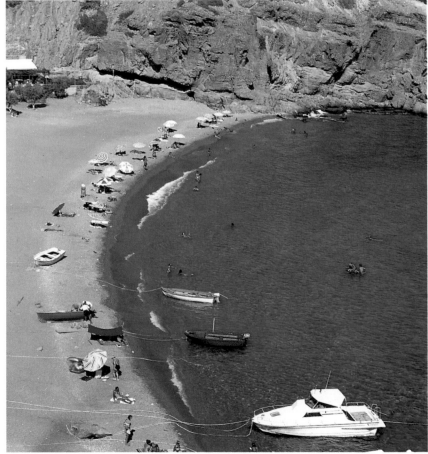

The modern town dates from 1870, when the Turk Avni Pasha rebuilt and repopulated it.

There are few remains of the past, but Siteia has an interesting **Archaeological Museum** with finds from excavations in the area, especially those at the nearby Minoan palace of *Káto Zákro*. Near the town there are excellent beaches at **Vai** (fringed with palm trees) and in the lovely bay of **Zákro**.

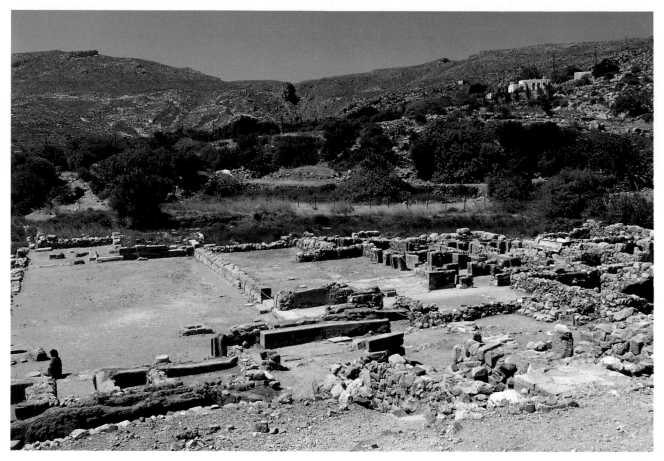

Káto Zákro: views of the central court and of the hall of pillars in the royal apartments.

THE MINOAN PALACE OF ZAKRO

On a beach among banana plantations, in the middle of a beautiful bay still untouched by tourist development, stand the ruins of the palace of Káto Zákro, the fourth-largest in Crete. Surrounded by a town which has been only partially excavated, the most important port for Egypt and the East was as usual structured around a **central court**, somewhat smaller than usual, opening before the eastern façade. Its orientation differs from the courts of the other palaces, which are laid out north-south. A large square stone at the north-west corner of the court must have been the **base of an altar**.

The **large room** in front of the altar was evidently the kitchen, with the dining room (the first to be found in a Minoan palace) and its adjacent series of **magazines** and service rooms. To the right of the court (east) there is a **paved portico**, with magazines at the back, connected by a ramp to the **northern quarters**.

Along the west side of the central court the entire ground floor is taken up with the **principal apartments**, paved and stuccoed and having a paved

skylight. The large room with columns opening directly onto the courtyard, with a row of supports along its central axis, has been called the **hall of ceremonies**. The room next to it was perhaps a banqueting hall, decorated with lively frescoes in relief with a frieze of interlaced spirals. Behind there is a series of cultic and official rooms, with a small **shrine**, a **lustral basin** with a protuberance on the back and a niche in the south wall, and another similar **large basin**, with a kind of baluster, reached by a well-preserved flight of eight steps. Also behind is the **archive room**, where many Linear B tablets were found; they had evidently been kept in wooden cupboards, the bronze hinges of which survive. The **treasury of the shrine** yielded valuable vases sculpted in semi-precious stone, kept in eight little enclosures of rough brick ranged along the wall of the room. Also in the west wing is a series of workshops and offices.

Along the east side of the central court was the **residential quarters of the royal family**, with spacious rooms the doors of which have thresholds and

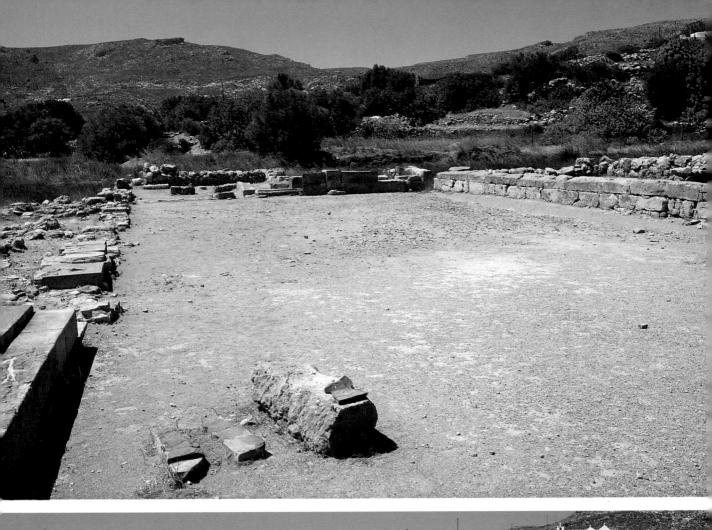
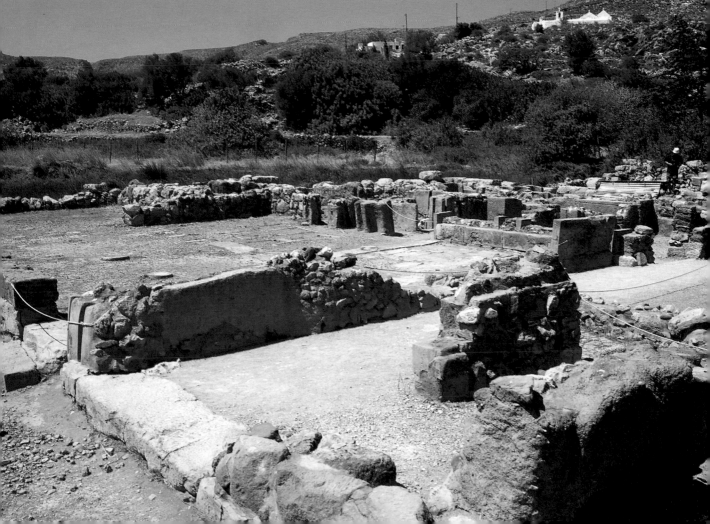

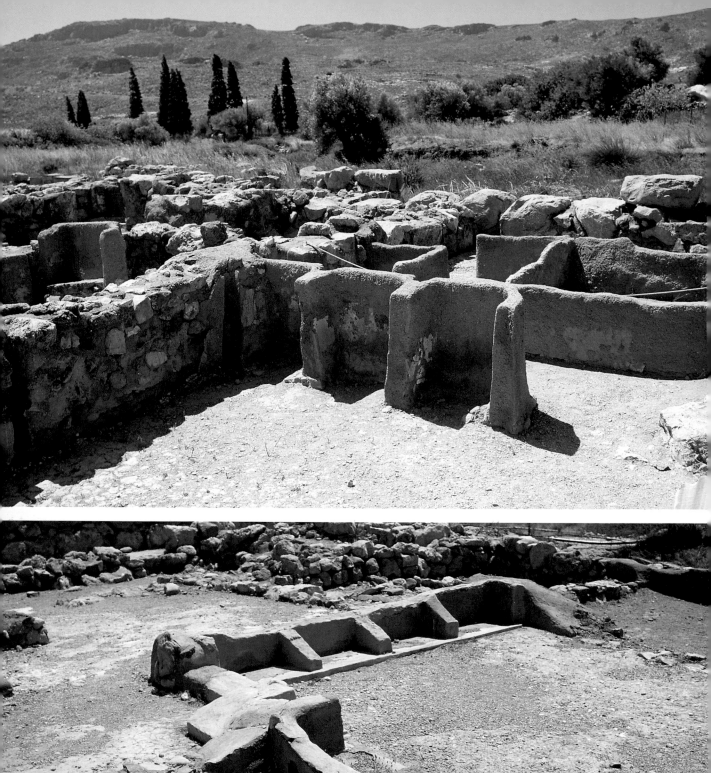
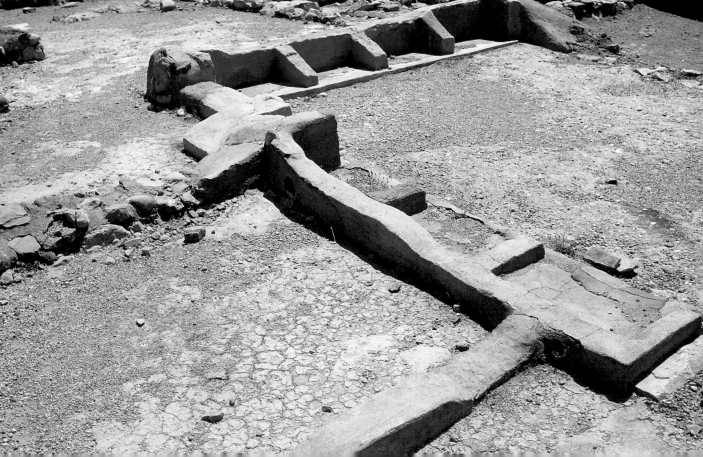

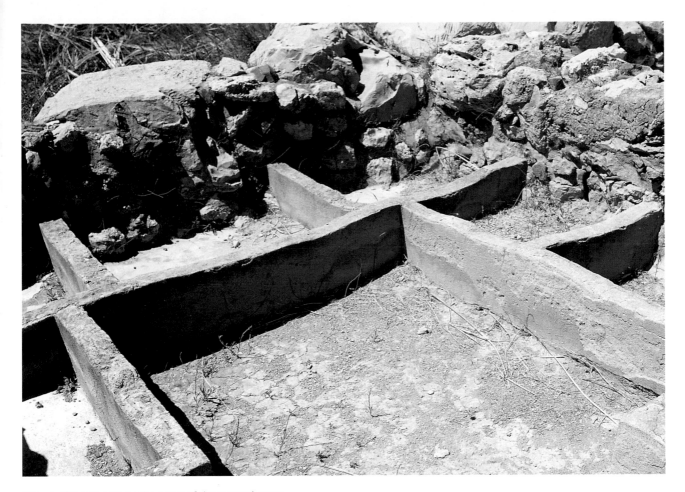

Views of the rooms to the west of the central court, with the treasury and its eight small recesses for valuable objects.

pilasters. The throne room must have been in this area. The **lustral basin**, with three wooden columns along the walls, was probably the bath room of the royal apartments. A large **room with a portico** opened onto a **large rectangular court** behind; in the centre a perfectly-preserved flight of eight steps led to a **circular pool** (7 metres in diameter), which at one time was probably covered by a roof supported by cylindrical columns whose bases may still be seen. The walls, built of stone and faced, were also stuccoed, and the water was maintained at a constant level. If this pool really was for swimming in, as the Greek archaeologist N. Platon believed, rather than for use as an aquarium (less likely), then it is the earliest known private swimming pool. Another **small pool**, a rectangular space

dug out of the earth and evidently intended to contain water, stands due south of the circular one, and was accessible only from outside the palace (perhaps to distinguish it from the other, exclusively royal, pool?).

At the south-east corner of the court, stairs lead to a well for sacred offerings, in which many vases were found. One of these was still full of olives, which the water had preserved in good condition; they dissolved within seconds on exposure to the air. A fireproof terracotta grill, and a most beautiful brazier, were also found.

The rooms along the south side of the central court, originally on two floors, were probably used as workshops for the production of articles in stone and ivory, of *faïence* (enamelled terracotta, similar

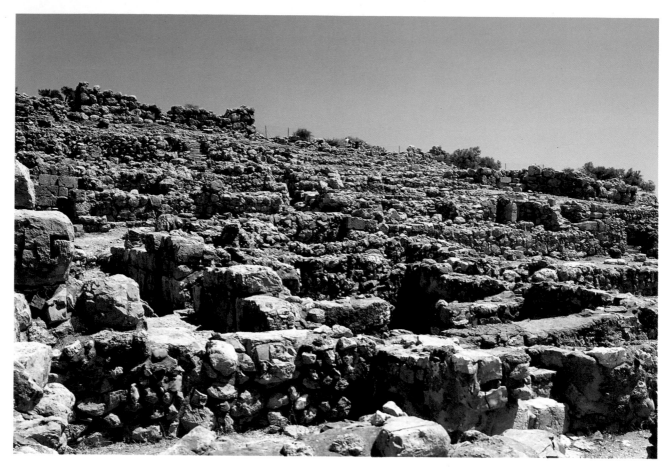

View of the village dwellings.

A paved road with steps.

The small outside "swimming pool", on the south-east side.

to majolica), and perhaps of perfumes. Along the west side of the workshops runs a long corridor leading to the central court, one of the most interesting features of the entire complex. A second entrance has been identified in the north-east part of the courtyard, where paved stairs led to another large court adjacent to the north rooms of the palace.

There was an excellent system of drains, with an elaborate network of conduits.

To the north-east of the palace itself a large **oblique building** was discovered, dating from the time of the first palaces, later incorporated into the royal palace and destroyed, together with the rest of the buildings, in the earthquake in c. 1450 B.C. This building, divided into two main parts and having an upper storey, was probably the residence of some high court official. Outside it, opposite its main (west) façade, there is a **paved road** with some steps.

To the north of the building, a number of isolated dwellings have been found, connected by pathways and ramps, some with steps, which intersect at right angles; among these houses is the **strong building**, so called from the thickness of its walls, with at least fifteen rooms.

In the area around the palace and the surrounding village a number of tombs have been excavated. Some of the finds are on display in the Archaeological Museum in Siteia.

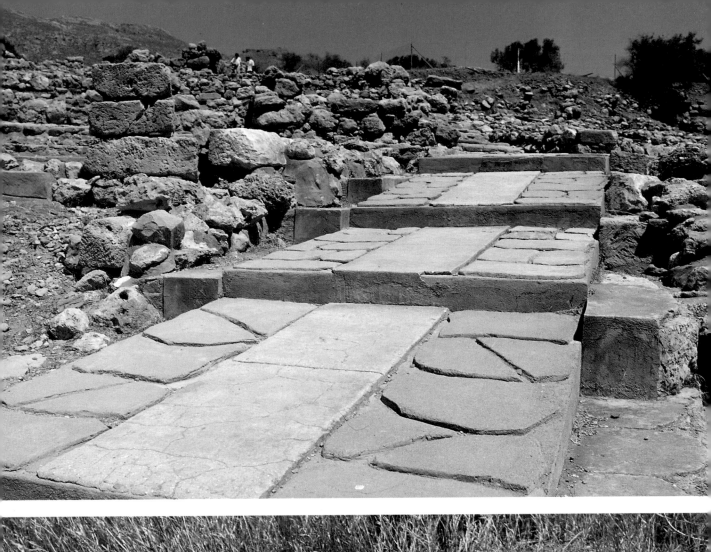

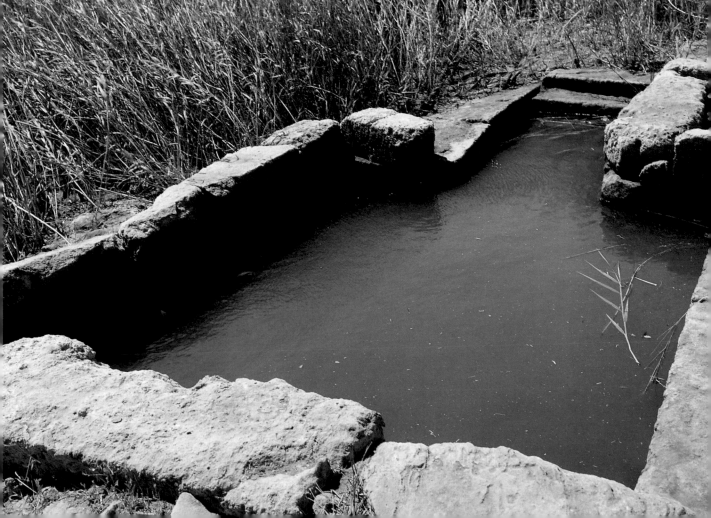

FOR LOVERS OF ARCHAEOLOGY

For those who particularly enjoy visiting archaeological sites,
often to be found in settings of rare natural beauty,
we offer suggestions for places to visit which are off the tourist itineraries
(beginning with the extreme west of Crete, moving towards the central and
southern areas to end with the eastern peninsula).

FALASARNA

Falasárna, which takes its name from a Nymph, lies at the far west of Crete, and because of its position it was allied with other Cretan cities and with cities on the Greek mainland, including Sparta. A very few ruins (rock sculptures, tombs) are to be seen in a wild and lonely landscape. There is a Byzantine fortification overlooking the sea.

LISSOS

On the south coast of the island, Lissos was the site of a famous shrine to Asclepius, the god of medicine. Excavations have revealed the remains of a sacred fountain and a temple with a mosaic pavement, showing animals and geometrical designs. Lissos also has two early-Christian basilicas, an aqueduct, a theatre and thermal baths. The setting is spectacular, with an unrivalled view of the Mediterranean.

APTERA

Lying in the Bay of Soúda, east of Khaniá, Aptera takes its name from the "wingless ones": according to legend, the Sirens were defeated in a musical contest by the Muses, so they plucked off their wings and threw themselves into the sea. The plain of Aptera, surrounded by an enormous fortification 4 km long, has the remains of huge Roman cisterns in an excellent state of preservation. There are temples (to Artemis and Demeter), a wall covered with inscriptions, and some remains of a theatre. Among more recent buildings are the monastery of Ayios Ioánnis and the Turkish fortress of Itzedin.

ARKHANES

This important Minoan site to the south of Knossos preserves the remains of a large circular building with stairs, perhaps a sacred well. Near the village of Phourni a large and very beautiful Minoan funerary complex has been excavated: the necropolis, built on top of a large communal tomb (for a whole family or clan), was in use from 2000 B.C. for many hundreds of years. It consisted of circular tombs with benches around the walls, covered with a dome (the *thòlos* type) and having small lateral rooms. The necropolis must have belonged to an important family; it has yielded gold jewellery and precious stones, as well as evidence of animal sacrifices for the dead (including a bull).

VATHYPETRO

South of Arkhánes a large country house of the fifteenth century B.C. was discovered at Vathypetro. Built on high ground to oversee the agricultural activity of the surrounding countryside, the villa includes a shrine complex with a portico of three columns, a large courtyard, magazines with pairs of central pillars and *pithoi* (terracotta jars) still in situ, and a large room whose roof was once supported by four pillars. Of great interest is the wine-press in one of the magazines, consisting of a *pithos* with pourer, basin and collecting channel, for gathering the grape juice traditionally pressed from the grapes by trampling on them with bare feet.

AMNISOS

On the coast east of Iráklion, almost on the sea, a two-storied Minoan villa has been excavated. It was built of fine stone blocks and paved, and the space was organised around a large hall with two columns in the middle. At one time it was adorned with splendid naturalistic frescoes, such as the one of the lilies, now in the Museum of Iráklion. A room on the north-east side was a kind of loggia with pillars, opening onto a paved terrace overlooking the sea. It is thought that the villa was the residence of a commander of the Minoan navy. Amnisos was one of Knossos's most important ports.

NIROU (KHANI)

In a small bay to the east of Amnisos, Nirou (or Nirou Khani), stood a luxurious Minoan villa, connected to a small harbour. It was built around 1550-

1500 B.C. and was destroyed by a fire. The villa is well worth visiting, not only because of its excellent state of preservation but also because it gives a very good idea of the luxury enjoyed in their private dwellings by Minoan notables, in this case perhaps a priest, since many cultic objects were discovered among the paved courtyards, rich magazines, rooms with benches and columned skylights.

LYTTOS

This powerful Greek city was the deadly enemy of Knossos, which after a long struggle destroyed it in 219 B.C. and enslaved its women and children. It stood south-east of Mallia, at the foot of Mt Diktys. The site has been systematically excavated only sporadically and recently. There are the remains of a large early-Christian basilica with mosaic pavements, found beside the ancient *agora* and today lying beneath a modern church. The theatre of Lyttos, with its oval portico, was the largest in Crete.

LATO

In the Gulf of Ayios Nikólaos, west of the town of that name, stood the ancient city of Lato (or Leto), allied to the powerful Lyttos. It took its name from the mother of the divine twins Apollo and Artemis, and stands on a hill commanding a superb view of the north coast and the southern part of the island. The surrounding countryside is well worth visiting. Lato preserves an *agora* of about 1000 B.C., a spacious pentagonal area with a large square cistern, a temple dedicated to Eileithyia goddess of childbirth, and a theatral area with steps (deriving from similar Minoan buildings and looking forward to the classical Greek theatre). Above are the public buildings, protected by two side towers, including the council chamber or *prytaneion*.

DREROS

Near the modern town of Neápolis, on a foothill of Mt Kadistos, the ancient Dreros dates from the eighth century B.C. It comprises a small *agora*, a theatral area surrounded by simple steps, a terraced wall, a large cistern, a prytaneion, and a temple of Apollo. This small and simple building, with its *eschara* (altar for burning the sacrificial offerings) in the centre and a bench on one side for cultic statues, is of great importance in the history of Greek temple architecture. On the bench three statues were found (the only such discovery ever made) representing Apollo, Artemis and their mother Lato (or Latona), of bronze hammered onto a wooden core - the ancient technique known as *sphyrelaton* (from *sphyri*, a hammer). The three statues are now housed in the Archaeological Museum of Iráklion.

OLOUS

The city of Olous (Eleunte, Elounda) stood on the isthmus between the mainland and the peninsula off which lies the island of Spinalonga, in the western part of the Gulf of Mirabello. At the beginning of this century the French cut a canal through this isthmus to link the Bay of Elounda with the open sea. Part of the ruins are now beneath sea level, but this fascinating and evocative site (which one visits by walking along narrow sand-banks) preserves the remains of two early-Christian basilicas (seventh century) with mosaic pavements decorated with plant forms and geometrical patterns, fishes and dedicatory inscriptions.

A few kilometres to the south, near Ellnika, are the remains of a temple to Aphrodite, of the second century B.C., divided into two parts, one dedicated to the goddess and the other to her lover Ares, god of war.

ITANOS

On the peninsula at the extreme north-east end of the island stood the city of Itanos, mentioned by Herodotus; it flourished in the Greek, Roman and Byzantine times but was destroyed by the Saracens and lay empty for a long time, so that today it is known as Erimoupolis ("the desert city"). It was excavated by the French, but the visible ruins are rather few: apart from a fine terraced wall on the western acropolis, the Roman and Greek houses were obliterated by Byzantine buildings and by a large basilica.

PALEKASTRO

The "city of the old castle", in a beautiful bay in the Gulf of Grandes, preserves the remains of a Minoan town (damaged during the second world war), with dwellings irregularly scattered and streets intersecting at right angles with the main road, but without any palace or public square. The houses, which had a communal drainage system, have most beautiful façades looking onto the streets; they are typical of Minoan private dwellings, but have some luxurious features (paving, porticoes, pilasters and columns, bath rooms, etc.).

MYRTOS

On a hill beside the road which runs along the south coast, between Ierápetra and Tertsa, there is a large Minoan settlement dating from 2500-2200 B.C. Its panoramic position no doubt allowed control of shipping.

The settlement consists of about eighty buildings forming a remarkable unity without isolated houses, built of rough stone and brickwork, with plastered walls painted red or brown.

It was destroyed by a fire, possibly on account of its strategic position. There are three small shrines (one being the oldest in the Minoan world), basins and various structures, including a workshop with eight rudimentary potter's wheels. In the area the famous "Goddess of Myrtos" was found (today in the Museum of Ayios Nikólaos), as well as some of the oldest engraved stone seals, unfinished (and therefore attesting to local production).

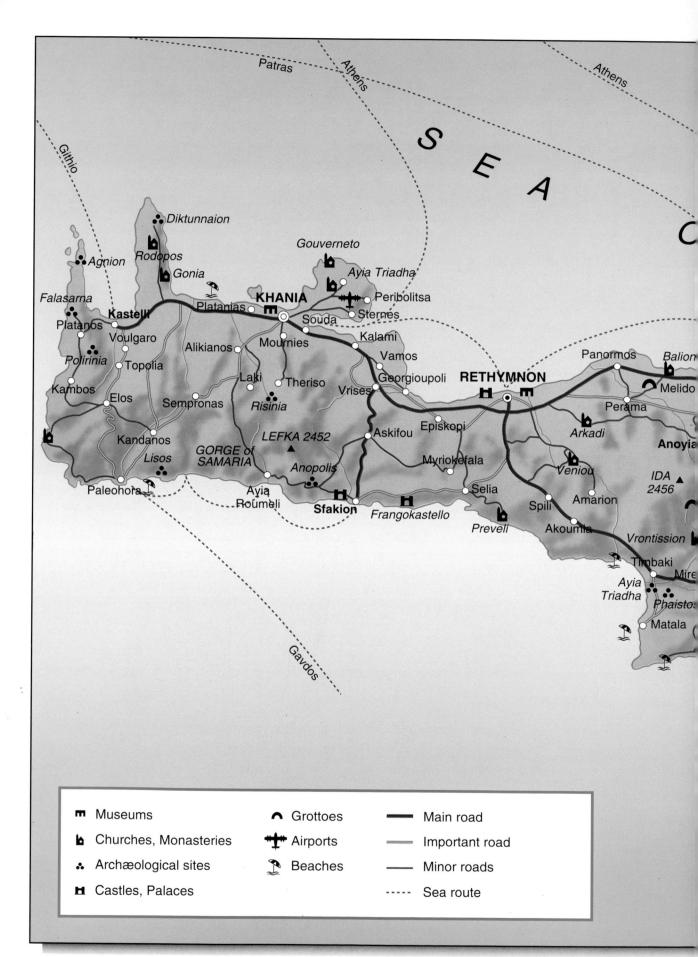

SEA

Patras
Athens
Athens

Githio

Diktunnaion
Agnion
Rodopos
Gonia
Falasarna
Gouverneto
Ayia Triadha
KHANIA
Peribolitsa
Kastelli
Platanias
Sternes
Platanos
Voulgaro
Souda
Mournies
Kalami
Polirinia
Alikianos
Vamos
Topolia
Laki
Panormos
Balion
Kambos
Theriso
Georgioupoli
RETHYMNON
Melido
Vrises
Elos
Sempronas
Risinia
Perama
Kandanos
LEFKA 2452
Askifou
Episkopi
Arkadi
Anoyia
Lisos
Anopolis
Myriokefala
Veniou
IDA 2456
Paleohora
Ayia
Roumeli
Sfakion
Frangokastello
Selia
Amarion
Spili
Vrontission
Preveli
Akoumia
Timbaki
Ayia
Triadha
Mire
Gavdos
Phaistos
Matala

GORGE of
SAMARIA

♏ Museums	∩ Grottoes	▬ Main road
⬘ Churches, Monasteries	✈ Airports	▬ Important road
⁂ Archæological sites	☂ Beaches	▬ Minor roads
⊞ Castles, Palaces		····· Sea route

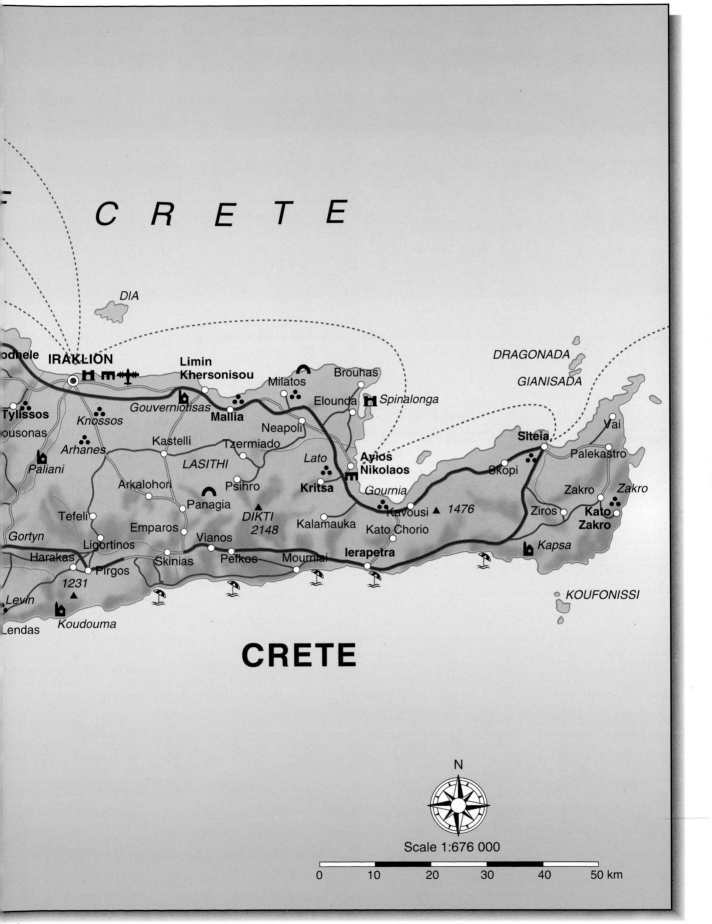

CRETE

CRETE

odhele **IRAKLION**

DIA

Limin Khersonisou

Milatos

Brouhas

Elounda

Spinalonga

Tylissos

Gouverniotisas

Mallia

ousonas

Knossos

Neapoli

Kastelli

Tzermiado

Arhanes

DRAGONADA

GIANISADA

Siteia

Vai

Palekastro

Paliani

LASITHI

Lato

Ayios Nikolaos

Skopi

Arkalohori

Psihro

Kritsa

Gournia

Zakro

Zakro

Tefeli

Panagia

Kalamauka

Kavousi ▲ 1476

Ziros

Kato Zakro

Gortyn

Emparos

Vianos

DIKTI 2148

Kato Chorio

Kapsa

Harakas

Ligortinos

Skinias

Pefkos

Mournlai

Ierapetra

1231 ▲

Pirgos

KOUFONISSI

Levin

Koudouma

Lendas

N

Scale 1:676 000

0 10 20 30 40 50 km

INDEX